FORM 19

THE CHICAGO PUBLIC LIBRARY

FEB 7

W9-AFI-050

DISCARD

CHICAGO PUBLIC LIBRARY
SULZER REGIONAL
4486 N. LINCOLN AV 60625

CLAUDE LORRAIN

Publishing director: Paul ANDRÉ
Adviser: Irina KOUZNETSOVA
Typesetting: Presse +

Printed by SAGER
for Parkstone Press Ltd
Copyright: 2e trimestre 1995
ISBN 1 85995 193 7

© Parkstone/Aurora, Bournemouth, England, 1995
All rights reserved. No part of this publication may be reproduced or adapted
without the prior permission of the copyright holder.

CLAUDE LORRAIN

Painter of light

Texts
Sergei DANIEL
Natalia SEREBRIANNAYA

PARKSTONE
AURORA

PARKSTONE PRESS, BOURNEMOUTH
AURORA, ST. PETERSBURG

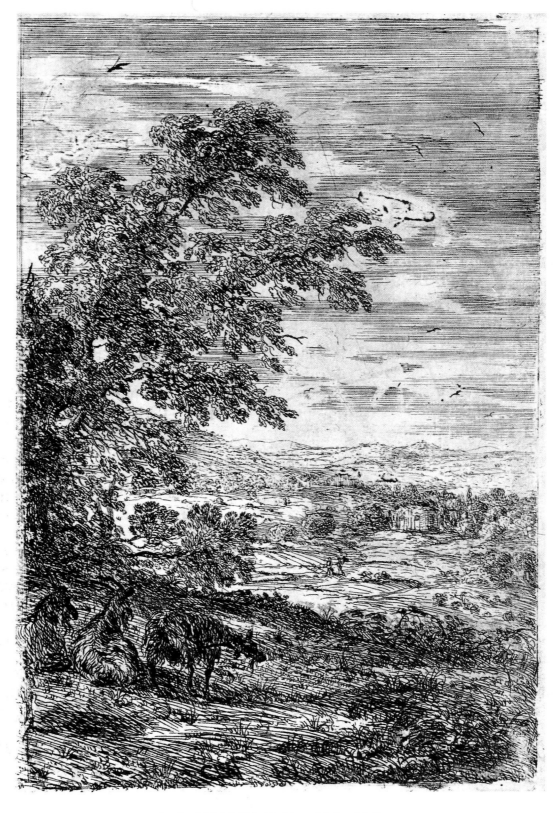

Goats. 1630-1634. Etching. 19,5 x 12,7 cm.
Hermitage, St. Petersburg.

R01212 25373

Sergei Daniel

THE ART OF CLAUDE LORRAIN AS A CULTURAL PHENOMENON

... And, his lyre in harmony with the rustic flute,
He sings of the torch that will soon take fire
V.A. Zhukovsky

If we liken history to a river, then, extending the analogy, we might say that its course is as uneven as that of any river. Some epochs create the sense of a measured, even slow passage of time, while in others the historical process moves forward by leaps and bounds, like an impetuous, rushing stream. The seventeenth century in Europe was just such an epoch of accelerated, stormy progress.

This heightened dynamism is the primary reason why we find it so hard to give an adequate name to the period. Of the many designations which have so far been proposed, none has been accepted decisively. Depending on their point of view, some scholars have called it the Age of Absolutism, others the Age of the Counter-Reformation, still others, the Baroque Period, and in their search for the dominant historical factor, they were each time faced with obvious alternatives.[1] Perhaps the closest anyone has come to an inclusive definition is a simple progressional formula, "from the Renaissance to the Enlightenment".

We will now try to establish the general nature of this progression, basing our analysis mainly on the study of seventeenth-century Western European culture.

This was a period of brilliant scientific discoveries which led to profound changes in man's picture of the world. In natural science, the researches of Kepler, Galileo, Descartes, Fermat, Pascal, Harvey, Leeuwenhoek, Huygens, Newton and Leibniz produced a kind of permanent revolution, whose enormous amplitude was marked, as it were, by the telescope at one end, and the microscope at the other. The idea of the unity of the physical world was associated with that of the unity of all biological forms. Science was placed on a firm basis of experiment and mathematical analysis. The rapid development of scientific knowledge and the increasing variety of its different branches called for a new synthetic philosophy, and seventeenth-century thinkers responded to this demand with an unprecedented effort, elaborating the doctrine of Universal Order.[2]

It was not without reason that some historians of science and philosophy called the seventeenth century an Age of Geniuses: this century saw the publication of writings by Bacon, Gassendi, Descartes, Spinoza, Pascal, Hobbes, Locke and Leibniz.

For art, closely interwoven with all other forms of cultural activity, this was also an age of discoveries.

John Donne wrote in the early 1610s:

> And new philosophy
> calls all in doubt,
> The element of fire
> is quite put out;
> The sun is lost, and the earth,

CHICAGO PUBLIC LIBRARY
SULZER REGIONAL
4455 N. LINCOLN AVE. 60625

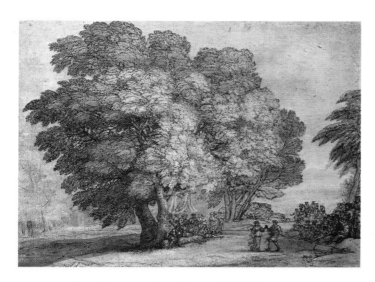

Landscape with a Dance. 1663. Drawing
Royal Art Collection, Windsor Castle, England

and no man's wit
Can well direct him
 where to look for it.
And freely men confess
 that this world's spent
When in the planets,
 and the firmament
They seek so many new;
 they see that this
Is crumbled out again
 to its atomies.
 'Tis all in pieces,
 all coherence gone;
...
This is the world's condition now...[3]

This passage may be viewed as a poetic expression of the new general pattern of thought, for it gives an eloquent formula of Baroque relativism, which permeated contemporaries' entire conception of the Universe. The proud and confident Renaissance optimism was replaced by a Baroque mood of morbid sensitivity, full of deep inner contradictions.

The Age of World Theatre is another name justifiably applied to the seventeenth century, and not only because the period included such authors as Shakespeare, Dryden, Congreve, Gryphius, Lope de Vega, Tirso de Molina, Alarcon, Calderon, Corneille, Racine and Molière. The very nature of the theatre made it particularly congenial to the spirit of the age. On the stage, appearances easily replace reality, reality wears a mask of illusion, and the world at large appears as an endless chain of transformations. It became a truism to compare the world to a stage where each plays a role assigned to him.[4] Hence such maxims as "All the world's a stage", or "Life is a dream", or phrases like "The comedy of life". The underlying idea may be summed up in the words, "Life is a play", and thus we may speak of the theatralization of reality during the Baroque era.

For all its love of strong spectacular effects, seventeenth-century art never moved too far from reality; on the contrary, it sought to convey the fullest possible picture of life, reproducing its infinite wealth of detail and the unity of its various aspects, and often deliberately exaggerating the contradictions. Whatever its form — whether it be a stage performance or a poem, a novel or an architectural ensemble — a work of Baroque art is always dramatic in spirit and form and always synthetic in nature.

The general picture is not one of the different arts tending to converge in a common focus, rather that each of the arts, having consolidated its position within its own province, began to expand into the adjoining areas, broadening its sphere of influence and jockeying for dominance in the arts. The result was what seemed a paradoxical situation: there was, so to speak, a struggle for the throne in the realm of culture, and yet there were no losers, for each participant benefited by borrowing from the others, constantly increasing its own chances of dominance. This productive exchange of values

carried the arts as a whole to new heights.[5] We should particularly note that the greatest seventeenth-century writers more often than not chose to convey their ideas in dramatic form, from whence derives the theatricality of Baroque poetry and prose. At the same time the pathtaking of the fine arts went hand-in-hand with that of literature. The classical principle *ut pictura poesis* retained its significance for both aesthetics and artistic practice; in the sphere of music, there emerged such new dramatic forms as opera and the oratorio, which were of paramount importance for the later development of music; in garden design, we see the dramatization of Nature itself;[6] and there are strong grounds to speak of a specifically dramatic quality to seventeenth-century architecture, sculpture and painting.[7]

The idea of the close intercourse between and indeed the essential homogeneity of the arts was central to the aesthetic doctrine of the period. In 1642 a treatise by Baltasar Gracian, one of the leading theoreticians of the Spanish Baroque, was published. This work, entitled *Agudeza, y Arte de ingenio* (The Art of Quick Wit), was innovatory, giving a new direction to aesthetic thought by shifting its focus from Aristotle's *Logic* and *Poetics* to his *Rhetoric*. The Spanish author strictly differentiated between man's powers of logical and aesthetic judgement. The latter is designated by the word *gusto*, taste, which is determined by creative intuition capable of grasping the essence of disparate objects of phenomena and establishing affinities between them. "The art of quick wit" was given a theoretical basis in the writings of Gracian's contemporary, Emmanuelle Tesauro, who was justly called the Boileau of the Baroque.[8] His treatise *Il Cannochiale Aristotelico* (The Telescope of Aristotle, 1655) contains a systematic exposition of the new prin-

ciples of poetics. Taking, like Gracian, Aristotle's *Rhetoric* as his point of departure, he placed an even stronger emphasis on the independence of *arte nuova*, new art, from any logical schemes, and dwelt at great length on this art's specific character. Tesauro declared the *concetto*, ingenious conceit, to be divine, and placed artists capable of it on a level with the Creator, who in turn is thus transformed into an accomplished rhetorician. The art of quick wit uses Metaphor as its princi-

Landscape with Shepherds. Drawing
Teylers Museum, Haarlem

9

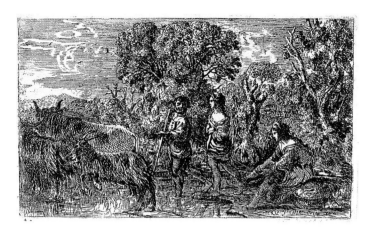

The Ford. 1634. Etching. 10.4 x 16.8 cm.
Hermitage, St. Petersburg

pal instrument, whereas logic assigns this role to Concept. Hence the basic importance of metaphor and allegory in the poetics of the *stile moderno*: the theory of art and aesthetics cognition takes on certain features of general rhetoric.

The rhetorical orientation of art and aesthetics in the seventeenth century is closely bound up with a phenomenon aptly described in recent literature on the subject as a "mythology explosion". "The seventeenth century is essentially the beginning of the end for mythology's dominant role in artistic subject matter, after holding undisputed sway for several millennia. And precisely at this crucial point, in a seemingly unfavourable historical and cultural situation, the mythological theme suddenly burst into flower, with an unprecedented growth in its repertory of themes and with an infinite wealth of forms and interpretations. In this respect, the seventeenth century left the preceding periods of art history so far behind that, by comparison, we may indeed describe the increase in its scope and intensity as a sort of mythology explosion."[9] Alongside the marked tendency towards extending the stock of subjects beyond the traditional limits, and the increasing variety of genres, seventeenth-century art demons-

trates an unflagging interest in myth. The question of interrelationship of myth and reality will be found to be central to any branch of Baroque art we turn to. Painting seems to have achieved more in the exploration of this problem than any other art. To convince oneself of this, it is enough to recall the work of such leaders of the different national schools as the Carracci, Caravaggio, Velazquez, Poussin, Rubens and Rembrandt.

The seventeenth-century approach to mythology had some characteristic traits, most notably a breaking away from traditional iconography (within certain bounds, of course) and the predominance of individual interpretations of mythological themes. Does that imply that myth was no longer perceived as myth in the proper sense of the word, but only as a body of material previously built up in the collective consciousness and liable to free creative interpretation? At any rate, it is an indisputable fact that seventeenth-century artists exercised considerable freedom in the treatment of mythological sources. Moreover, the "mythology explosion" in Baroque art may have been prompted by a desire to employ the synthesizing potential of myth in a rational way. Viewed like this, myth may be understood as a particular means of generalizing reality, as an instrument of artistic cognition. This granted, it takes only one step to establish a direct relationship between mythology and rhetoric in seventeenth-century art. The idea of such an interconnection can already be found in the treatises of the leading theorists of the Baroque era. Later this idea was brilliantly developed by Giambattista Vico, who advanced, in particular, the concept of the mythological roots of poetic tropes — Vico held that every metaphor is a myth in miniature.[10] Fundamental to the understanding of

seventeenth-century art is the problem of its principal stylistic concepts. Among a wide variety of stylistic trends, there were two leading ones, the Baroque and Classicism. It has been suggested that the Baroque played a prevalent, and Classicism a subsidiary role. Some authorities distinguish yet a third trend, unconnected with either the Baroque or Classicism. We are not inclined to adopt either the former, or the latter view, believing as we do that the notions of Baroque and Classicism, neither of which can be placed in a subordinate position to the other, amply suffice for the reconstruction of a complete picture of seventeenth-century stylistic evolution, with all the interaction of its conflicting trends. The terms Baroque and Classicism may be said to mark the two extreme points between which the process of style formation developed as a struggle between opposing tendencies.

The Baroque style can be characterized in a general way, using such features as heightened expressiveness, eccentricity, a rejection of the norms and rules, a taste for sharp contrasts and extravagant effects, a combined use of different viewpoints, imagery of exuberant splendour,

Forest Landscape. 1630-1635. Drawing
Teylers Museum, Haarlem

metaphorical language, love of allegory, and a strong and direct appeal to the emotions and the imagination in a deliberate effort to overwhelm the spectator.

Classicism is based on the cult of Reason and the Classical ideal of Antique art. Hence its fundamental features: a sense of measure, structural logic, clarity of form, strictly ordered and well balanced composition, rational self-control and discipline, and, last of all, an elevated, didactic tone in addressing the viewer.

Heinrich Wölflin, who was the first to systematically apply typological principles to the study of style, drew a clear and sharp dividing line between the Renaissance and the Baroque.[11] But a similar demarcation between styles can obviously be effected within the Baroque era itself. Whereas the Baroque style arose largely in opposition to the preceding artistic system, seventeenth-century Classicism was a sort of a "negation of the negation", reasserting much of what the Baroque denied. But the role of seventeenth-century Classicism is not confined to this sort of positive conservatism. The rise of the Baroque style was associated with the process of the destruction of the old picture of the world; it was a generalized expression of the dynamic spirit of the time. By contrast, Classicism contributed to the creation, on the ruins of the old foundations, of a new building, no less strong and stable than the demolished one. Just as Newtonian mechanics produced an absolute space and time framework of reference, so did French Classicism elaborate a strict logical system of artistic representation, totally opposed to the relativism of the Baroque. Nor could this system have ever emerged otherwise than in opposition to the Baroque. Thus the two leading, and rival, seventeenth-century styles owed not a little to each other.[12]

Having outlined the historical, cultural

and artistic problems facing the student of seventeenth-century art, we will now turn our attention to the more specific theme of this book.

Claude Lorrain occupies a leading position among the great artists of the seventeenth century. But the question arises of how far, if at all, we may be justified in assessing his art as a cultural phenomenon, as in the title of this essay. We would feel no scruples on this score, were we to deal with Galileo or Bernini, Leibniz or Rubens, Rembrandt or Spinoza, Poussin or Descartes, for the scale of their activities is obvious and speaks for itself. By comparison, the art of Claude Lorrain might seem to be a local phenomenon, fully confined within the realm of the visual arts, and even within the limits of a single genre. Such a view would seem to be corroborated by the popular legend of the artist as a simple soul, safely removed from the temptations of a sophisticated intellect, hardly able to sign his own name, and creating art as naturally as a bird sings.

We intend to show that this stereotype is at least superficial, if not totally incorrect. Claude Lorrain's descent held no great promise of a brilliant future. Claude Gellée, later nicknamed Lorrain after his native province, was born into a peasant family, and received hardly any education as such. Nor did local artistic tradition leave any imprint on his mind. It was only later that Claude's artistic instinct was awakened, during a trip to Rome, where he journeyed for reasons presumably having nothing to do with art.[13]

In the first half of the seventeenth century, Rome was an artistic centre of international, rather than purely Italian importance. All the roads of European art led to Rome and converged there. A veritable treasure-house of Antique and Renaissance masterpieces, and a guardian of the Classical tra-

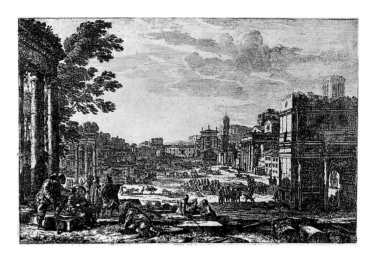

Campo Vaccino. 1636. Etching. 18 x 25.2 cm.
Hermitage, St. Petersburg

dition, Rome played a role something like an international Academy of Arts, attracting artists from all over Europe. This brought to Roman artistic circles a steady inflow of fresh blood, and widely varying traditions, archaizing and innovatory, local and foreign, existed there side by side, forming a dynamic unity of conflicting elements. It was in Rome that Claude's talent developed, matured and rose to its heights. Italy became his second homeland.

In this respect the lives of three great contemporaries, Jacques Callot, Nicolas Poussin, and Claude Lorrain, present the same pattern.

Nevertheless, it would be a mistake to infer from this that Claude's art was wholly rooted in Latin soil, and that his ancestry as a painter is to be traced exclusively to Italian sources. Indeed, among the earlier influences during his formative years art historians name, in addition to Agostino Tassi who actually taught him, the Flemish painter Paul Bril and the German Adam Elsheimer.[14] Obviously, Claude's formation as an artist had an international basis, and so, for that matter, had the branch of painting he specialized in — the so-called historical landscape.

Alexander Benois once wrote that "the historical landscape with all its ramifications was a phenomenon of international character. Its birthplace was the Cosmopolis, i.e. Rome, and its principal authors, the eclectic Academicians of Bologna and 'the French Roman', Poussin..."[15] The Bolognese school, as represented by the Carracci, Domenichino and some other masters working in the same vein, paved the way for a sort of union between History and Nature, combining landscape and history painting, the latter regarded by the academic trend as the noblest form of art. The union of these two branches of painting was finally consummated in the genre of the historical landscape, also known as classical, ideal, heroic or Arcadian. It was further consolidated by Poussin, who elevated Nature from its former status of a mute witness of events to the position of the protagonist of historical action; and, accordingly, the language of grand art became the language of landscape. In the history of art the names of Poussin and Claude Lorrain stand side by side. They are so placed not only because both belonged to the same national school, worked at the same period, and kept up personal contact. What is far more important, they both stood at the source of European Classicism, both owed a debt to Christian history and Classical mythology, and both shared in the creative development of lofty traditions inherited from the past. The basic idea of Classicism, which is, after all, a form of traditionalism, was precisely the adoption of Classical models, their reproduction and repetition. But for all the affinity of the two masters' aesthetic views and artistic practice, they differed in their approach to landscape, which was predominantly epic with Poussin, and predominantly lyrical with Claude; the art of each gave rise to a distinct trend in European landscape painting.

View of the Trinità dei Monti in Rome. 1632
Pen and ink and brown wash. 14 x 21 cm.
Hermitage, St. Petersburg

Poussin's landscape compositions, directly descended from history painting, invariably centred around a historical subject. Claude's work underwent a process of evolution which led him, by a gradual yet consistent shifting of accents, to a discovery of Nature as an independent object of artistic interest. We must admit, however, that this discovery was attended by a drastic reduction in the range of subject matter, as Claude entirely concentrated on his cult of Nature.

So what are the elements of Claude's image of Nature which recur from one canvas to the next? To begin with, we should note that the true heroes of his pictures are by no means the people named in the titles, whether figures from sacred writings, Classical mythology, or epic poetry. They are a fixed set of natural features, the high Heaven, the green Earth, and the great Sea stretching away into the luminous distance. Nearly all of Claude's known paintings really depict the encounters, always attended by the Sun, of these eternal elements of Nature. Those who called Claude a "sun-worshipper" had some reason to do so. To use the rhetoric figure of chiasmus

(very popular in the Baroque), it is not "Le Roi-Soleil" but "Le Soleil-Roi" who reigns in Claude's world. The themes he loved best were the birth or fading of Day, when the innumerable faces of Nature turn towards the Sun, watching him rise or following his retreat. This characteristic heliotropism is expressed in his art through a system of compositional devices repeated from one painting to the next until they acquire the force of principle. The first of these devices is the relatively low skyline. If we placed Claude's pictures in a row, we would find that these lines almost, or exactly, touch, forming a sort of

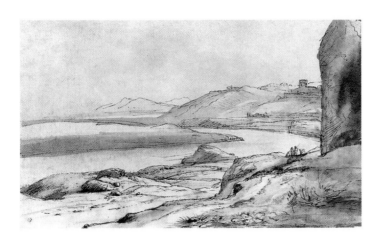

Landscape with River. 1635-1640
Pen and ink and wash. 20.5 x 32.5 cm.
Hermitage, St. Petersburg

horizontal axis. Claude's sky always occupied the greater part of picture space, so that the upper part dominates over the lower. A low horizon, as is well known, contributes to the effect of monumentality, and the introduction of human figures serves to enhance this effect. In accordance with contemporary artistic practice, Claude would often entrust the execution of his staffage to other painters (one such was Francesco Lauri), yet all the time he would keep the compositional structure of the painting under his own control. Placed

near the line of the horizon, the main source of light creates a powerful perspective effect, turning the picture space into a vista of infinite depth, as the tangibility of objects, so strongly expressed in peripheral features, breaks up towards the centre, and finally disappears in the halo of the distant sun.

Highly illustrative of this are Claude's numerous views of harbours, sea-ports and bays. He uses sharp perspective fore-shortening to achieve an illusion of distance. All the lines tend to strain towards a common point at the back of the picture, but lose their distinctness as they recede, and altogether vanish in the stream of outflowing light. This happens because of the coincidence of the imaginary vanishing point and the visible source of light; inward movement is checked and reversed by the outflow of light. Claude's space is built, as it were, on a merger of two perspectives, one of them developed from the spectator's viewpoint, and the other from the Sun's, which is the Eye of the Universe. A slight shifting of the solar disc away from the geometrical centre of the canvas adds to the dynamic quality of the space. Charles Bouleau, who analysed the "secret geometry" of Claude's compositions, noted the regular articulation of format in Claude's preparatory drawings, where diagonals are used to fix the central point, to ensure the proper balance of masses and to determine the main direction along which the composition unfolds.[16] Frequent repetition of this scheme testifies to the methodical and carefully considered nature of Claude's work, and against any undue exaggeration of the spontaneous element in his art.

Claude's dynamic space and light effects make one think of Rembrandt, who developed a similar approach; the parallel is further substantiated by the fact that both painters were influenced by

Elsheimer. Claude's painting was aptly characterized by Alexander Benois as *Scheinarchitektur*.[17] His sunrises and sunsets are stately pageants staged by Nature to mark the arrival or departure of Claude's main protagonist, the Sun. Using light as a dominant compositional factor, Claude organized

Landscape with Moses and the Burning Bush. 1664
Collection of the Duke of Sutherland, Merton, England

his picture space in such a way as to invest it with a sense of time. Spatial depth unfolds before the viewer as the eye moves farther and farther into the back of the picture, and this evokes a feeling of travelling in time.

Some reference to Time is almost invariably incorporated into Claude's landscapes, and practically all of his pictures include ruins of ancient temples and palaces. Permeated with a sense of aesthetic nostalgia for the past, these reminders of Rome's ancient glory gave a powerful impulse to the viewer's imagination; and the greater the destruction, the greater the force of this appeal. In the process of reconstructing past beauty, the viewer's fancy tends to create images surpassing reality itself in their splendour. Apart from a vast body of anonymous architecture, Claude would often depict such famous masterpieces of antiquity as the temple of the Sibyl (Temple of Vesta) in Tivoli, the Forum Romanum (Campo Vaccino) and many others; and this was not a matter of chance. The ruins also convey an idea of the artist's involvement in the scene, as if he were to say, "A painter of the present age, I am here, in the land of the marvellous

Antique". Claude's signature on a ruin may be thus regarded as an equivalent of such a statement. There is another aspect to Claude's ruins: they are an emblem of memory as a bond between epochs, a sort of tribute to Mnemosyne, Mother of the Muses. Just as perspective connects distant objects and those which are near, so do ruins, rising among living nature, connect the past and the present. And lastly, the ruin motif is associated with a concept essential to Claude's philosophy, the contrast of Time and Eternity, the transient and the eternal, of human and universal life. In Claude's painting, as in all historical landscapes, ruins fulfil a function similar to that of the skull in *Vanitas* still lifes: they are a *memento* of mortality, a symbol of the transitory nature of human existence. The "aesthetics of ruins" with its specific message, which aroused a wide response in eighteenth- and nineteenth-century art, had its source in the art of Claude.[18]

Claude's stock of natural motifs includes tall trees with leafy crowns, and the sea with its infinite expanse dotted with silhouettes of sails: they occur in most of his landscapes. His woods and meadows are always peopled by peaceful shepherds who live in harmony with Nature. These anonymous background figures are more at one with Claude's scenery than are his foreground figures, characters from the Bible or Classical mythology.

The shepherds, these artless children of Nature, play a role similar to that of satyrs and nymphs, minor deities from the Antique pantheon. In general, Claude displays a marked tendency towards depersonalizing his staffage. His shepherds and their flocks form a kind of composite image, harmonizing, by its anonymity, with the impersonal aspect of Nature. Claude modified the historical landscape and achieved his greatest successes precisely where he dealt with quasihistorical, mythological and poetic subjects tending by their content towards the pastoral.

If subjected to structural analysis (deconstruction), any of Claude's landscapes will be found to resolve itself into a system of standard elements, including architectural or natural coulisses (ancient edifices, ruins or trees) enframing a green world with animals at pasture on the banks of rivers and streams or harbours with ships in them, and a luminous distance with silhouettes of far-off mountains, crags rising on the coast, towers, lighthouses, and white sails. These features compose the three planes inherent in Claude's compositional scheme, which also comprises a figural subject of some kind, although — as in a number of examples — not necessarily so.

Altogether, one gets an impression of a permanent stage with changing, variously illuminated settings, adapted for the performance of different episodes from the Scriptures, Classical mythology or epic

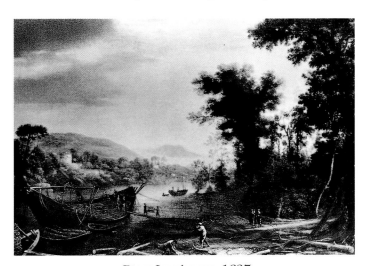

River Landscape. 1637
Wildenstein Collection, New York

poetry. This has led not a few of the scholars to regard Claude's landscapes as essentially theatrical in nature. In some cases, this view gave rise to broad historical and aesthetic generalizations. "From the middle of the sixteenth century to the beginning of the nineteenth," wrote Paul Valéry, "landscape is treated in Italy and in France in an essentially theatrical style. Nicolas Poussin constructs noble sets for tragedies. Claude Lorrain creates, on the seashores, Dido's palaces, and at the back of the stage, on the glistening waves, he places the gilded flotilla of the legendary Aeneas. Watteau introduces into his parks magical effects and melting tableaux."[19] Although not utterly groundless, this concept is too abstract and tends to reduce artistic facts to a system of generalities.

The fundamental role of the integrating principle to Claude's art is beyond all doubt. The invariable character of the picture's structure, the standard set of their chief components, the multitudinous quotations from Classical Antiquity as a generally recognized system of values, testify to an obvious preference for the universal before the individual. In depicting nature, Claude concentrates on those phenomena which are essential to the eternal order of things; he regards sunrises and sunsets as diurnal spectacles from Nature's perpetual repertory. Repetition, the re-creation of one and the same, is Claude's guiding principle in his striving to grasp the image of Nature in

its entirety. Since this goal is un-attainable in a single act of perception, he gives primary importance to selection and synthesis. Thus he arrives at an ideal image of Nature, perfect in its beauty, free from any incidental features, and perceived *sub specie aeternitatis*. As a result, the viewer is sorely tempted to mentally fuse Claude's various works into a single picture of "happy Arcady", and to see in his art an entrancing fantasy of the Golden Age, something like a nostalgic dream related by one of Dostoyevsky's characters who thus describes it, "I dreamed a dream that was a complete surprise to me, for I had never had any dreams of the sort before. In the gallery at Dresden there is a picture by Claude Lorrain, called in the catalogue 'Acis and Galatea', but I used to call it 'The Golden Age', I don't know why … I dreamed of this picture, but not as a picture but, as it were, a reality. I don't know exactly what I did dream though: it was just as in the picture, a corner of the Grecian Archipelago, and time seemed to have gone back three thousand years; blue smiling waves, isles and rocks, a flowery shore, a view like fairyland in the distance, a setting sun that seemed calling to me — there's no putting it into words. It seemed a memory of the cradle of Europe, and that thought seemed to fill my soul, too, with a love as of kinship. Here was the earthly paradise of man; the gods came down from the skies, and were of one kin with men… Oh, here

lived a splendid race! They rose up and lay down to sleep happy and innocent; the woods and meadows were filled with their songs and merry voices. Their wealth of untouched strength was spent on simple-hearted joy and love. The sun bathed them in warmth and light, rejoicing in her splendid children… Marvellous dream, lofty error of mankind!"[20] By this interpretation, an image itself not without mythological associations is subjected to a second mythologization, with the result that all individuality is lost, entirely absorbed into the newly created ideal whole.

Caprice with the Ruins of the Roman Forum. 1630-1635
Museum of Fine Arts, Springfield, Mass.

It was precisely in this ideal light that Claude's landscape was regarded by European artistic tradition; and art history gives it, as a rule, practically the same treatment.[21] With all due respect for the generalizing force and beauty of this view, we feel that it is hardly adequate. There is always the danger that, having narrowed our vision to the idea of Claude's landscape as an eternal theatre of Nature, with different versions of earthly paradise staged there, we may overlook other values of his art which lie beyond the sphere of an abstract typological approach.

Dialectic interaction of the typical and the individual is the key issue for the interpretation of Claude's art, and of seventeenth-century Classicism as a whole. The general statement of the dominance of the typical should not be taken too literally. In Claude's case, we have to deal with

a type which is individually interpreted and this presents us with what would seem to be the task of reconciling two irreconcilable principles. And this is the cornerstone of Claude's art. The impact of all art based on canon depends upon its function as an aid to memory and a stimulator of intellect, rather than as a source of information in itself.[22] The complete information is contained not in each individual work, but in a model on which a vast variety of works are built: in other words, it is the canon itself that acts as a source of information. But the canon is always materialized in a certain cultural context and cannot be properly understood apart from it. We may not place a sign of equation between the canons of Medieval and Classicist art; the former is an organic component of an overall canonic culture, whereas the latter stands in a more complex relation to its cultural background. The conflict between traditionalism and innovation made itself felt as far back as the Renaissance and acquired dramatic intensity in the seventeenth century. For the first time in the history of art individual creative concepts attained such independence, and gained so much influence, as to assert themselves against the collective tradition with quite remarkable, often scandalous, success.

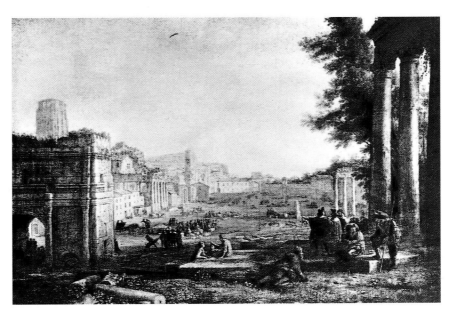

Roman Forum. Etching
Hermitage, St. Petersburg

The case of the rebel Caravaggio, whose pictorial style became popular throughout Europe, is possibly the most spectacular example, in the early part of the century, of this novel attitude. At the close of the century, there arose in France a violent literary controversy known as *La Querelle des anciens et des modernes*, where the right to artistic independence was championed by a vast body of cultural figures. Under such conditions, the use of the canon became a matter of the artist's conscious, individual choice. Claude was far removed from academic disputes, and the idea that his principles needed theoretic justification never crossed his mind. He was guided in his work by the promptings of his soul and by force of habit. Yet this does not exclude the existence of artistic principles. It was just that his traditionalism happily harmonized with his individual tastes. Claude's landscapes may be metaphorically described as a kind of visual equation in which the *loci communes*, items of general knowledge, stand for known quantities, and the details of the changeable image of Nature, discovered each time anew by individual perception, for the unknown quantities. Hence the juxtaposition of the stable repertory of standard elements, like the famous ruins, and variable motifs characterizing

momentary states of Nature. The *loci communes* correlate the master's art with tradition — they are, so to speak, a tribute to Mnemosyne — whereas the wealth of imagery proceeds from direct observation of Nature, and is evidence of its close and painstaking study.

Thus, what would seem to a superficial observer to be a mere theatrical effect, appears to form part of a far more complex structure, bearing a close affinity with the art of rhetoric. By organizing his landscape in terms of interaction of the known (the general) and the unknown (the individual), Claude realizes the fundamental principle underlying the structure of metaphor.[23]

We will now pass on to the analysis of concrete examples.

A key to the interpretation of Claude's canvas conventionally designated *The Bay of Baia* (Hermitage, St.Petersburg; 4*) is provided by the central episode, illustrating the myth of Apollo and the Cumaean Sibyl. According to Ovid's *Metamorphoses* (14: 130-140), the amorous god offered to fair maiden, in exchange for her love, the fulfilment of any wish. The young Sibyl took up a handful of dust and asked for as many years of life as there were grains of dust in it, but forgot to stipulate for perennial youth. Although in the end she rejected her divine wooer, Apollo left her in possession of the promised gift of long life — but she spent most of it aged and decrepit. Seeing this picture as a mythological *mis-en-scène* with a landscape backdrop would reduce its poetic content to nothing. Claude's landscape is liable to metaphorical interpretation. Just as the masonry of the once majestic building aged, crashed, and overgrew with grass and moss, so shall the beauty of the young and fair maiden be destroyed by

Figures refer to the numbers in the plate section

cruel Time. Nature alone has the gift of eternal youth and eternal beauty. In conformity with this concept, Claude contrasts the ruin, gradually growing into the ground (left), to the tall young trees stretching their crowns toward the sky (right); and fragments from the ancient building's architectural decoration (foreground), to the sea, ever alive, breathing and full of movement (background). This compositional arrangement leaves the central space free for the figurative subject. And however mediocre the figures themselves, we should not underrate Claude's staffage, for it fully answers its purpose as an organic part of the painting's conceptual and compositional structure. A minute inspection of the canvas will reveal a wealth of lively minor detail: goats and sheep nibbling grass among the ruins, the funny butting goats, boats with fishermen drawing in their nets, other boats drying on the shore, a flotilla rounding the point of a distant promontory and sails, leading the eye farther and farther back, into the endless blue expanse of the sea... And imperceptibly, as we look, the accents shift, until there comes upon us a realization that the true subject of the picture is none other than Nature herself, living Nature obeying the law of never-ending flux and transience, all her works breathing, growing, labouring, ageing, dying and being reborn.

In *The Rape of Europa* (Pushkin Museum of Fine Arts, Moscow; 7), the subject is of greater significance and is treated in more detail than in *The Bay of Baia*. It seems that the story (Ovid, *Metamorphoses*, 2: 844-875) had a stronger appeal for the master. The reason for this is not difficult to find: it was as easy to integrate a mythological episode with Claude's pastoral landscape as it would be for the metamorphized Zeus to get lost among

the herd grazing on the coast of the azure bay. Nevertheless, Claude assigns a central position to the group of the bull and the beautiful girl and emphasizes it by tone and colour so as to focus the spectator's attention upon it. At the same time, Claude opens up a miraculous possibility for the viewer to make an imaginary journey far out to sea, along the route to be taken by Europa. This possibility is created by the skilful spatial arrangement of the canvas with its deep perspective, by the seaward turn of the central group, and by the use of a specific device comparable to rhyming in poetry — a regular recurrence of accents of white, which flash in the figure of the bull, making its way towards the water with the girl on its back, and in the sunlit sails, bright against the blue waves, emblems of the sea where Europa will presently be carried off. It is interesting to note that here Claude does not resort to the coulisse type of composition. Instead, he builds his perspective on two diagonals, one, designating the coastline, running from left to right and the other, marking the horizon, running in the opposite direction, so that the contrast between far and near reaches its peak at the lower left of the painting. Following the gaze of the Princess's attendants, seated on a knoll beneath a mighty tree — the vantage point for watching the

event — the spectator's eye is led to the brilliantly lit, colourful central group, and turns with it towards the sea in a movement echoed, as it were, by the curved line of the coast. This compositional scheme ensures the dynamism of the painting, enhanced still further by the intensive cool tones, subtly graduated, yet retaining their local unity. The fleeting clouds, the lively rhythm of the waves and the fluttering draperies blown about by the wind all add to a sense of fresh, invigorating sea air filling Claude's landscape.

Metaphorically speaking, we might say that Claude's art is a never-ending journey of discovery into the depths of nature, and each of his paintings is an invitation to, and an imaginary experience of, a journey beyond the limits of the familiar and commonplace into the land of the unknown. His compositions are clearly calculated to give one this feeling: they assign to the spectator an ideal point for contemplation, as if to provide an impulse to his fancy, and set him daydreaming. Claude's favourite motifs of bay or harbour have great symbolic potential. They may symbolize the traveller's starting point, the opening of visible space. The spectator is placed at the dividing line between land and sea, so that he may, like a pilgrim who has reached the land's end, indulge in free contemplation, enhancing his power of

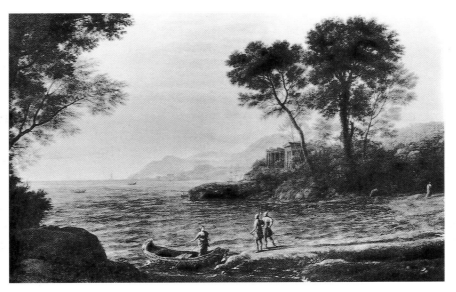

Landscape with Carlo and Ubaldo. 1667
Art Gallery of Ontario, Toronto

Seascape with Trojan Women Burning the Fleet
Metropolitan Museum of Art, New York

vision by the exercise of his imagination. Or else the bay or harbour motif may symbolize a quiet haven where the weary traveller ends his wanderings, feels himself once more standing on firm ground, and hears again the speech of his fellow men.

It should be borne in mind that Claude's seventeenth-century spectator could momentarily grasp the meaning of the rhetorical figures we have alluded to. To the cultured public of his day, literature like Ovid's *Metamorphoses* was as much a corpus of *loci communes* from the point of view of aesthetics, as were the Scriptures from that of ethics; nor was it coincidental that the former was often referred to as "a painter's Bible". Turning for his subjects to what was common knowledge, Claude expected his spectator not only to have the gift of visual perception, but also to be able to read his picture's conceptual message.[24] It is precisely in the process of such reading that the artistic content of his landscapes can be fully and adequately revealed.

Claude's figurative subject is a sort of key to the entire picture of nature, its meaning resounding all through the canvas in a thousand echoes. The landscape thus becomes a polyphonic projection of

the Word that animates it. And in its turn, the Word, whether scriptural or poetic, returns here to its primeval source, the world of nature, of the first names for people and things, where its inherent wealth of meaning is realized in an infinite range of natural motifs.

Viewed from this angle, a group of works by Claude in the Hermitage, generally known as *The Times of the Day* [10-13], deserves particular attention. Assuming that the pictures really form a set, it seems a matter of some interest to study them by comparison with Poussin's famous cycle *The Four Seasons* (Louvre, Paris).

The Poussin cycle presents a unity of three conceptual aspects, including the life of nature, the history of mankind and individual human life. The states of nature are paralleled by definite phases of human history: this is clear from the subject matter based on scriptural texts. History, in its turn, is paralleled by the life of an individual: as society passes from one stage of its evolution to the next, so does man who comes into the world, reaches maturity, gathers the fruits of his life, and passes into eternity. The three themes may be regarded as forming a kind of hierarchy where individual existence is the minimal life cycle, part of the common history of mankind, integrated, on a cosmic scale, into the life of the Universe which is the maximal life cycle. Although each of the paintings is a pictorial unit complete in itself, it is only as a cycle that they constitute a conceptual whole.

Characteristically, Claude's set embraces a much shorter time, a single day and night. In contrast to Poussin, who views his subject in terms of eternity, Claude concentrates on what may be called a minor time scale. Poussin's paintings describe stable states and absolute conditions; but Claude's landscapes record

moments of transition. Neither does his set possess the conceptual unity of Poussin's. Each of Claude's works retains its autonomy in a great measure; they are integrated into a set on fairly conventional grounds. What really unites *The Times of the Day* into a single whole is the painter's emotional attitude towards Nature, as expressed in his subjective, lyrical approach.

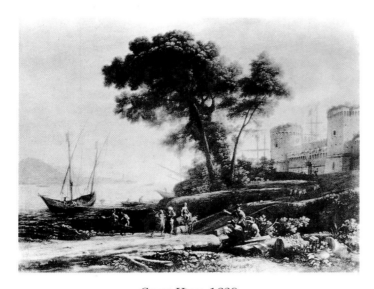

Coast View. 1639
Art Museum, Cincinnati, USA

Morning (*Landscape with Jacob, Rachel and Leah at the Well*; Genesis 29:2-10;12) is one of Claude's most fascinating lyrical pieces. He recreates the beauty of the nascent day with the same thrill of love, the same fervour of feeling as filled his hero's heart at young Rachel's first appearance. In the group of personages, however, this feeling is only hinted at; its full force is brought out by the emotional impact of the landscape as a whole. The dominance of the lyrical mood is due to the artist's complete identification of the subject and object in the process of creating art. Nature is animated and endowed, as it were, with a soul capable of experiencing

the subtlest gradations of feeling. Using his favourite device of *contre jour* painting, Claude suggests a flow of light in the direction of the spectator, and this gives us an impression of the day dawning while we look. The faintly outlined crowns of trees, enveloped in the morning mist, are echoed by the shapes of the clouds lightly gilded by the rising sun. The pictorial structure of the painting is based on finely nuanced colours with prevailing silvery tones. The colouring, clear and soft, harmonizes with the compass of emotions aroused by the picture.

Claude's artistic concept is realized through a series of poetic associations linking the meeting of Rachel and Jacob with sunrise, the birth of love with the birth of day, and an incident of legendary history with the viewer's individual experience. The movements of human soul find a universal response in nature, and, conversely, a picture of nature becomes a universal expression of the life of the human soul. Of the four paintings composing the set, *Noon (Landscape with the Rest on the Flight into Egypt*;10) stands closest to tradition. By presenting a stretch of open country crossed by a river with a narrow bridge leading to its other bank, the artist seems to have deliberately emphasized the motif of wayfaring. This motif also recurs in the staffage: the traveller on the bridge moves in a direction opposed to that of a herd of cattle seen fording the river in the shady middle ground. This crossing of the ways is rendered, however, by the intersection of gently sloping diagonals, hardly deviating from the horizontal. The masses of verdure are beautifully balanced, and the tonal contrasts are subdued so as to bring them into conformity with the moderate colour scheme. A sense of serene repose pervades the landscape. The bright sky of *Noon* seems to take on a deeper colouring in *Evening*

(*Landscape with Tobias and the Angel*; apocryphal Book of Tobit 6: 2-5;11), with the Angel instructing young Tobias on the bank of the River Tigris. The painting has much in common with *Noon*. Here, too, the action of the central episode is echoed in the staffage. Tobias' catch of the marvellous fish is paralleled by the fishermen tugging at their nets, and the Angel, his spiritual shepherd and guide, has a parallel in an actual shepherd driving his flock before him. The structural correlation between the right-hand and left-hand parts of the picture is built on the same pattern as in *Noon*, but mirrored by a corresponding reversal of the diagonals. The colour scheme is softer, with golden pinks prevailing in the sky. The earth is steeped in an evening mist which robs the outlines of their daytime purity. Nature, as it were, takes her last look at the setting sun before going to sleep; and the scene itself seems to be laid in dreamland. Claude's brilliant handling of glazes helped him to preserve the basic unity of colour and tonal values while subtly modelling his details. There seems to be an infinite number of them and the eye can wander about, discovering one new motif after another. Thus, in spite of some darkening of the painted surface, one may discern at lower right, under some trees, several figures of deer: Claude's spiritualized landscape is populated by many creatures living in harmony with nature's rhythms. In early Christian symbolism, a thirsting deer was an emblem of a thirst for righteousness; Claude's deer on a river bank thus appear to have symbolic connotations. Yet they are incorporated into the landscape in a perfectly natural manner, suggestive of no hidden meaning. The symbolic essence is concealed in a world of natural phenomena as are the deer in the evening shadows among the trees of the forest. This trans-

formation of a symbol into a thing of nature — we might call it naturalization of the symbol — is a device fundamental to Claude's landscape art. *Night* (*Landscape with Jacob Wrestling with the Angel*; Genesis 32: 24-26;13) is, so to speak, the finale.

Landscape with Dancing Figures. 1648. Detail
Galleria Doria-Pamphili, Rome

The night scene enabled Claude to display his pictorial mastery in all its brilliance. The picture is not devoid of detail, especially in the portion depicting Jacob's distant camp, or his divided herds in the middle ground. And yet the greatest merit of the painting undoubtedly lies in its compositional and colouristic unity, achieved by a strict hierarchy of the expressive means. The painting is dominated by a deep tone, harmonizing with which is a cool range of colour of

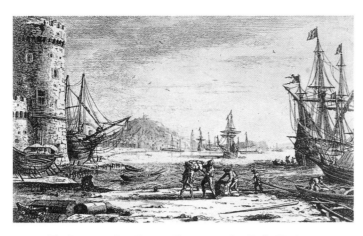

Harbour with a Large Tower on the Left. Etching
Hermitage, St. Petersburg

marvellous beauty, composed of subtle shades of blue, green and bluish-grey. The central group presents a contrast of blue in the Angel's garments and red in Jacob's cloak. However, the contrast is not unduly exaggerated, but skilfully tempered to suit the colour structure built on a definite basic chord. As compared with Claude's earlier landscapes, this night scene stands out for the quite exceptional freedom of its handling; and this again makes one think of Poussin's *Four Seasons*, also painted by the master at an advanced age. Yet stylistically, and in particular in his use of light as a means of artistic expression, Claude is closer to Rembrandt, whose landscapes are distinguished by similar features, both artists having experienced the influence of Elsheimer. This influence is especially obvious in their ways of conveying changing light at different times of day and night, more notably at night, which was depicted by Elsheimer with a degree of perfection which astounded his contemporaries. Also, in studying Claude's treatment of night subjects, we should remember his strong interest in transitional states of nature. In Genesis, the Angel says to Jacob, "Let me go, for the day breaketh". Claude's painting shows some

time before daybreak. But already, as if called forth by the gesture of the Angel's upraised hand, the first faint light of dawn begins to filter through the verdure of the trees, still steeped in night's shadows. This light marks the end of the daily cycle, and the birth of a new morning: the beginning of the next act in the ever-recurring spectacle which Claude was never tired of watching.

It is certainly most tempting to see the key to Claude's art in his "mute admiration", his silent rapture at the beauty and majesty of nature.[25] Still, his art, rooted in a culture of the rhetorical type, can be adequately interpreted only in the light of analogies with literary phenomena. "Rhetorical creativity — rhetoric in the broader sense of the word — means that a painter or poet never deals with unadorned, raw reality, but always with a reality ordered in accordance with certain rules, and transformed into art by the use of typified imagery which, while absorbing reality, at once superimposes upon it a rigid rationalizing scheme. Obviously, such a system cannot but change through the centuries, but in the process of constant change some of its features are kept intact. The constant element is the poetic, *rhetorical Word* (here and later, my italics — S.D.), which is the focal point of this culture and which implies a certain interpretative force, apt to direct every process of cognition and understanding along recognized lines, and serving as a carrier of the cultural tradition. The broadly understood rhetorical system must clearly rest upon the basis of *rhetoric in the narrow sense*, seen as a system of rules providing a pattern for constructing any speech or oration: here all practice is regulated, and the Word itself is the regulating factor. In particular, this system predetermines the specific impact of the Word on pictorial art"[26]...

There are indeed serious grounds for assuming the existence of close ties between Claude's art and rhetoric in the narrow sense — with poetic rhetoric, to be more exact. We may add to what has already been noted that Claude's repertory of visual characteristics is associable with stock diction, including the *epitheton ornans* as used in Baroque and Classicist poetry: a sort of pictorial counterpart of the permanent epithets like the French "bocage riant", "onde fraîche" (or "pure"), "prés délicieux", "rameaux touffus", "rochers déserts"; or the English "floating clouds", "lucid stream", "flowery vale", "shady grove" and "smiling fields".[27]

Thus, Claude's art developed within the framework of the rhetorical tradition. This does not by any means signify that his landscapes were merely illustrative. We have already noted that in Claude's day, a whole century before Lessing, the interrelation of the literary and visual arts was basically different from what it was to become in later epochs, even in the nineteenth century, to say nothing of the twentieth. Anyway, the Baroque painter was safe from criticism for excess of literary associations, a common enough accusation later.

Claude reformed the tradition from within. Without disclaiming its achievements, and devoutly painting ever the same, he concentrated on the incessant refinement of rhetorical formulas as a result of the direct observation of nature. Probably unaware of it himself, Claude projected into his work so much of his individuality as to carry the traditional method of depicting nature almost to the verge of self-expression. "To true poets, such as Poussin or Claude," wrote Alexander Benois, "the canons of noble, decorative, ideal landscape were of use as laws of a carefully elaborated poetic language, able to lend to their creations a peculiar dignity, loftiness and grandeur. Also, such true poets did much to enrich and purify this language, and (something that is of prime importance) to breathe new life into it by renewed contacts with nature, by new experiences, and new enthusiasm."[28] This was greatly due to the practice of sketching out of doors. Claude's paintings suggest, and his sketches prove, the closest contact with nature. His drawings are quite amazing in the keenness and accuracy of their observation, joined to incomparable freedom of handling. Working in bistre and ink, alternating the fine, sharp pen drawing with washes and vigorous brushstrokes, and using scarcely perceptible tonal gradations alongside powerful contrasts of light and shade, Claude the draughtsman evolved a graphic technique of such exquisite versatility as to create sheets which seem to come not from a human hand, but from the hand of Nature herself — like the play of sunlight in the verdure or patterns made by the wind in passing over the water's surface. His graphic studies have a pictorial quality, achieved by the use of chiaroscuro modelling, so

View of the Port of Santa Marinella. 1639-1640. Drawing
British Museum, London

subtle and variable as to suggest colour. Scholars of different periods have likened Claude's art, more particularly his drawings, to traditional Chinese painting, an analogy that may seem arbitrary, but is in fact perfectly justified.[29]

This analogy is not a mere record of superficial resemblance. It also helps one to realize the intrinsic values of Claude's art. Just as in the case of ancient Oriental masters, his creative powers were not suppressed but stimulated by the challenge of a system of limitations. What has not been anticipated can give no aesthetic satisfaction. The artist is dominated by an urge to endless repetition; and this gives even the slightest modification in his picture of the world immense significance. His is an art of infinite nuances.

Although it owes not a little to external factors, Claude's Classicism cannot be properly assessed in terms of a purely stylistic approach.[30] Its roots lay deeper, in his artistic personality, where two aspects, the individual and the universal, were happily combined. He was, so to speak, a natural Classicist. That is what makes Claude's art so unconventional within the limits of a convention, so poetic in its re-creation of reality, and so realistic in its poetic dreams.

Claude's typological orientation may be easily established by a comparison of his art with that of other great seventeenth-century painters. If we assume that Poussin's art tends towards the epic, and Rembrandt's towards the dramatic, we must define Claude's sphere as that of lyrical poetry (I have already tried to justify my claim to the use of literary terms). This partly explains the limited scope of his artistic activity, and the sparse use of expressive means, sometimes verging on naive simplicity. Claude's lyrical landscape, like any lyrical art, demands a cultivated mind, and is addressed to a discerning viewer, whose appreciation is not wholly determined by the hedonistic principle of delighting the eye, but has been trained for intense spiritual effort. No wonder that poets have ever been the subtlest and most profound interpreters of Claude's art. It is well known that during his lifetime Claude compiled the so-called *Liber Veritatis*, or The Book of Truth (a chronological series of copies of his major commissions).[31] Goethe, who valued the master's art highly, once said of the *Liber Veritatis* that it might as well be called *Liber Naturae et Artis* (The Book of Nature and Art), "for here nature and art appear in perfect union."[32] The latter characteristics would be as appropriate if applied to Claude's artistic heritage as a whole. For the purpose of an objective assessment of Claude's art and its significance to world culture, it would be helpful to trace the Claude tradition over the three centuries which separate us from his day. His tradition appears to have prospered and his influence to have been extremely broad. At first defined as Classicist, Claude's art gradually came to be perceived as classic, and later generations of painters turned to it as an original source of inspiration. Many outstanding landscapists were indebted to Claude. His influence crossed the boundaries of the French national school and became an important factor in the all-European process of artistic evolution. The long list of followers did not stop even with Turner. Recent scholarship, notably the authors of the works published to mark the 300th anniversary of the master's death, has established that Classicism was an international phenomenon. A group of scholars directed by Marcel Röthlisberger studied its various forms as represented by the works of Italian, French, German, Dutch, English and even American painters.[33] The time range was also widened:

echoes of the Claude tradition reached the Impressionist epoch.

In the latter half of the eighteenth century and the earlier half of the nineteenth, the study of Claude's art formed part of the curriculum at the St. Petersburg Academy of Arts, as a component of what was then ironically termed the Gallic diet, by which was meant French Classicism. Claude's influence played a significant role in the rapid progress of Russian landscape painting. It was quite in the spirit of a well-established tradition that Alexander Benois referred to Fiodor Matveyev (not without a tinge of irony) as the Russian Claude Lorrain.[34] The art of another Russian landscapist, Maxim Vorobyov, likewise shows signs of the French master's influence.

Claude's "Lyrical Classicism" went beyond the limits of the purely pictorial tradition and affected the development of other arts and, notably, of poetry. In the latter case, great credit is due to Goethe who was an enthusiastic admirer of Claude. In his discourses with Eckermann, the name of Claude Lorrain occurs quite often, each time followed by profound reflections of a philosophical or aesthetic nature. This is what he is reported to have said once, while looking through an album of Claude's landscapes: "Here you have before you a perfect man, a man of thought endowed with a sense of beauty. And in his soul,

Port Scene. 1640. Drawing
British Museum, London

the world is every time born anew, such as it can hardly ever be seen in real life. His pictures embody the higher truth, and do not tend to give a mere transcription of nature. Claude Lorrain studied the real world thoroughly, and knew it down to the smallest detail; but this knowledge was, to him, no more than a means for re-creating the beautiful world of his soul. True idealism consists precisely in such a use of attributes of reality as will give to artistic truth a semblance of actual life."[35]

Strange as it may seem Goethe's formula holds good for both Classicism and Romanticism. In the field of literature, this can be exemplified by the poetry of Vasily Zhukovsky, who rendered an inestimable service to Russian culture acquainting the Russian reader with the cultural values of Europe — notably with the rhetorical tradition.[36] Some of Zhukovsky's lyrics contain poetic descriptions of natural scenery, showing a close affinity to Claude's landscapes:

... How lovely is the sunset
 over the mountain,
When the fields are clothed in shadow,
 and the distant groves
And the city mirrored in the lapping waters
Are flooded with a crimson light.
... It's eventide... the clouds' edges darken,
The last dying rays of sunlight
 fall on tower roofs.
The last gleam on the river's surface
Dies in the shadow of a darkling sky.

...But lo! .. What magic ray has flashed
 yonder ?
The tops of eastern clouds
 have caught its fire;
The babbling brook, hitherto enveloped
 in shadow, is flecked by sparks;
The woods stand reflected in the river...

The three passages just cited come from
Zhukovsky's early elegy *Eventide* (1806),
a work of Sentimentalist inspiration.[37]
Many more instances of this kind could be recalled; for Russian Sentimentalism and Romanticism, like their European counterparts, took up the tradition of lyrical landscape, a tradition in which Claude produced truly classical examples. An important aspect of Claude's influence was that his mar-

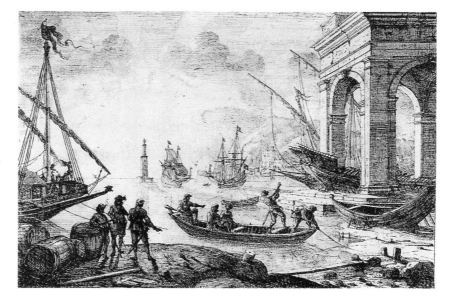

Harbour with a Lighthouse. Etching
Hermitage, St. Petersburg

vellous landscapes taught the poets to
see Nature as a living unity, and to seek
to understand its language. Like Goethe,
as characterized by Evgeny Baratynsky in
his poem on the latter's death, Claude
... lived at one with Nature, hence
He knew what brooks related
And forests whispered, he could sense
 how grasses vegetated;
He read the starlit Universe
And, with the ocean wave conversed.[38]

As time went on, the cultural significance of
Claude's art gained in scope. We have al-

ready mentioned how one of his works ins-
pired Fiodor Dostoyevsky's philosophical
and ethical concept of the cradle of
Europe. Although Dostoyevsky's inter-
pretation may be too free, yet the very fact
of a pictorial image serving as an impulse
for ethical thought can hardly be overrated.
At the close of the century, Viacheslav
Ivanov, who was soon to become one of the
leaders of Russian Symbolism, devoted to
Claude a beautiful stanza in the conclu-
ding piece of
his *Epigrams
of Paris.*

Claude Lorrain
fascinates you,
like airy
distance,
Like siren
song, he lures
you, by the
spell of his
greenish seas,
Into captivity
of calm harbours
where strange
waters lie asleep,
Under mighty
pillars,
and marble
vaults,
And resting masts with furled sails,
Under a sky slit open by a brilliant sickle.
 (Two Painters, 1891)[39]

We are fully aware that such a casual sur-
vey of the problem of Claude's influence
on a foreign culture, viewed, moreover, in
terms of a different art, cannot be other-
wise than schematic and fragmentary. Yet
it helps to realize the scope of this
influence, the power of an art which had
an equally strong appeal to the Classicist
and the Romantic, the Realist and the
Symbolist, uniting them all in a common

feeling of delight and admiration.

Goethe associated Claude's "artistic truth" with his ability to create "a semblance of actual life". We can see how right he was from the fact that in the course of time Claude's "artistic truth" took material shape. The illusions created by his brush inspired the experiments of landscape gardeners. Authorities tell us that the very origins of Rococo and Romanticist landscape gardening were closely connected with seventeenth-century landscape painting, notably that of Claude.[40] Let us remember that Romanticism produced the most organic forms for the synthesis of the arts in garden and park ensembles, within a wide range beginning with poetry and ending in painting, running from the conceptual to the visual. In his *Les Jardins ou l'art d'embellir les paysages* (1732), a work very famous in its day, Jacques Delille called upon the gardener to restore to Nature all that painting had borrowed from it. And that is precisely what was achieved in the art of garden design under the inspiring and stimulating influence of Claude.

Thus did Claude's art, born of Nature, repay its debt, by being embodied in reality.

Sergei DANIEL

NOTES

1. These difficulties are discussed in Yu. Vipper's important work, "On the Seventeenth Century as an Epoch in the History of Western European Literature". In: *The Seventeenth Century in the Development of World Literature,* Moscow, 1969. pp. 11-60 (in Russian). This work, provided with an extensive bibliography, still retains its significance for the student of seventeeth-century culture.

2. Michel Foucault, *Les mots et les choses. Une archéologie des sciences humaines.* Paris, 1966.

3. John Donne, "An Anatomy of the World". In: *The Selected Poetry of Donne.* New York, 1979. p. 211.

4. H. Huizinga, *Homo Ludens. A Study of the Play Element in Culture.* London, 1970. p. 23.

5. S. Daniel, *The Picture of the Classical Period. The Problem of Composition in Seventeenth-Century Western European Painting.* Leningrad, 1986. pp. 22-39 (in Russian).

6. *Cf.* D. Likhachov's characterization of Baroque gardens, "There arose a cult of exuberance, a taste for rich colours and strong odours. The fountains grew in size, their jets climbed higher up into the air; the noise of the water increased; and there developed a fashion for fragrant shrubs, trees, and flowers, especially orange and lemon trees. Nature was ordered on dramatic principles, and a tendency towards synthesis of the arts made itself felt. The impact of expressive means on human senses became quite powerful..."(D. Likhachov, *The Poetry of Gardens. Towards the Semantics of Garden Styles.* Leningrad, 1982. p. 72 (in Russian). A few pages below he writes, "Characteristic of Baroque gardens was an architectural feature known as the Theatre. It was an ornamental semi-circular wall with statuary in, generally, tufa niches. Such theatres are to be seen in the gardens of the Villa Belvedere in Italy, of the Palazzo Mandragona, the Villa Pamphili and others. They formed a good decorative background, sometimes used for purposes other than stage spectacles, although as a rule Baroque gardens much oftener seved for masquerades, theatricals, and fêtes than Renaissance gardens..."(*Ibid.,* pp. 75, 76).

7. S. Daniel, *The Picture of the Classical Period. The Problem of Composition in Seventeenth-Century Western European Painting.* Leningrad, 1986 (in Russian).

8. I. Golenishchev-Kutuzov, *Romanic Literatures. Papers and Researches.* Moscow, 1975. p. 326 (in Russian).

9. E. Rotenberg, "Problems of Subject Matter in Seventeenth-Century Paintings". In: *Problems of Art: Antiquity. The Middle Ages. The Modern Epoch,* Moscow, 1977. pp. 79, 80 (in Russian).

10. Giovanni Battista Vico, *Scienza nuova.* Naples, 1744? (English transl., 1944). For a summary of Vico's views in the context of the problems under discussion, see I.

Golenishchev-Kutuzov, *op. cit.,* pp. 349-352. On Vico's philosophy of the myth in the light of modern theories, see E. Meletinsky, *Poetics of the Myth,* Moscow, 1976, pp. 13-17 (in Russian).

11. H. Wölflin: *Die Kunstgeschichtlichen Grundbegriffe,* Munich, 1915.

12. *Cf.* D. Likhachov's view that "Classicism did not replace the Baroque but existed side by side with it. This was one of the peculiarities of the new phase in the evolution of styles, based on the newly evolved, progressive ability of a man of cultivated intellect to perceive the world in terms of a variety of stylistic systems, as well as from different historical viewpoints." (D. Likhachov, *op. cit.,* p. 83).

13. The principal sources on Claude's life and work include J. von Sandrart, *Teutsche Akademie...,* vols 1, 2, Nuremberg, 1675-1679; F. Baldinucci, *Notizie de' professori del disegno...* Florence, 1746; notable among the more recent publications are: M. Röthlisberger, *Claude Lorrain. The Paintings,* vols 1, 2, New Haven, 1961; M. Röthlisberger, *Claude Lorrain. The Drawings,* vols 1, 2, Berkeley, Los Angeles, 1968; *Tout l'œuvre peint de Claude Lorrain* (introduction and catalogue raisonné by Marcel Röthlisberger with the assistance of Doretta Cecchi), Paris, 1977; H. Diane Russell, *Claude Lorrain. 1600-1682,* Washington, 1982; *Im Licht von Claude Lorrain. Landschaftsmalerei aus drei Jahrhunderten* (edited by Marcel Röthlisberger, essays by Eva-Maria Marquart, Christian Lenz and Erich Steingräber), Munich, 1983.

14. J. Hess, *Agostino Tassi, der Lehrer des Claude Lorrain,* Munich, 1935; also literature listed in Note 13 above.

15. A. Benois, *A History of Painting of All Times and Nations,* issue 19. St. Petersburg, s. a., p. 183 (in Russian).

16. Charles Bouleau, *The Painter's Secret Geometry. A Study of Composition in Art,* New York, 1963. pp. 125-128.

17. A. Benois, *op. cit.,* p. 204.

18. See, e.g., Yu. Gerchuk: "Architectural Fantasies in Painting and the Graphic Arts". In: *Eighteenth-Century Western European Artistic Culture,* Moscow, 1980. pp. 89-103 (in Russian); D. Likhachov, op. cit.

19. Paul Valéry, *Ecrits sur l'art,* Paris, 1962. p. 150. "Du milieu du XVIe siècle au commencement du XIXe, le paysage est traité en Italie et en France dans un style essentiellement théâtral. Nicolas Poussin dispose de nobles décors pour tragédies. Claude Lorrain, sur les rives de la mer, dresse les palais de Didon, place au fond de la scène, sur l'onde illuminée, les escadres dorées du fabuleux Enée. Watteau recherche dans les parcs des effets de féeries et de tableaux fondants."

20. *A Raw Youth.* A novel in three parts by Fyodor Dostoyevsky (translated from the Russian by Constance Garnett), London, 1916, part 3, chapter 7, pp. 461, 462. Accentuating Dostoyevsky's strong interest in the art of

Claude. D. Likhachov notes that a reproduction of the picture in question was included in a set which was composed by Anna Dostoyevskaya. Curiously enough, he himself twice refers to the canvas as *The Golden Age*, using the name given to it by Version Dostoyevsky's character: another evidence for the extraordinary force of Dostoyevsky's interpretation of it (D. Likhachov, *op. cit.*, p. 256).

21. The motif of a dream of the Golden Age was borrowed from Dostoyevsky by H. Sedlmayr for his *Epochen und Werke. Gesammelte Schriften zur Kunstgeschichte*, vol. 2., Vienna, Munich, 1960, pp. 338, 339.

22. Cf. the following comment by Yu. Lotman: "Whereas the decanonized text serves as a source of information, the canonic one acts as its stimulator." (Yu. Lotman, "Canonic Art as an Information Paradox", In: *Problem of the Canon in Ancient and Medieval Art of Asia and Africa*, Moscow, 1973, p. 20, in Russian).

23. Of the three known views of metaphor: substitutional view, comparison view, and interaction view (according to M. Black, *Models and Metaphors*, New York, 1962), we would prefer the last-mentioned one, by which metaphor is regarded as an interaction of meanings.

24. As we know, Claude worked almost exclusively for the aristocracy. For a survey of his patrons, see M. Röthlisberger, "Le paysage comme idéal classique", in: *Tout l'oeuvre peint de Claude Lorrain* (introduction and catalogue raisonné by Marcel Röthlisberger with the assistance of Doretta Cecchi), Paris, 1977, p. 8. But the problem of the viewer in a painter's art is much broader and deeper than the question of concrete patrons.

25. Cf. a recent work with a most telling title, "The 'Silence' of Claude Lorrain". In: C. M. Ionescu, *Lorrain*, Bucharest, 1983.

26. A. Mikhailov, "Antiquity as Reflected in Late Eighteenth- and Early Nineteenth-Century German Culture", in: *Antiquity in the Culture and Art of Subsequent Ages. Materials of a Scientific Conference (1982)*, Moscow, 1984, pp. 183, 184 (in Russian).

27. See, e. g., V. M. Zhirmunsky: *Theory of Literature: Poetics, Stylistics (Selected Works)*, Leningrad, 1977, pp. 358, 359 (in Russian).

28. A. Benois, *op. cit.*, p. 182.

29. See, e. g., K. Clark, *Landscape into Art*, London, 1952, p. 66. C. M. Ionescu, *op. cit.*, pp. 19, 20.

30. It would be correct to say that Claude paved the way for future "typical Classicists"; yet his own art is not of a purely Classicist orientation. Claude's compositional scheme often shows a prevalence of the principle of subordination over that of coordination, and this brings it stylistically closer to the Baroque. At the same time, Claude's rendering of space and

31. Engraved by Richard Earlom and published in London in 1777 (edited by Boydell).

32. Johann Peter Eckermann, *Gespräche mit Goethe in den letzten Jahren seines Lebens*, Leipzig, 1908, p. 149.

33. *Im Licht von Claude Lorrain. Landschaftsmalerei aus drei Jahrhunderten* (edited by Marcel Röthlisberger, essays by Eva-Maria Marquart, Christian Lenz and Erich Steingräber), Munich, 1988.

34. A. Benois, *op. cit.*, p. 187.

35. J.P. Eckermann, *op. cit.*, pp. 136, 137.

36. To further motivate our claim to considering certain aspects of Zhukovsky's poetry in the context of problems bearing upon the art of Claude, we may add that the Russian poet, like Goethe, was also an artist, an excellent and enthusiastic draughtsman, and a connoisseur of the visual arts; and recall the fact of his personal acquaintance with Caspar David Friedrich, one of the leading Romantic painters of Europe, whose name came to be widely known and highly esteemed in Russia through Zhukovsky's efforts. See, e. g., M. Liebman, "Zhukovsky as Draughtsman. Toward the Problem of the Links between C. D. Friedrich and V. A. Zhukovsky". In: *Problems of Art: Antiquity. The Middle Ages. The Modern Epoch*, Moscow, 1977 (in Russian). We are prevented by lack of space from citing other instances of a similar nature — which are numerous enough — in support of our right to the use of this method.

37. V. Zhukovsky, *Lyrics*, Leningrad, 1956, pp. 78, 79 (in Russian).

38. E. Baratynsky, "On the Death of Goethe (translated by Peter Tempest)", in: *Poetry of Europe*, vol. 3 (1), Moscow (Progress Publishers), 1977, p. 182.

39. Vyacheslav Ivanov: *Lyrics and Poems*, Leningrad, 1978, p. 83 (in Russian). It is worthy of note that in his *Siren*, written more than ten years later, Ivanov, still clinging to the motif of magic charm, rhymes Lorrain and Siren.

40. D. Likhachov, *The Poetry of Gardens*; also to be consulted is the bibliography in this book, and in particular the work of J. D. Hunt, *The Figure in the Landscape: Poetry, Painting and Gardening during the Eighteenth Century*, London, 1976.

1. MORNING IN THE HARBOUR. (1634)

Oil on canvas. 97.5 x 120.5 cm.
Hermitage, St. Petersburg
Inv. No 1243
LV* 5.

On the basis of a drawing in the *Liber Veritatis* and the year printed on Claude's corresponding etching this painting was dated 1634 (A. Blum, *Les Eaux-fortes de Claude Gellée*. Paris, 1923, No 10). But Pattison (1884) and Friedländer (1921) disagreed, believing it was painted in 1649.

* LV refers to the *Liber Veritatis*.

Coast scene. Drawing.
British Museum, London.

Morning in the Harbour. 1674.
Alte Pinakothek, Munich.

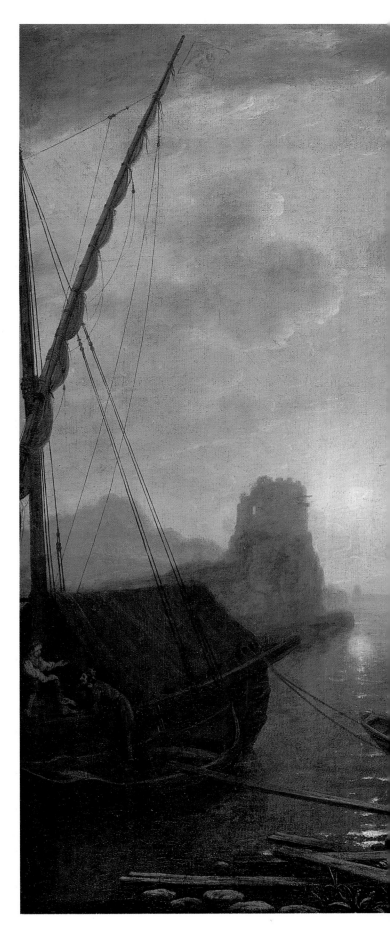

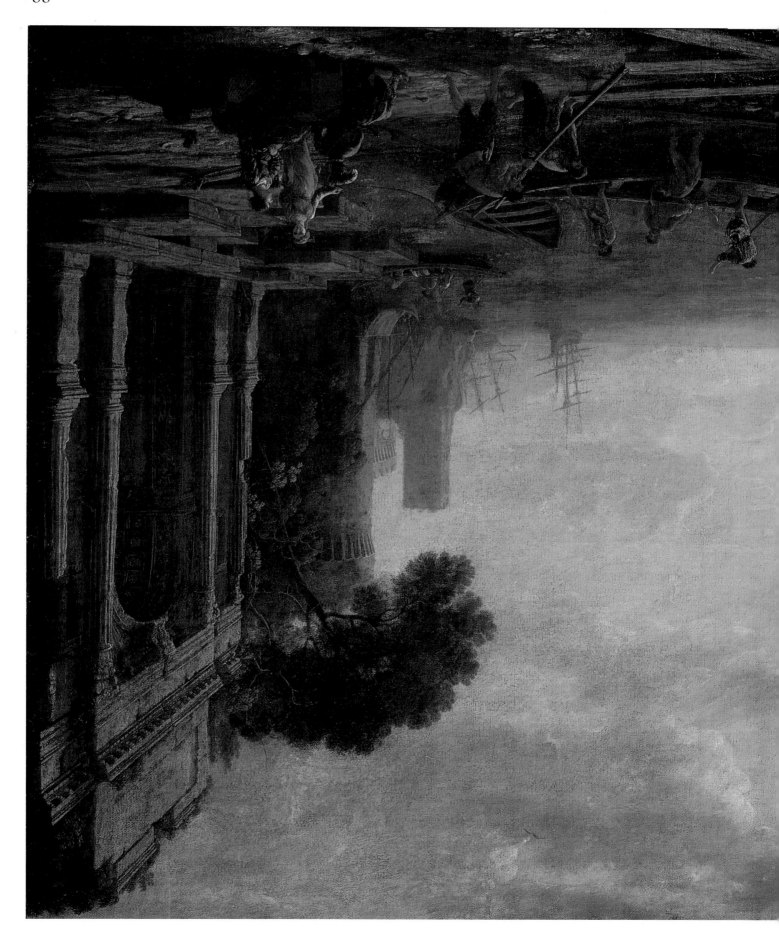

Pattison proceeded from the reference to the artist's customer on the verso of the *Liber Veritatis* drawing: *faict pour monsigneur l'avec du mant. Claudio fecit in VR.* Röthlisberger (1961) pointed to the obvious confusion of two personages: Charles de Beaumanoir, Bishop of Mainz from 1601 to 1637, and Philibert-Emmanuel de Beaumanoir, who headed this diocese after 1649. However, a date of 1634 is more in keeping with the painting's style. Like all the early harbour pieces it is subject-free, and the landscape's depth is not fully developed; the Arch of Titus, the trees and the towers in the background lend the view a fanciful, romantic note. Motifs of this kind are absent from the emphatically representative harbour pieces, produced in the late 1630s and the early 1640s.

The closest compositional analogy is *The Harbour* (1637; LV 19) from the Royal Collection at Windsor Castle.

There is an artist's copy executed in 1674 for Franz Mayer, now in the Alte Pinakothek in Munich.

Provenance: 1720, Collection of the Count de Morville, Paris; acquired by the Hermitage in 1779 with the Walpole Collection.

Exhibitions: 1955 Moscow, (p. 43); 1956 Leningrad, (p. 35); 1972 Warsaw - Prague - Budapest - Dresden (No 56); 1977 Tokyo - Kyoto (No 28).

Catalogues and inventories: Cat. 1773-1785, No 2336; *Cat.* 1797, No 2430; *Inv.* 1859, No 3440; *Cat.* 1863-1916, No 1437; *Cat.* 1958, p. 305; *Cat.* 1976, p. 200.

References: Aedes Walpolianae or Description of the Collection of Pictures at Houghton Hall in Norfolk, London, 1752. p. 84; Smith 1837, Nos 242, 308; *Livret* 1838, p. 171, XIX, No 24; Waagen 1864, p. 293; Pattison 1884, p. 108; Friedländer 1921, pp. 105, 106, 140; Röthlisberger 1961, vol. 1, pp. 102-105, vol. 2, fig. 32, 33; Röthlisberger 1968, vol. 1, p. 105, vol. 2, fig. 85; Röthlisberger 1977, p. 89, No 49.

36

2. MORNING IN THE HARBOUR

Oil on canvas. 73 x 98 cm.
Hermitage, St. Petersburg
Inv. No 1782

According to Röthlisberger (1961), this is a copy of *The Harbour* of 1637 in the Royal Collection in London, a highly popular canvas which produced a spate of copies by Claude himself and by other artists. (In the 1630s Claude readily took up seaport scenes for his paintings and drawings.) In my own opinion, the Hermitage piece is an author's copy of the London picture. The composition of the two paintings is identical : not so their details: the arrangement and number of boats and ships in the harbour, and the rigging of ships on the left are different; an extra tower appears on the horizon in one case. The foreground details and the staffage, which differs from that of the London canvas, are carefully worked up but the arch is less elaborate, something Claude often allowed himself to do when producing copies of his works. The gentle painterly treatment is characteristic of his early period.

An X-ray comparison of this work and the 1634 *Morning in the Harbour* from the Hermitage has proved a certain similarity in the manner of painting, especially in the treatment of ship masts in the middle ground. The overall conclusion is in favour of this work being a replica executed by the artist before 1650.

The Hermitage painting was received from a French collection, like the harbour scene in the Royal Collection in London, which was commissioned by the prominent collector Chancellor Perochel of France.

Provenance: acquired by the Hermitage in 1781 from the Baudouin Collection, Paris.

Exhibitions: 1956 Leningrad (p. 35); 1965 Bordeaux (p. 9, No 7); 1965-1966 Paris (p. 13, No 4); 1978 Prague - Bratislava (No 8).

Catalogues and inventories: Cat. 1773-1785, No 2554; *Cat.* 1797, No 2858; *Inv.* 1859, No 3409; *Cat.* 1863-1916, No 1433; *Cat.* 1958, p. 305; *Cat.* 1976, p. 200.

References: Smith 1837, p. 240, No 305; *Livret* 1838, p. 7, I, No 3; Waagen 1864, p. 292, No 1433; Pattison 1884, p. 246; Friedländer 1921, pp. 106, 239, 247; Röthlisberger 1961, vol. 1, p. 136, vol. 2, fig. 384.

1.

4.

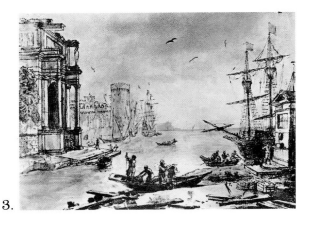

2.

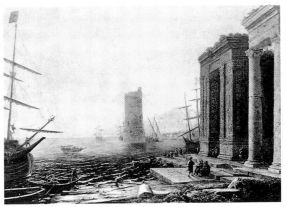

3.

4.

1. *The Harbour.* 1637.
Royal Collection,
Windsor Castle,
Berkshire, England.

2. *Seaport.*
Drawing. 1637. LV 19
British Museum,
London.

3. *Seaport.*
Drawing. 1636. LV 6
British Museum,
London.

4. *Seaport*
Allen Memorial
Art Museum,
Oberlin, Ohio.

41

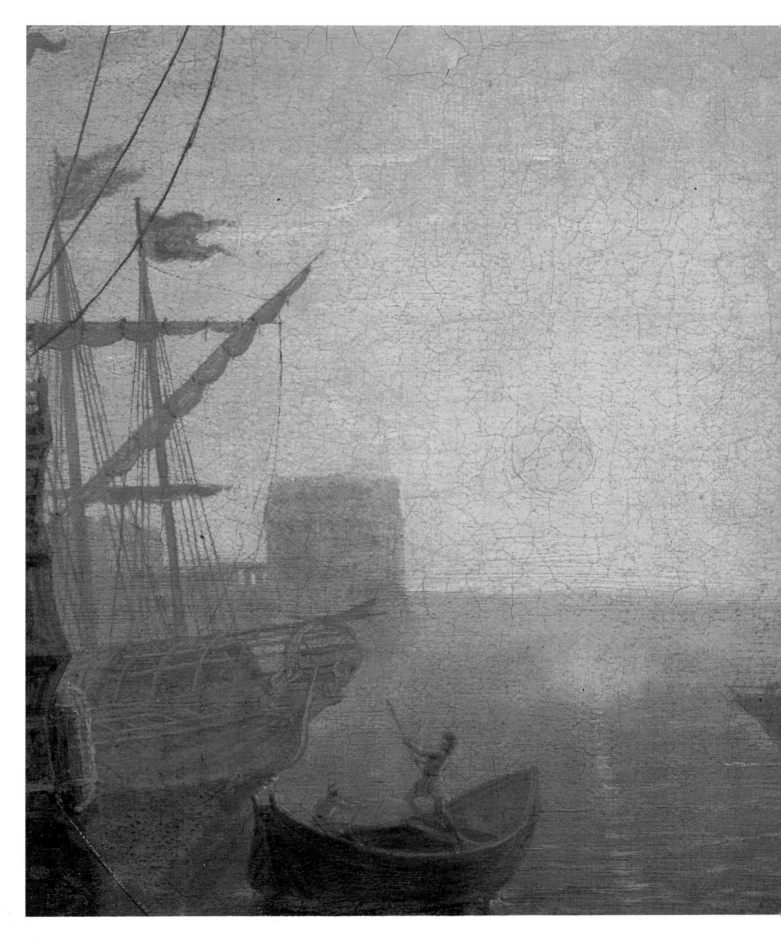

44

3. LANDSCAPE WITH APOLLO AND MARSYAS.
(1639-1640)

Oil on canvas. 101 x 133 cm.
Pushkin Museum of Fine Arts, Moscow
Inv. No 915
Source: Ovid, *Metamorphoses*, 6:382-400
LV 45

According to the inscription (*quadre faict per m. perochel,*) on the reverse of the *Liber Veritatis* drawing, this was one of the three pieces commissioned by Chancellor Perochel in 1639-1640.

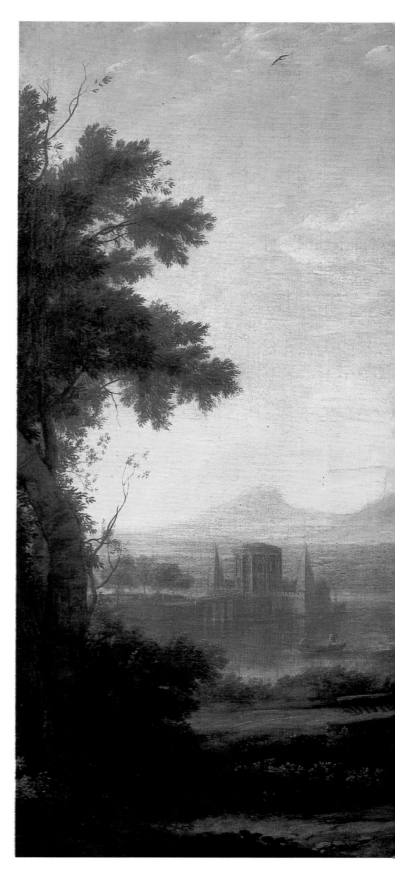

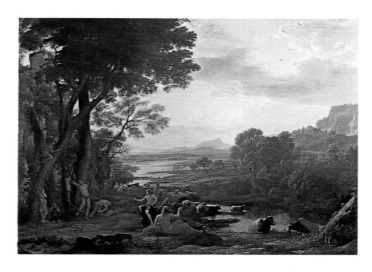

Landscape with Apollo and Marsyas. 1645.
Collection of the Earl of Leicester, Holkham Hall,
Norfolk, England.

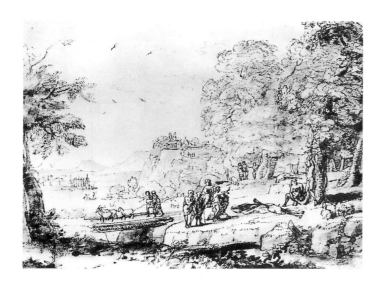

Landscape with the Flaying of Marsyas. Drawing. 1639-40.
British Museum, London.

Another composition on the same subject (LV 95), executed for Abbé Joly (Smith 1837), is at present in the collection of the Earl of Leicester (Holkham Hall, Norfolk, England).

An engraving from the Pushkin Museum version was done in 1774 by Miller (Smith spells the name Müller). This version has replicas and copies, one of which is in the Ringling Museum of Art, Sarasota, Florida.

Provenance: acquired by the Hermitage in 1772 with the Crozat Collection; 1924, transferred to the Pushkin Museum of Fine Arts, Moscow.
Exhibitions: 1972 Dresden (No 24).

Catalogues and inventories: Cat. 1773-1785, No 1133; *Cat.* 1863-1916, No 1438; *Cat. Pushkin Museum* 1948, p. 46; *Cat. Pushkin Museum* 1957, p. 82; *Cat. Pushkin Museum* 1961, p. 113.

References: Catalogue des tableaux du cabinet de M. Crozat, baron de Thiers. Paris, 1755, p. 9, No 28; A.-J. Dezallier d'Argenville: *Voyage pittoresque de Paris ou indication de tout ce qu'il y a de plus beau dans cette grande ville en peinture, sculpture et architecture.* Paris, 1757, p. 120; Smith 1837, p. 215, No 45; Waagen 1864, p. 291; Pattison 1884, pp. 211, 215, 246; Réau 1928, p. 85, No 589; Röthlisberger 1961, pp. 178, 255-286; M. Stuffmann: "Les Tableaux de la collection de Pierre Crozat. Historique et destinée d'un ensemble célèbre établis en partant d'un inventaire après décès inédits" (1740), *Gazette des Beaux-Arts*, 1968, July-September, p. 131, No 150; Röthlisberger 1977, No 205; Kuznetsova Georgievskaya, 1979, No 8; Kuznetsova 1982, p. 148.

50

4. COAST VIEW WITH APOLLO AND THE CUMAEAN SIBYL. (1646)

Oil on canvas. 95.5 x 127 cm.
Before it was acquired by the Hermitage the painting had two side panels of 4.7 cm each, added at Houghton Hall between 1720 and 1775.
Traces of the artist's signature are visible on a column fragment, bottom left.
Hermitage, St. Petersburg
Inv. No 1228
Source: Ovid, *Metamorphoses*, 14:130-140
LV 99

For a long time the painting was known as *The Bay of Baia* due to the association of "Cumaean with Cumae, an ancient town not far from Naples".

Coast View with Apollo and the Cumaean Sibyl.
Drawing. 1646.
British Museum, London.

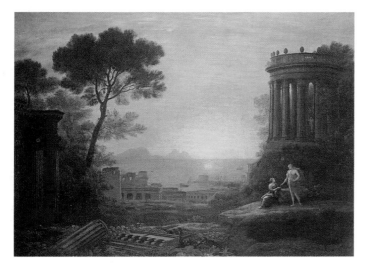

Coast View with Apollo and the Cumaean Sibyl. 1665.
Private collection.

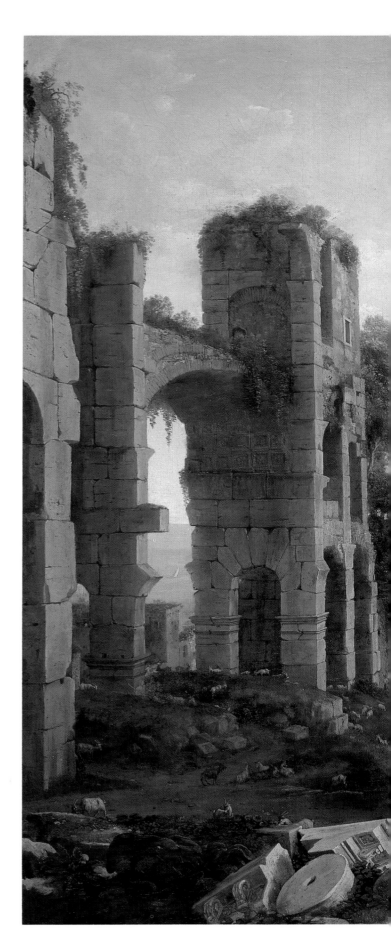

Landscape with Argus Guarding Io. 1644.
Collection of the Earl of Leicester,
Holkham Hall, Norfolk, England.

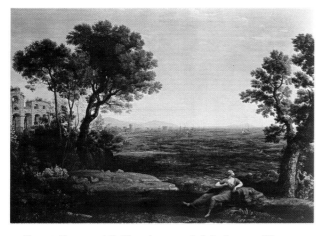

Coast Scene with Bacchus and Ariadne on Naxos.
1656. Arnot Art Gallery, Elmira, New York.

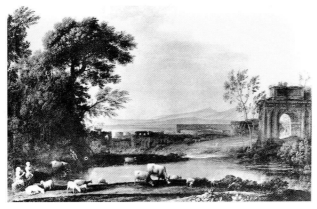

Landscape with the Arch of Titus. 1661.
Collection of the Duke of Westminster, London.

This title appeared in the 1859 Hermitage inventory. In actual fact the painting does not depict this bay. Portrayals of concrete natural settings were alien to Claude. The view, however, incorporates buildings and relics with real prototypes which the artist chose to place side by side. Seen in the background are the ruins of the Colosseum and of an aqueduct in Rome (the Aqua Marcia, which can still be seen on Piazza Vittorio Emmanuele); arranged in the lateral arches are the trophies of Mario (their real site is the Capitoline Hill, next to the statues of Castor and Pollux). The presence of these rare details is most probably a tribute to the man who commissioned the painting: Cardinal Massimi took a special interest in archaeology. Röthlisberger (1961) pointed out that the ruins in the foreground represent a free version of the Colosseum theme which often occurs in Claude's landscapes.

The figures are attributed to Filippo Lauri.

A companion piece, *Landscape with Argus Guarding Io* (1644), is in the collection of the Earl of Leicester (Holkham Hall, Norfolk, England).

A version of *Apollo and the Cumaean Sibyl* dated 1665 is in a private collection (Röthlisberger 1961, vol. 1, No 164).

After the death of Cardinal Massimi in 1676 (Claude worked for him between 1645 and 1649) his collection was kept by his brother Fabio until the latter's death in 1686. According to the *Aedes Walpolianae* (1747), the painting was purchased for Houghton Hall from the collection of Marquess De Mari.

Provenance: acquired by the Hermitage in 1779 with the Walpole Collection.

Exhibitions: 1985 Sapporo - Fukuoka (No 17).

Catalogues and inventories: Cat. 1773-1785, No 2337; *Cat.* 1797, No 2434; *Inv.* 1859, No 3414; *Cat.* 1863-1916, No 1432; *Cat.* 1958, p. 305; *Cat.* 1976, p. 200.

References: Aedes Walpolianae or Description of the Collection of Pictures in Houghton Hall in Norfolk. London 1752. p. 94; Smith 1837, No 99, p. 244; *Livret* 1838, XIX, No 59; Waagen 1864, p. 292; Pattison 1884, p. 107, No 245; A. Neustroyev, *The Picture Gallery of the Imperial Hermitage*, St. Petersburg, 1898, p. 327 (in Russian); Réau 1928, No 225; Röthlisberger 1958, p. 225; Röthlisberger 1961, vol. 1, pp. 261, 262, vol. 2, fig. 180; Röthlisberger 1977, No 164.

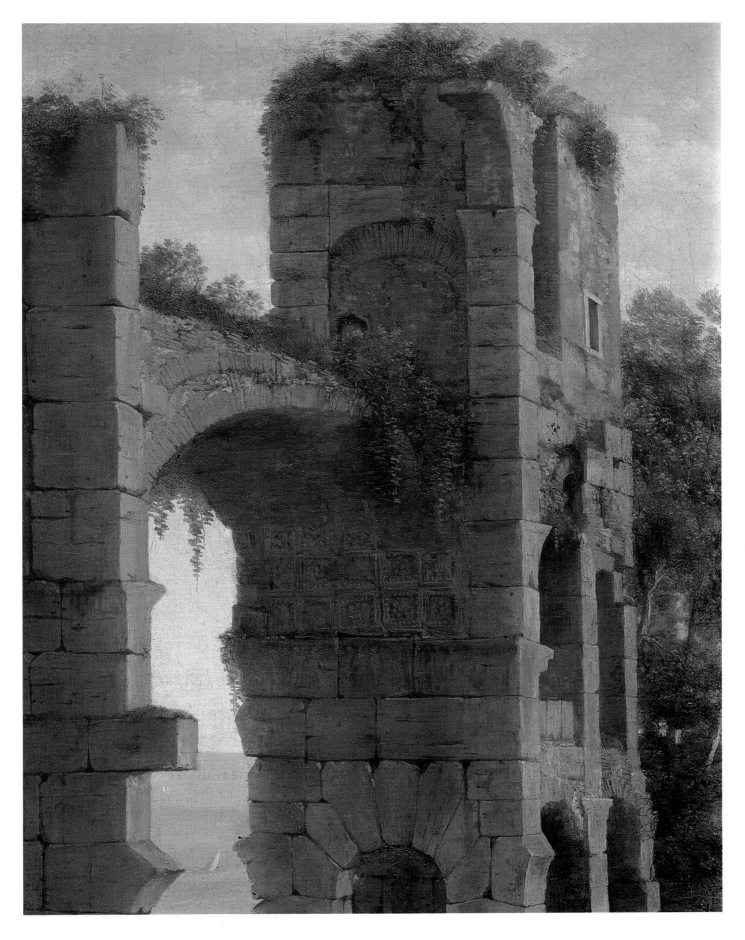

58

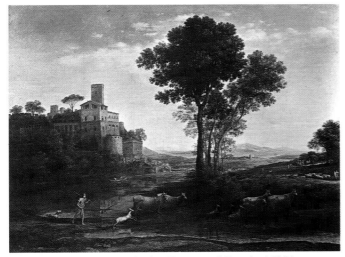

Pastoral Landscape. 1647.
Museum of Fine Arts, Budapest.

5. ITALIAN LANDSCAPE. (1648)

Oil on canvas. 75 x 100 cm.
Signed and dated, bottom right: *CLAVD. 1648 ROMAE*
Hermitage, St. Petersburg
Inv. No 1225

This is an author's copy of the *Pastoral Landscape* (1647), now in the Museum of Fine Arts, Budapest (LV 107), which differs from it in some details.
The pastoral landscape is a subject on which Claude drew throughout his long artistic career.
Similar foreground figures occur in the *Pastoral Landscape* (1645; Barber Institute of Fine Arts, Birmingham) and the *Landscape with Paris and Oenone* (1648; Louvre, Paris).

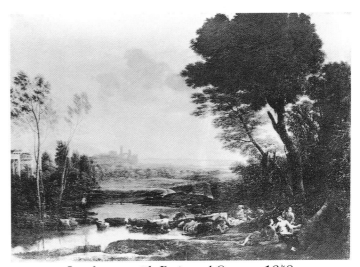

Landscape with Paris and Oenone. 1648.
Louvre, Paris.

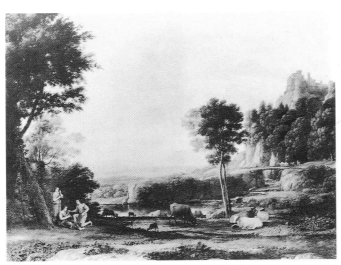

Landscape with the Voyage of Jacob. 1677.
Clark Art Institute, Williamstown, Massachusetts.

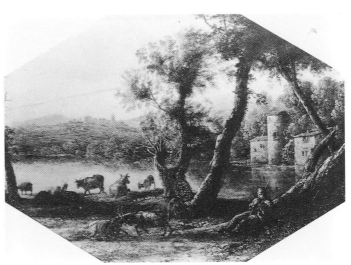

Rural Landscape. 1636.
Private collection, France.

Pastoral Landscape. 1645.
Barber Institute of Fine Arts, Birmingham.

60

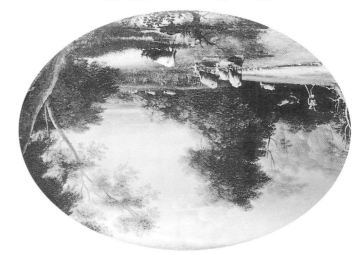

Pastoral Landscape. 1630-35.
Louvre, Paris.

Provenance: acquired by the Hermitage in 1772 with the Crozat Collection.

Exhibitions: 1956 Leningrad (p. 35); 1968-1969 Belgrade (No 47, p. 52); 1972 Dresden (No 23, p. 72); 1987-1988 Belgrade - Ljubljana - Zagreb (No 8, p. 20).

Catalogues and inventories: Cat. 1773-1785, No 952, Cat. 1797, No 1746; *Inv.* 1859, No 3408; Cat. 1863-1916, No 1434; Cat. 1958, p. 308, Cat. 1976, p. 200.

References: Catalogue des tableaux du cabinet de M. Crozat, baron de Thiers, Paris, 1755, p. 57; Smith 1837, No 302, p. 338, *Livret* 1838, p. 171, XIX, No 22; Waagen 1864, p. 291; Pattison 1884, p. 246; Réthlisberger 1961, vol. 1, p. 474, vol. 2, fig. 211; M. Stuffmann: "Les Tableaux de la collection de Pierre Crozat, Historique et destinée d'un ensemble célèbre établis en partant d'un inventaire après décès, inédits" (1740), *Gazette des Beaux-Arts,* 1968, July-September, p. 110; Réthlisberger 1977, p. 108, No 172 bis.

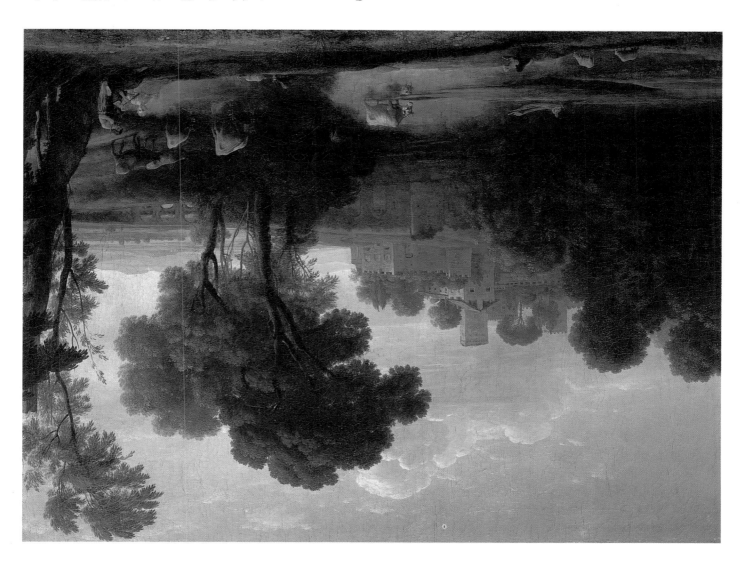

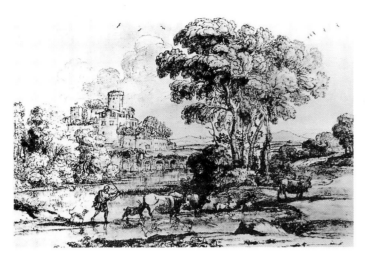

Pastoral Landscape. Drawing.
British Museum, London.

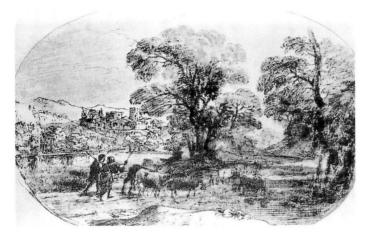

Pastoral Landscape. Drawing.
Louvre, Paris.

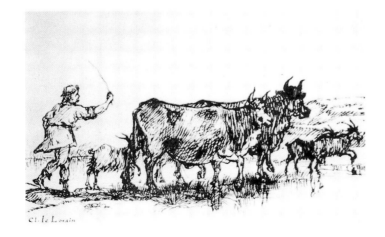

Pastoral Landscape. Drawing. *c.* 1645.
Musée Bonnat, Bayonne, France.

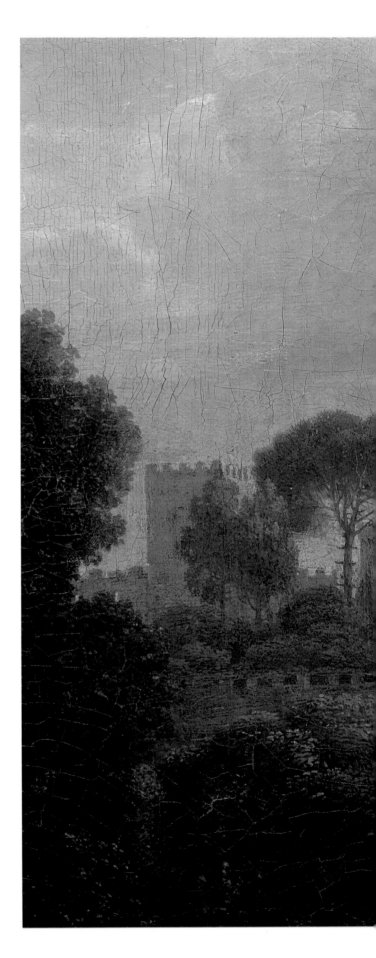

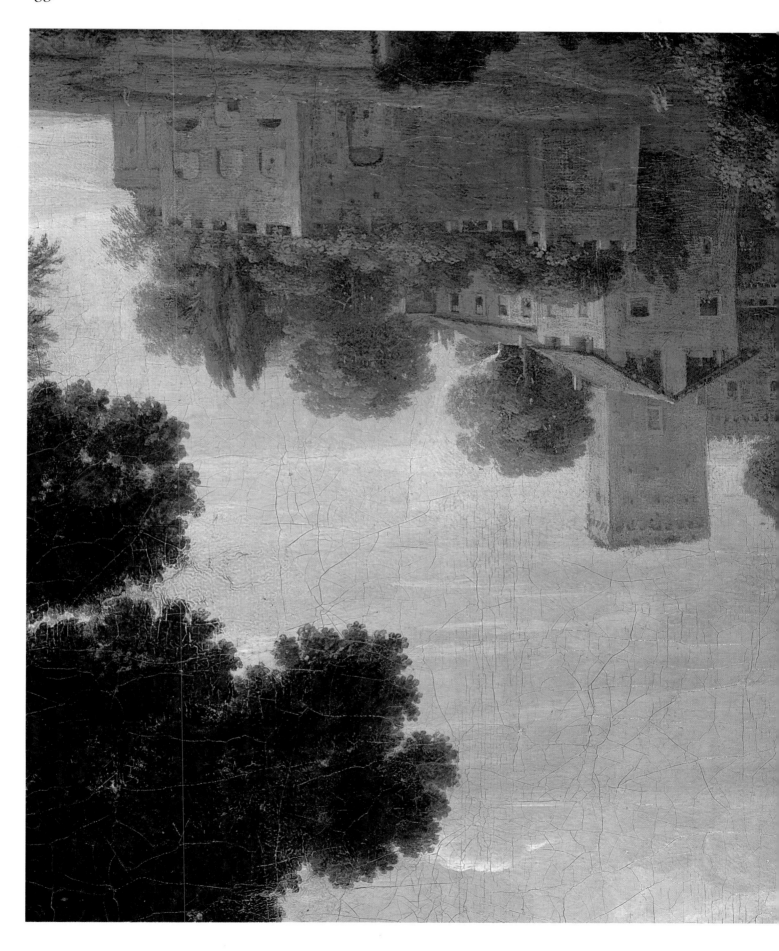

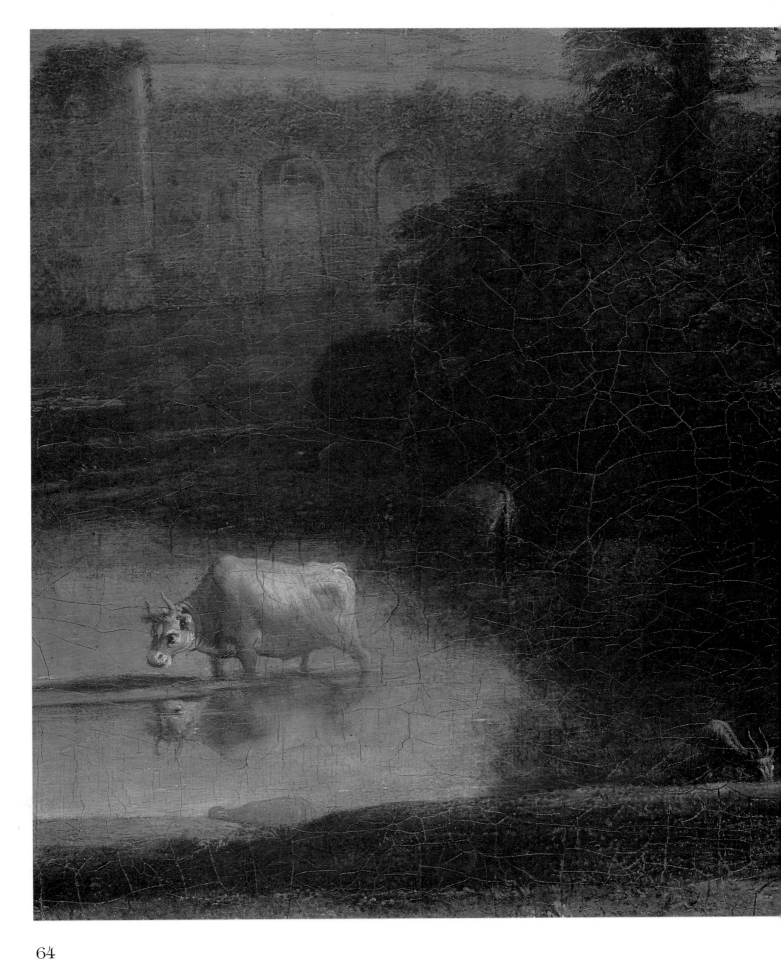

64

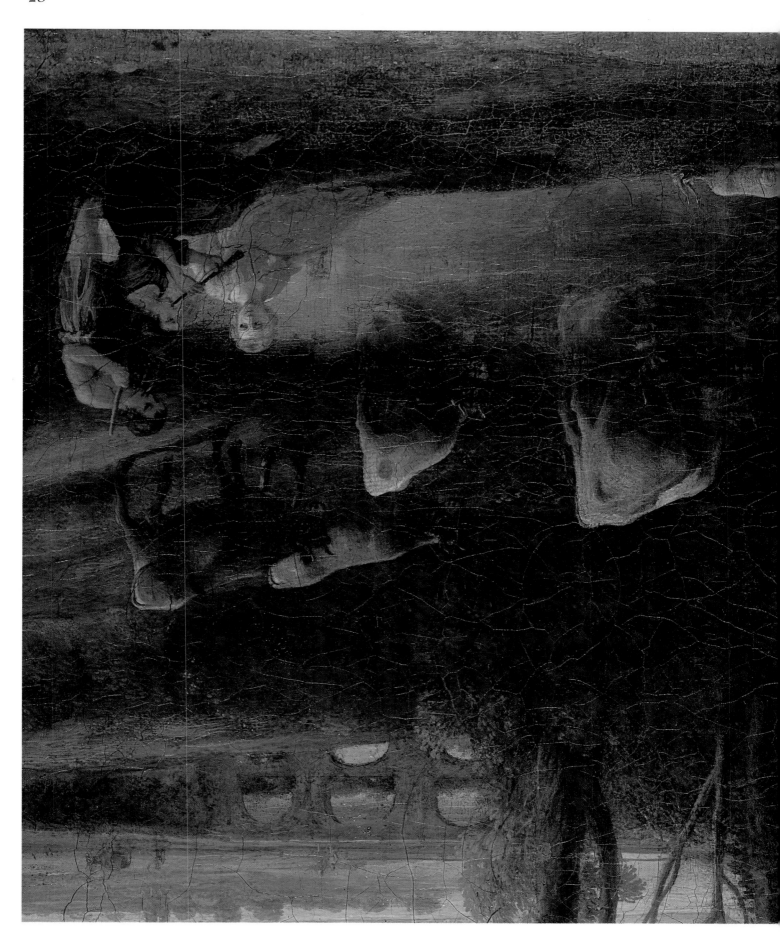

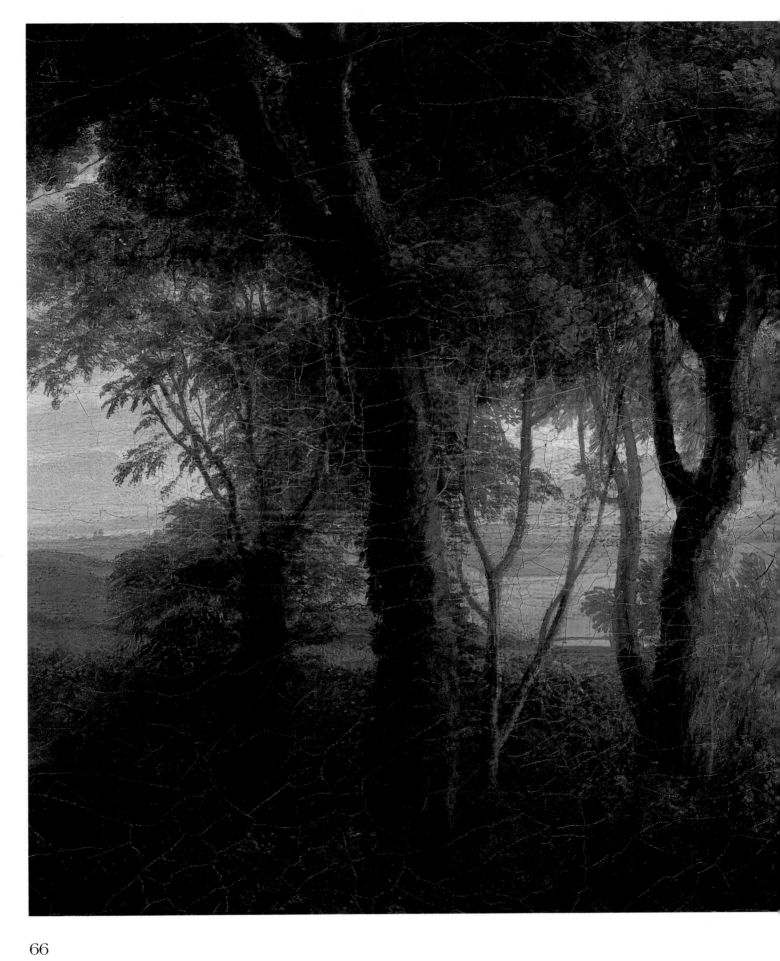

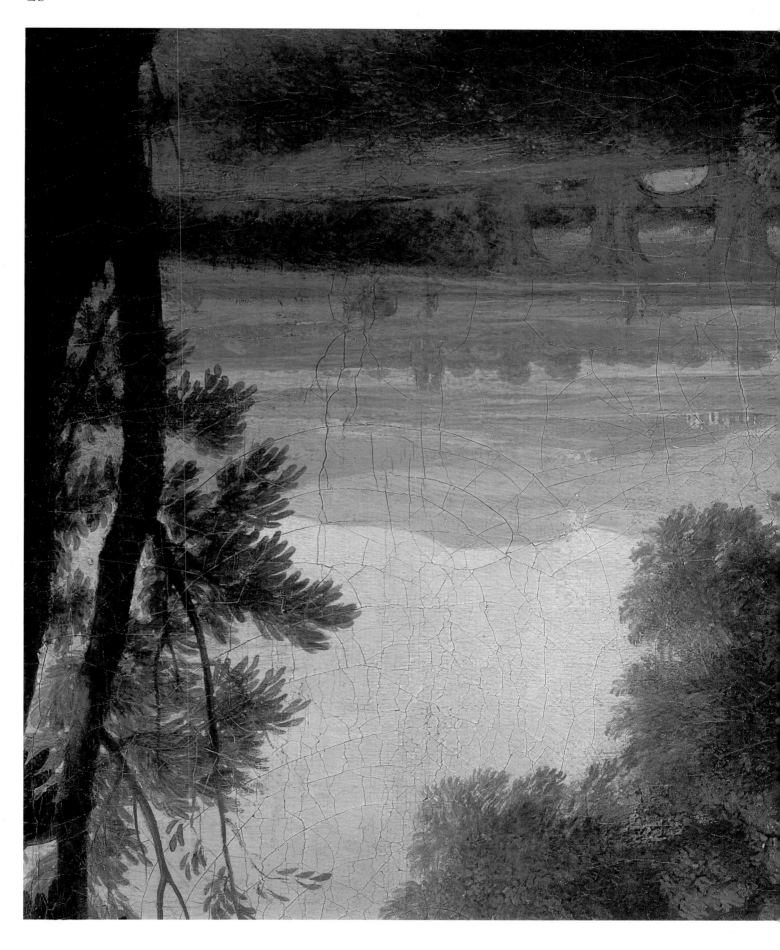

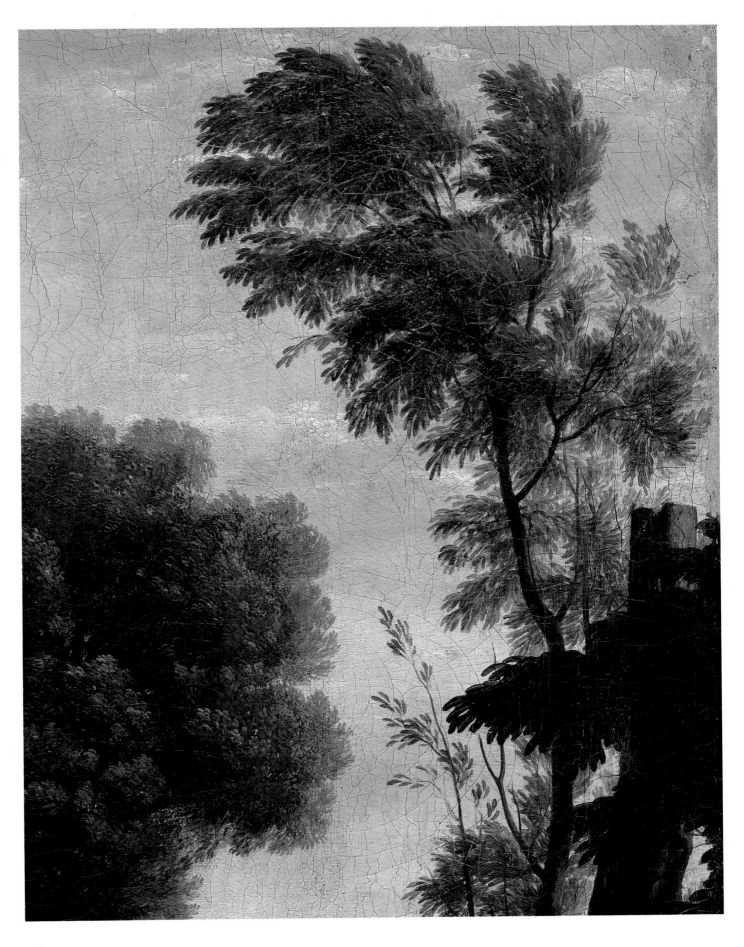

68

The Goatherd (Herd Returning in Stormy Weather). c. 1650. Etching. 15.8 x 22 cm.
Hermitage, St. Petersburg

6. THE ARRIVAL OF ULYSSES AT THE COURT OF LYCOMEDES. (c. 1648)

Oil on canvas. 91 x 133 cm.
Hermitage, St. Petersburg
Inv. No 1784
Source: Ovid, *Metamorphoses*, 13:162

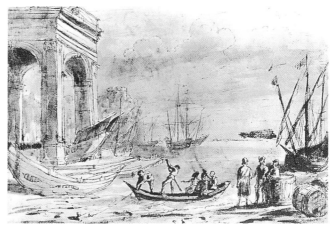

1

The composition is traceable to a *Liber Veritatis* drawing (No 4).

Röthlisberger (1961) doubts this painting's traditional attribution to Claude Lorrain, but X-ray photographs reveal changes in the palace's architecture, suggesting that it is not a copy by another artist.

The story of Ulysses occurs on two other occasions in Claude's oeuvre: in *Seaport: Ulysses Returns Chryseis to Her Father* (1644; Louvre, Paris) and *Seaport with the Embarkation of Ulysses* (1646; Louvre, Paris).

The palace's architecture is reminiscent of that in *The Embarkation of the Queen of Sheba* (1648; National Gallery, London) and *Landscape with Bacchus and the Palace of Staphylus* (1672; Pallavicini Collection, Rome).

The painting may be tentatively dated c. 1648. Its source, as in the case of the two other Ulysses compositions, is a French collection.

Provenance: acquired by the Hermitage in 1774. (In 1772 Ménageot purchased it for Diderot, who acted on behalf of Empress Catherine the Great of Russia, at the sale of the Van Loo Collection in Paris; Saint-Aubin made a drawing of this painting on the margin of the sale catalogue.)

Exhibitions: 1954 Leningrad (p. 53).

Catalogues and inventories: Cat. 1773-1785, No 1703; *Cat.* 1797, No 2500; *Inv.* 1859, No 3431; *Cat.* 1863-1916, No 1436; *Cat.* 1958, p. 305; *Cat.* 1976, p. 200.

References: Smith 1837, No 304, pp. 339, 340; *Livret* 1838, XIX, No 55, p. 179; Waagen 1864, p. 295; Pattison 1884, p.246; *Catalogue de ventes et livrets de salons illustré par Gabriel de Saint-Aubin* (introduction and notes by Emile Dacier), vol. 5: *Catalogue de la vente Louis-Michel Van Loo (1772)*. Paris, 1911, No 17, p. 16; Röthlisberger 1961, vol. 1, pp. 475, 476, vol. 2, fig. 209.

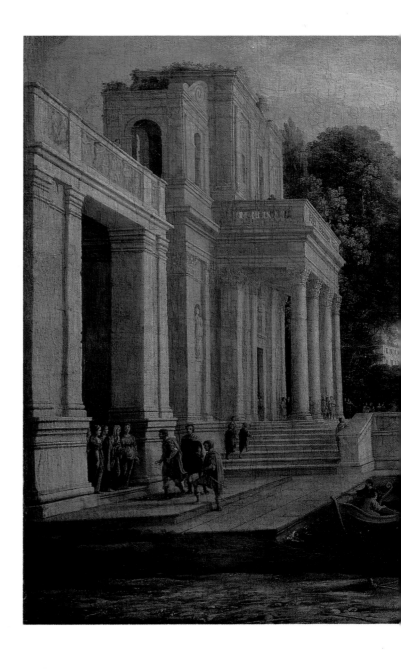

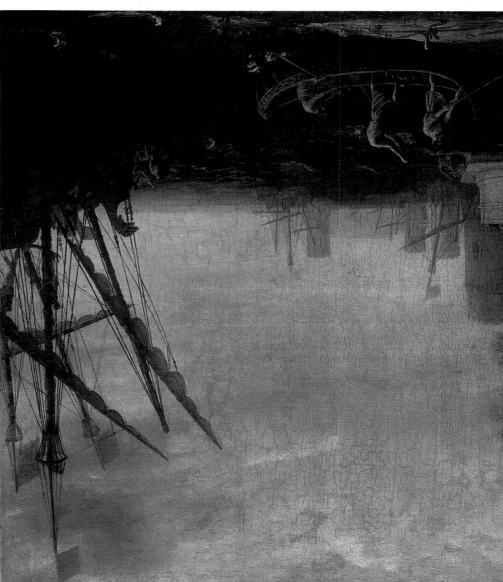

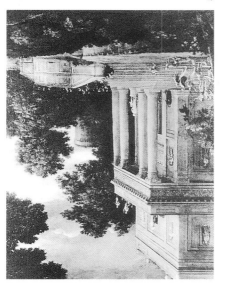

1. *Coast View*. Drawing. 1634.
British Museum, London.

2. *Seaport: Ulysses Returns
Chryseis to her Father*. 1644.
Louvre, Paris.

3. *Seaport with the Embarkation
of Ulysses*. 1646.
Louvre, Paris.

4. *Landscape with Bacchus
and the Palace of Staphylus*. 1672.
Pallavicini Collection, Rome.

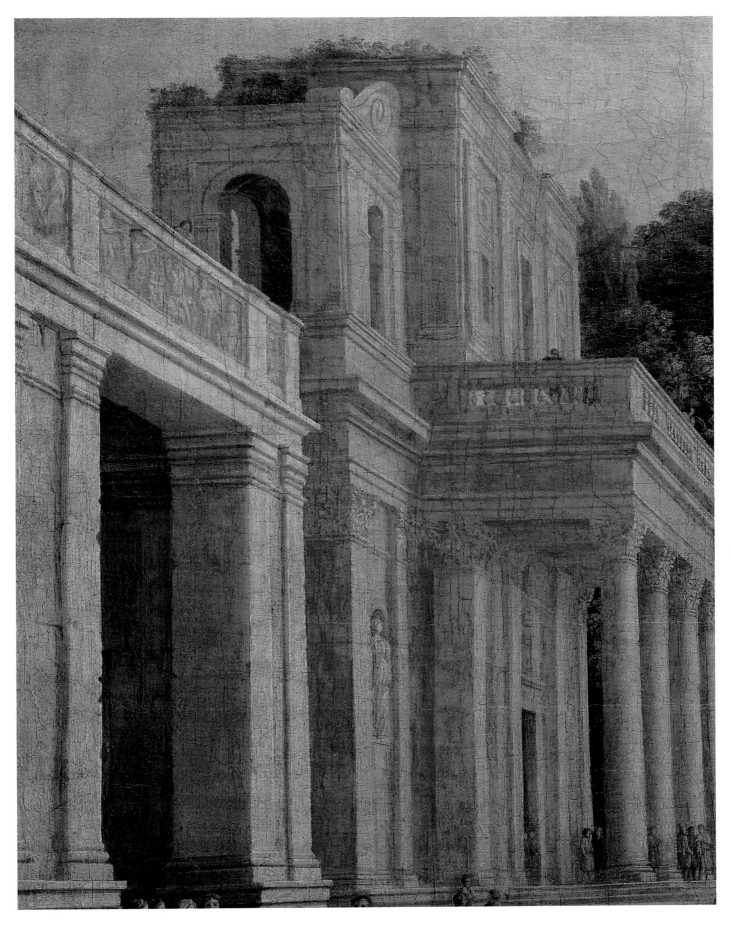

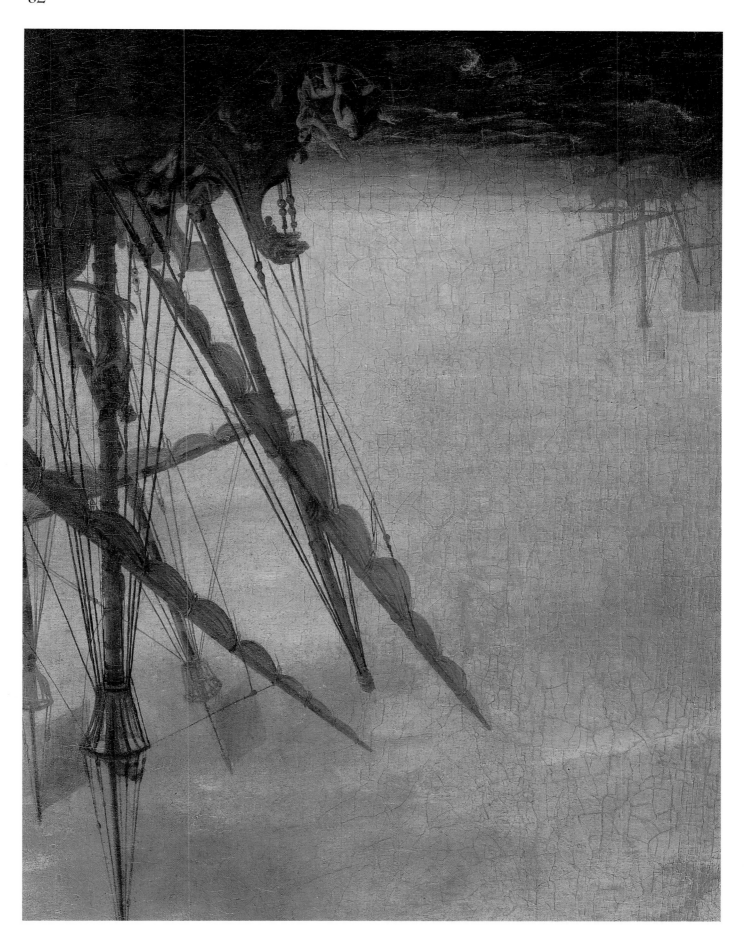

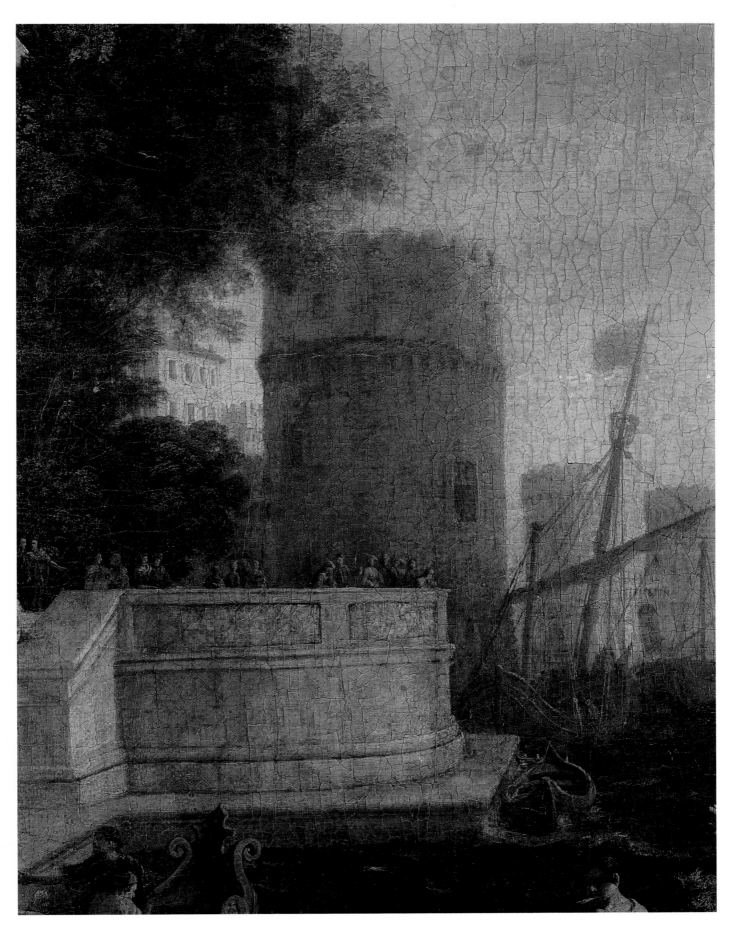

74

Coast Scene with an Artist Drawing. 1639. Etching. 12.4 x 17.3 cm.
Hermitage, St. Petersburg.

7. THE RAPE OF EUROPA. (1655)

Oil on canvas. 100 x 137 cm.
Signed and dated, bottom right: *Claudio G. IV Romae 1655*
Pushkin Museum of Fine Arts, Moscow
Inv. No 916
Companion piece to *Battle on a Bridge* (No 8)
Source: Ovid, *Metamorphoses*, 2:844-875
LV 136 (companion to LV 137)

Commissioned from Claude Lorrain by Cardinal Fabio Chigi who became Pope Alexander VII (1655-1667) before the painting was finished.
There is a preparatory drawing in the Kupferstichkabinett of Staatlichen Museen, Berlin (Röthlisberger 1968, No 758) with the following inscription made by the artist on the reverse: *facto al Emosg Cardinal [...] creato pero guis pap [...] Claudio*. (Ernst, 1924, cites a somewhat modified text.) The name of the client and the date on the drawing's reverse are in full accord with

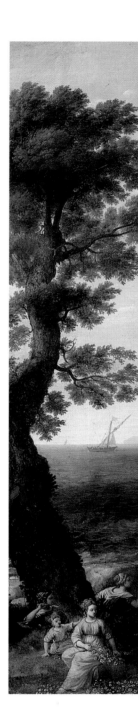

1

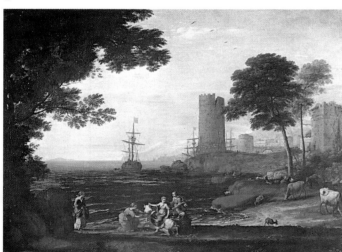

1. *The Rape of Europa*. 1647. Centraal Museum, Utrecht.

2

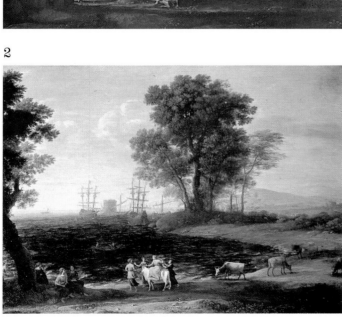

2. *The Rape of Europa*. 1667. Royal Collection, Buckingham Palace, London.

the canvas in the Pushkin Museum of Fine Arts. Claude first took up this subject in a 1634 painting, which formerly (before 1977) was in the collection of Dr. Claus Virch in Kiel (now a private collection in Texas). The Virch Collection was published for the first time by Michael Kitson in 1973. The compositional scheme and principal figures of this large painting (172 x 199; Röthlisberger 1977, No 48) dominate all the later versions. One of the fundamental works of the artist's early period, it is not recorded in the *Liber Veritatis* because the latter was started only in

1636. However, the artist reproduced it in an etching in 1634, which became known to the public much earlier than the original painting. The artist next turned to the story of Europa in 1647. This painting (93 x 118; LV 111) is now in the Utrecht Centraal Museum; previously it was in the collection of Sir Joshua Reynolds in London; it was engraved by Vivarès in 1771. Compositionally, it differs notably from the Pushkin Museum canvas. A preparatory drawing for it is in the Louvre (Röthlisberger 1968, No 640).

The most popular version of *The Rape of Europa*, painted as late as 1667, is in the Royal Collection of Buckingham Palace, London (Röthlisberger 1977, No 243). Its size (102 x 135) is almost identical to that of the Moscow canvas dated 1655, and it has the same *Liber Veritatis* number (136) because compositionally it is almost a repetition of the 1655 painting. Still, the figures in the Moscow painting are grouped in a somewhat different way, and the treatment of space is also different: the line of the horizon is lower and the space between the top of the canvas and the tree-

The Rape of Europa. Drawing. 1655.
British Museum, London.

The Rape of Europa. Drawing. 1647.
British Museum, London.

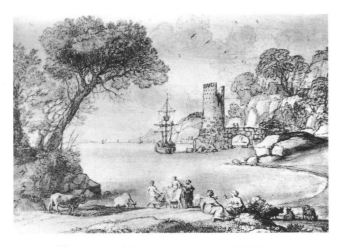

The Rape of Europa. Drawing. 1645-50.
Louvre, Paris.

78

top is greater. The figures are very much in the foreground, giving a free access into the picture's depth. The London version, which in the 18th century was in the Paris collection of the Comtesse de Bandeville, was purchased during its sale in 1787 by the antique dealer B. Lebrun. It reappeared in England at the sale of Lord Gwydyr's collection in 1829 when it was purchased for King George IV. When Smith (1837), who was unaware of the Yusupov Collection, described *The Rape of Europa* from the Buckingham Palace in his *Catalogue raisonné*, he believed the London piece to have been executed for Pope Alexander VII.

The fifth and last version of this subject, now in an English private collection, was previously in the collection of Morrison and his descendants (Basildon Park, Berkshire, England). It corresponds to the *Liber Veritatis* drawing No 144, and its composition may be likened to the missing link between the painting from the Pushkin Museum and that from Buckingham Palace (Röthlisberger 1977, No 214).

Provenance: before 1798, in the possession of the descendants of Pope Alexander VII; late 18th century, acquired by Prince Nikolai Yusupov (according to the Italian engraver Ludovico Caracciolo, in 1798 the painting was in the Yusupov palace in Rome: Caracciolo: *Libra di Verita*, Rome, 1815); 1839, brought to St. Petersburg; 1924, acquired by the Hermitage; 1924, transferred to the Pushkin Museum of Fine Arts, Moscow.

Exhibitions: 1908 St. Petersburg (No 294); 1955 Moscow (p. 42); 1956 Leningrad (p. 36); 1981 Vienna (p. 64); 1982 Moscow (No 27).

Catalogues and inventories: Cat. Pushkin Museum 1948, p. 47; *Cat. Pushkin Museum* 1957, p. 82; *Cat. Pushkin Museum* 1961, p. 112.

References: Smith 1837, pp. 250, 255, 269, 307; *Musée de prince Joussoupoff contenant les tableaux, marbres, ivoires et porcelaines qui se trouvent dans son hôtel à Saint-Pétersbourg*, St. Petersburg, 1839. No 26; Waagen 1864, p. 417; Pattison 1884, pp. 71, 94, 190, 191, 216, 218, 227, 276, 306; L. Cust: *The Royal Collection of Painting at Buckingham Palace and Windsor Castle*. London, Paris, 1905, p. 82; A. Benois, *History of World Painting of All Times*, vol. 4, St. Petersburg, 1912, p. 196 (in Russian); *State Museum Fund. Catalogue of Works of the Former Yusupov Gallery*, Petrograd, 1920, No 86 (in Russian); S. Ernst, *The Yusupov Gallery: French School*, Leningrad, 1924, pp. 2, 3 (in Russian); L. Dimier: *Histoire de la peinture française du retour de Vouet à la mort de Lebrun, 1627 à 1690*. vol. 1. Paris, Brussels, 1926. p. 78; Réau 1928, p. 85, No 587; Ernst 1929, pp. 246, 247; Röthlisberger 1958, p. 221; Röthlisberger 1961, pp. 24, 25, 276, 325-328; Röthlisberger 1977, No. 204; Kuznetsova, Georgievskaya 1979, No 7; Kuznetsova 1982, pp. 148, 149.

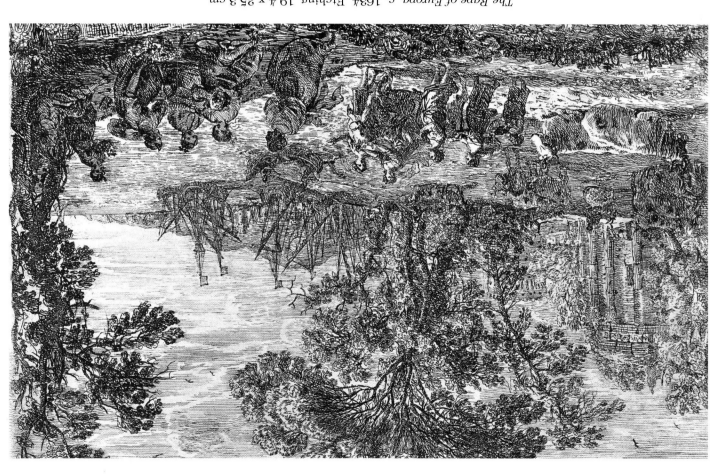

The Rape of Europa. c. 1634. Etching, 19.4 x 25.3 cm.
Hermitage, St. Petersburg.

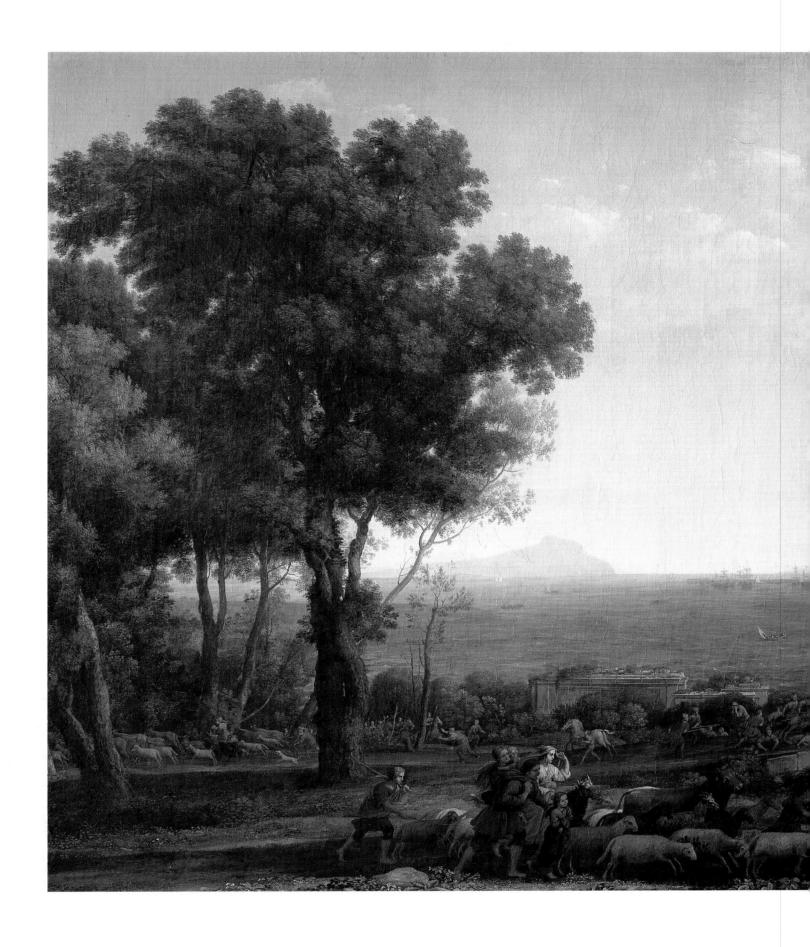

8. BATTLE ON A BRIDGE. (1655)

Oil on canvas. 100 x 137 cm.
Signed and dated on the stone, bottom right: *Claudio G ...*
V Romae 1655
Pushkin Museum of Fine Arts, Moscow
Inv. No 1283
Companion piece to *The Rape of Europa* (No 7)
LV 137 (companion to LV 136)

The subject was formerly identified by some scholars as the Battle between Constantine and Maxentius, two rivals who in 312 fought a battle for the Byzantine throne on the banks of the Tiber near the Milvian Bridge (known as Ponte Molle): Constantine emerged victorious and Maxentius perished in the Tiber.

The *Battle* was commissioned by Cardinal Fabio Chigi as a companion piece to *The Rape of Europa*. The inscription on the reverse of the corresponding *Liber Veritatis* drawing reads, Fai pp Alessandre ("made for Pope Alexander"). This means that the *Battle* was painted directly after *The Rape of Europa*. Its copy (104 x 139), which is identical to the Pushkin Museum canvas, was signed and dated by the artist in the same year, 1655. This canvas (now in the Virginia Museum, Richmond, Vir.) was purchased in 1960 by George Wildenstein, who had bought it from the heirs of the Earl of Leitrim, Ireland. A drawing made by the artist for this composition has remained in the Wildenstein Collection; it is a companion to *The Rape of Europa* — a drawing in Berlin. The early version of *Battle on a Bridge* which corresponds to LV 27 (Röthlisberger 1977, No 87) is dated 1637. Its composition bears only a general

Coast Scene with Battle on a Bridge. 1655.
Virginia Museum, Richmond, Virginia.

resemblance to the Pushkin Museum canvas, chiefly because it is oriented in the opposite direction. In the first half of the 19th century this early version was in the possession of Oldfield Bowles (Smith 1837, p. 467); its next owner was Viscount Weymouth (Norton Hall, England).

Provenance: See No 7.

Exhibitions: 1908 St. Petersburg (p. 53); 1955 Moscow (p. 42); 1956 Leningrad (p. 35).

Catalogues and inventories: Cat. Pushkin Museum 1961, p. 113.

References: Smith 1837, pp. 266, 467; *Musée de prince Joussoupoff contenant les tableaux, marbres, ivoires et porcelaines qui se trouvent dans son hôtel à Saint-Pétersbourg.* St. Petersburg, 1839. No 8; Waagen 1864, p. 47; Pattison 1884, pp. 71, 72, 190, 218, 227; A. Benois, *History of World Painting of All Times*, vol.4, St. Petersburg, 1912, p. 196 (in Russian); *State Museum Fund. Catalogue of Works of the Former Yusupov Gallery*, Petrograd, 1920, No 84 (in Russian); S. Ernst, The *Yusupov Gallery: French School*, Leningrad, 1924, p. 6 (in Russian); L. Dimier: *Histoire de la peinture française du retour de Vouet à la mort de Lebrun. 1627 à 1690.* vol. 1. Paris, Brussels, 1926. p.761; Réau 1928, p. 75, No 590; Ernst 1929, pp. 246, 247; Röthlisberger 1961, vol. 1, pp. 300-302; Röthlisberger 1977, No 205; Kuznetsova, Georgievskaya, 1979, No 8; Kuznetsova 1982, p. 150.

Battle on a Bridge. Drawing. *c.* 1665. George Wildenstein Collection, New York.

Battle on a Bridge. Drawing. 1655. British Museum, London.

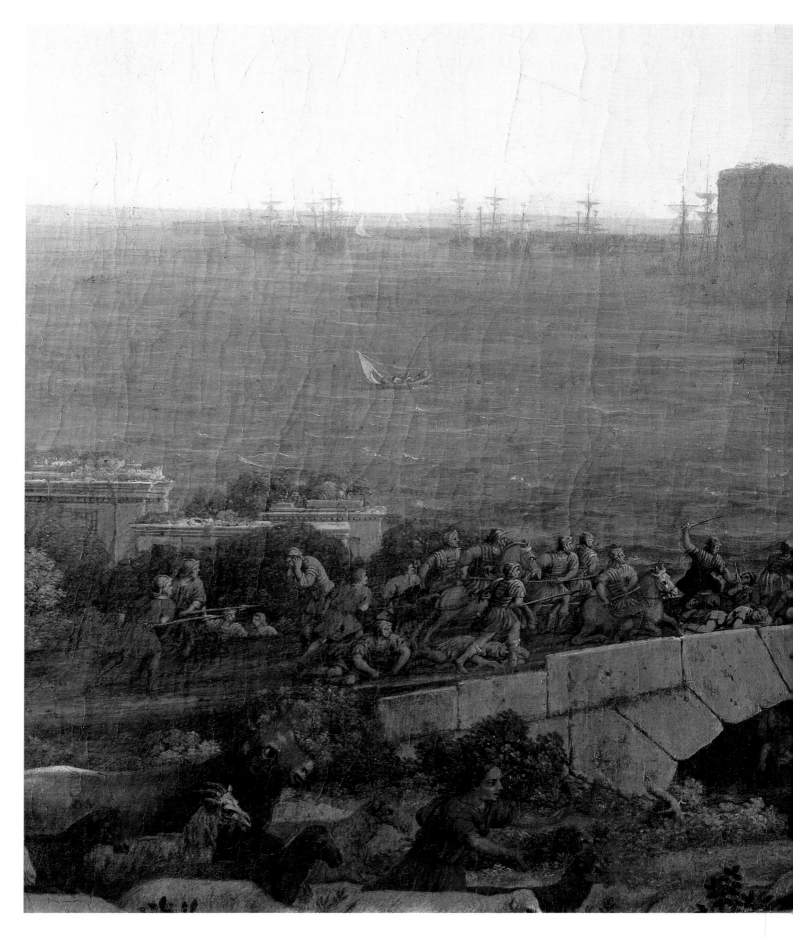

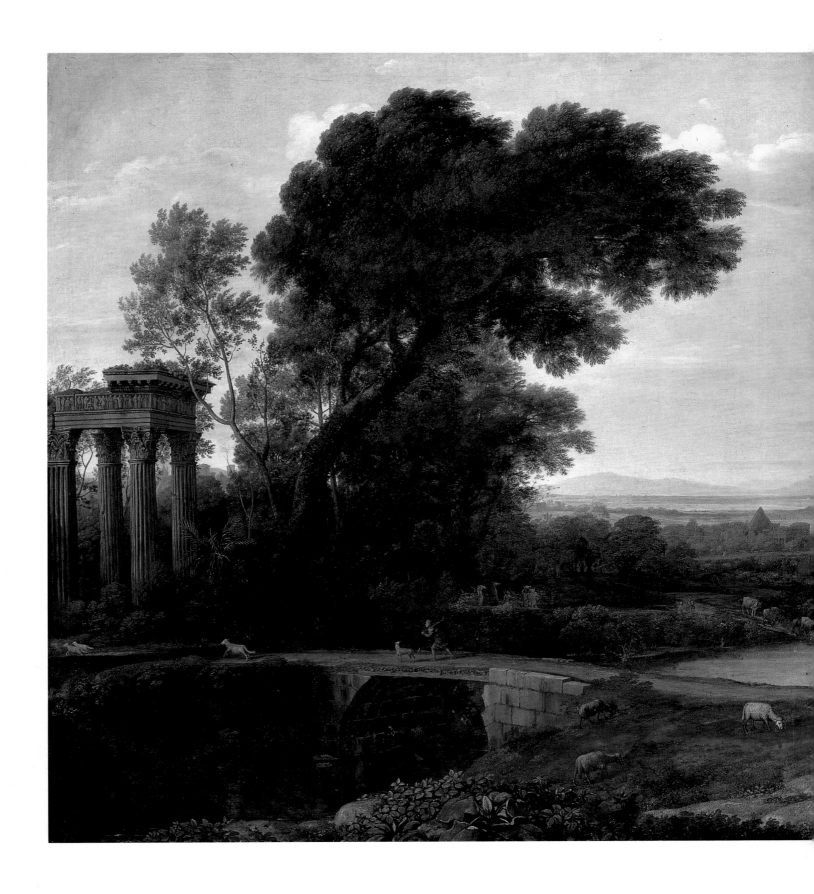

96

10. NOON (LANDSCAPE WITH THE REST ON THE FLIGHT INTO EGYPT)
(1661)

Oil on canvas. 116 x 159.6 cm.
Signed and dated, bottom right: *CLAUDIO INF. ROMAE*
1661
Hermitage, St. Petersburg
Inv. No 1235
Companion piece to *Evening (Landscape with Tobias and the Angel)*, No 11
Source: Matthew 2:13-15
LV 154 (companion to LV 160)

In the catalogue of the Kassel Gallery (*Verzeichniss* 1783) owned by the Electors of Hesse-Kassel the painting was listed as one of four Claudes in the series *Four Times of the Day*. It was under this title that they entered the Hermitage collection in 1815.

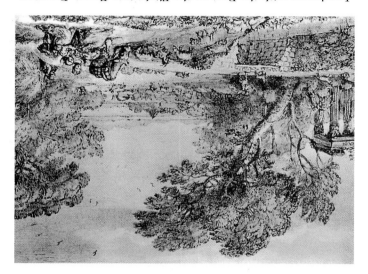

Landscape with the Rest on the Flight into Egypt. Drawing. c. 1660. Boymans-van Beuningen Museum, Rotterdam.

Landscape with the Rest on the Flight into Egypt. Drawing. British Museum, London.

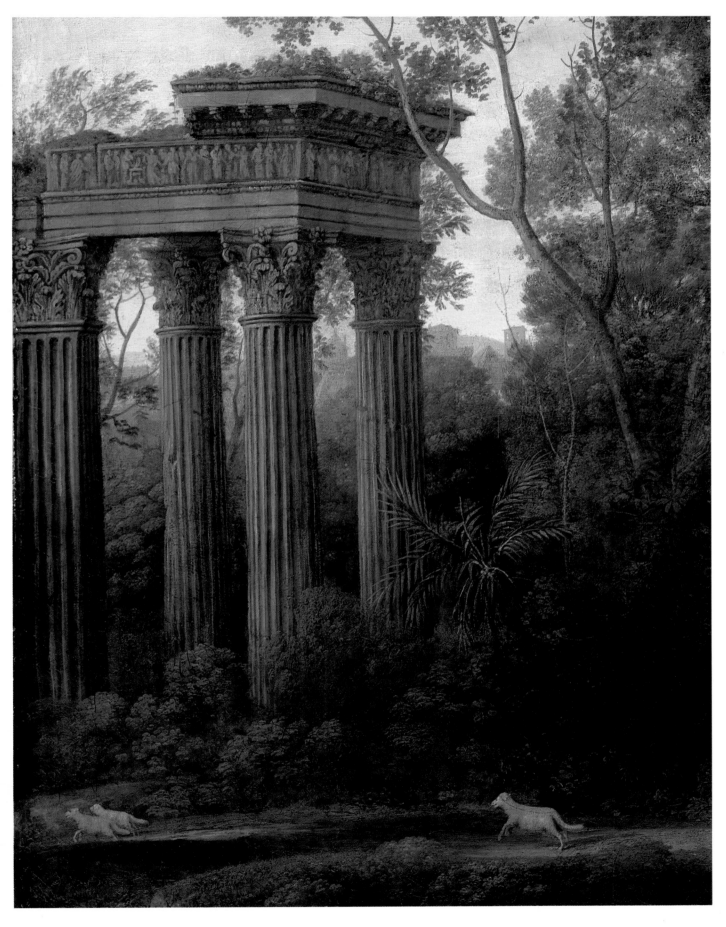

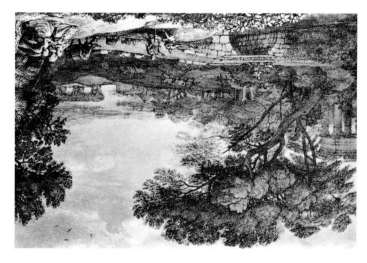

Rest on the Flight into Egypt. Drawing. 1660. Albertina, Vienna.

Landscape Drawing. 1660. British Museum, London.

Röthlisberger (1961) believes that these are two pairs of pendants, each of them marked by compositional affinity and congenial subject matter. The first pair, Noon (*The Rest on the Flight into Egypt*) and *Evening* (*Tobias and the Angel*), has as a common feature the figure of the guardian angel. The other pair, *Morning* (*Jacob, Rachel and Leah at the Well*) and *Night* (*Jacob Wrestling with the Angel*), have a common subject — the story of Jacob. Chronologically, the two scenes follow the sequence of the biblical events. But, according to Röthlisberger, there are no apparent links between the pairs and, moreover, Claude never created painting series around the popular Baroque concept of the four times of the day.

Yelena Kozhina (*Gemälde aus der Ermitage und dem Puschkin-Museum. Kunsthistorisches Museum. Wien.* Exhibition catalogue, Vienna, 1981, pp. 68-71) assumes that the four paintings were not originally conceived as a set; but since they were all painted for the same person, they became a series in the process of the artist's work. The first piece, *The Rest on the Flight into Egypt*, is not tied to any particular time of the day, but *Tobias and the Angel* accurately follows the biblical source where the scene is set in the evening. The Bible states the sun is high in the episode presented in *Morning* (*Jacob, Rachel and Leah at the Well*); but knowing that the four paintings were meant to be displayed next to each other, the artist may have decided to set the scene at dawn for the sake of variety. Finally, *Jacob Wrestling with the Angel* may be interpreted as a night-time scene, in full accordance with the Bible, and indeed night is the only time that does not occur in the other three pieces.

It should be noted that at about the same time the artist executed for the same customer (Bishop of Ypres) another pair of landscapes which have no bearing on the four Hermitage paintings and are at present in England: *Apollo Guarding the Herds of Admetus* (1660; Wallace Collection, London) and *Landscape with Mercury and Battus* (1663, Collection of the Duke of Devonshire, Chatsworth, England).

In all four paintings the atmospheric medium is rather vague and transient, and this provoked a confusion of their titles: *Morning* (*Jacob, Rachel and Leah at the Well*) was interpreted by Smith (1837) as *Noon*, and by Friedländer (1921) as *Morning*; *Tobias and the Angel* and was referred to now as *Morning* and then as *Evening*. Röthlisberger (1961) was right when he said that the four paintings received their time-of-the-day designations only at the end of the 18th century.

That these are two pairs of paintings is warranted first of all by their compositions, which are based on the pendant principle; the artist selected two different approaches, one for each pair. *The Rest on the Flight to Egypt* (1661) and *Tobias and the Angel* (1663) were the first to be executed; there followed *Jacob, Rachel and Leah* (1666) and *Jacob Wrestling with the Angel* (1672). Characteristically, the artist signed only the first piece in each pair.

There are preparatory drawings for *The Rest on the Flight into Egypt* in the Boymans-van Beuningen Museum in Rotterdam, in the British Museum in London (Hind, 1926, No 254) and the Albertina in Vienna. In general outline the composition corresponds to the *Liber Veritatis* drawing No 155 (1661). The artist evolved in this painting motifs from his previous works: *Village*

Festival (1642; Staatliche Museen, Berlin), *Village Festival* (1643-1644; formerly in the collection of the Earl of Jersey, destroyed 1945) and the *Pastoral Landscape* (1645; City Museum and Art Gallery, Birmingham).

Smaller-size copies of the four pieces were made in 1812 at Malmaison by Carlo Ranucci (now in the Museum at Mainz).

The series was commissioned by Henri van Halmale (1624-1676), dean of Antwerp Cathedral, who in September 1672 became Bishop of Ypres. He was one of the artist's principal patrons. We do not know when the paintings came into the gallery of the Electors of Hesse-Kassel, but they are listed in the 1783 catalogue of this collection. At the time of the Napoleonic Wars the Kassel treasures were taken to Paris for Napoleon's museum. The Elector tried to hide 48 of the finest paintings but they were seized by the French general Lagrange and so did not find their way into official French galleries, being used to augment Empress Josephine's private collection at Malmaison. Because of this they were not returned to the Elector of Hesse-Kassel under the edict on the restoration of requisitioned works of art and remained at Malmaison. In 1815 Emperor Alexander I of Russia purchased them for the Hermitage.

Provenance: acquired by the Hermitage in 1815 from the collection of the Empress Josephine at Malmaison.

Exhibitions: 1956 Leningrad (p. 35); 1975-1976 Washington-Houston (No 9); 1987-1988 New Delhi (p. 43, No 34).

Catalogues and inventories: Cat. 1797, No 4226; *Inv.* 1859, No 3421; *Cat.* 1863-1916, No 1429; *Cat.* 1958, pp. 304, 305; *Cat.* 1976, p. 200.

References: Verzeichniss 1783, p. 6, No 17; Smith 1837, No 154, pp. 276, 277; *Livret* 1838, XL, No 7, p. 391; Waagen 1864, p. 294; Pattison 1884, p. 220, 245; Bouyer 1905, p. 69, 70; Friedländer 1921, pp. 90-95; Réau 1928, No 216; Courthion 1932, pp. 32, 49, fig 58, 59; Weisbach 1932, pp. 319, 320: Christoffel 1942, p. 153; Hetzer 1947, p. 16; Sterling 1957, pp. 29, 30; Röthlisberger 1958, p.222; Röthlisberger 1960, pp. 210, 218; Röthlisberger 1961, vol. 1, pp. 361-365, fig 258, 333; Röthlisberger 1968, vol. 1, p. 319, vol. 2, No 853-857; Chatelain 1973, pp. 179-181; Röthlisberger 1977, No. 224, p. 116.

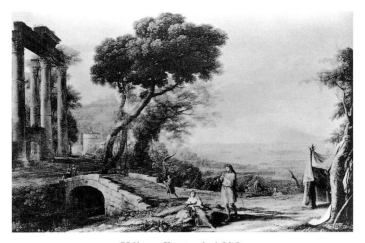

Village Festival. 1642.
Staatliche Museen, Berlin.

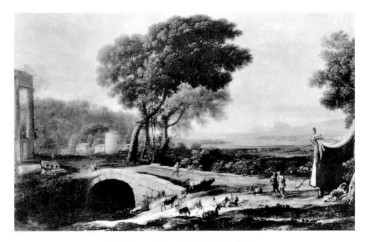

Village Festival. 1643-44.
Destroyed 1945.

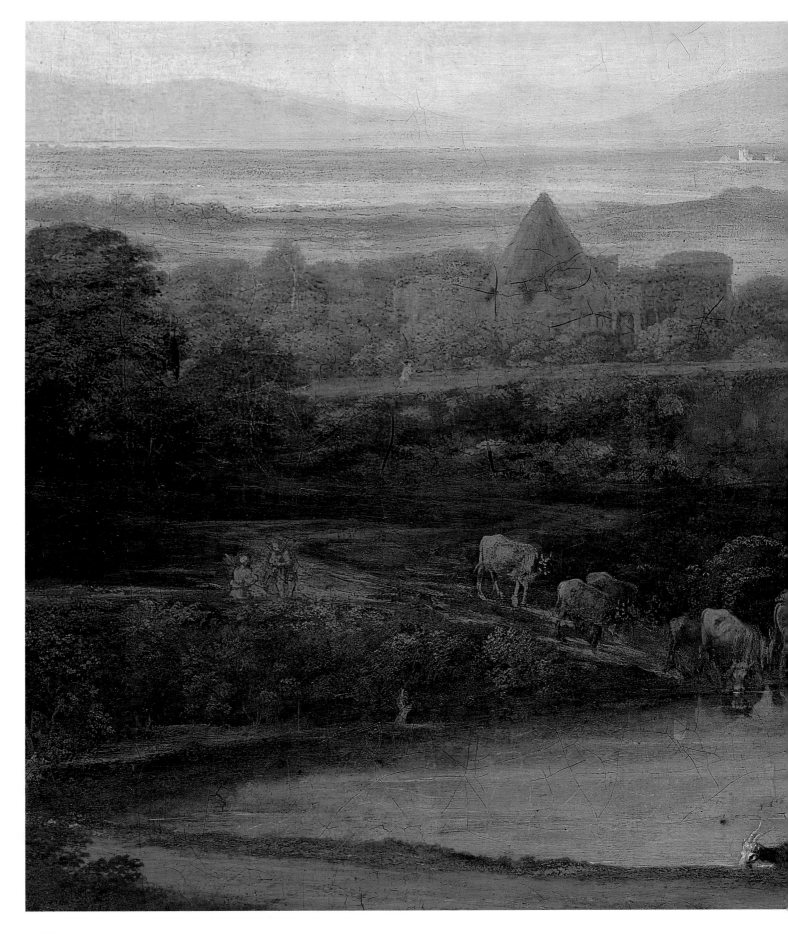

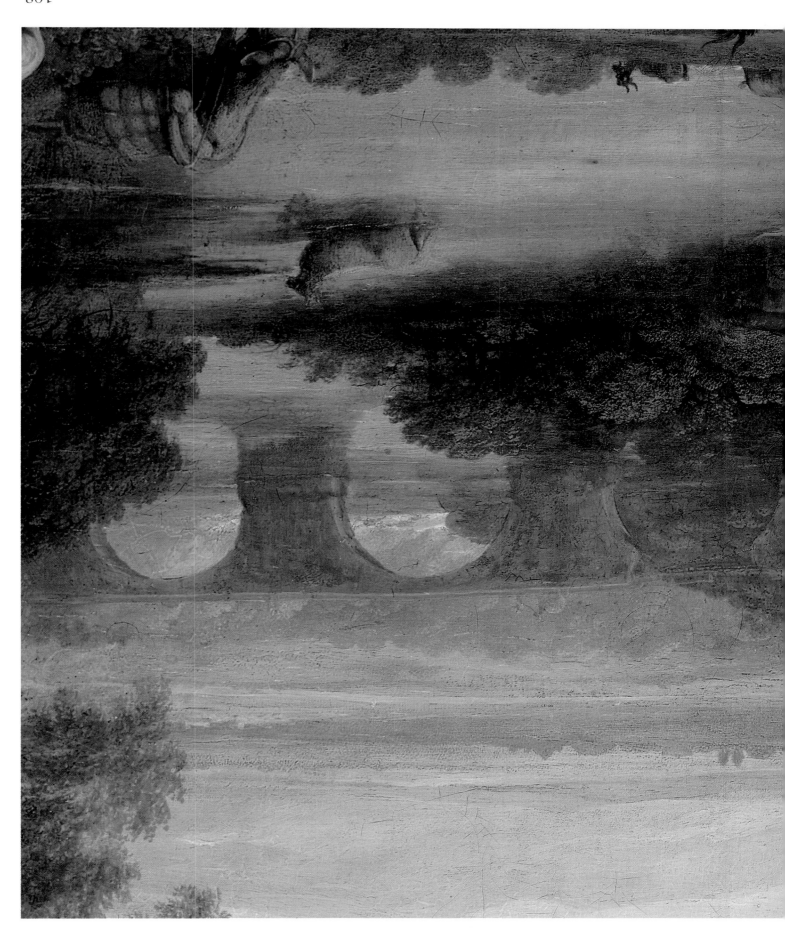

104

The Goatherd. 1663. Etching. 16.6 × 21.3 cm.
Hermitage, St. Petersburg

The Cowherd. c. 1636. Etching. 12.6 × 19.2 cm.
Hermitage, St. Petersburg.

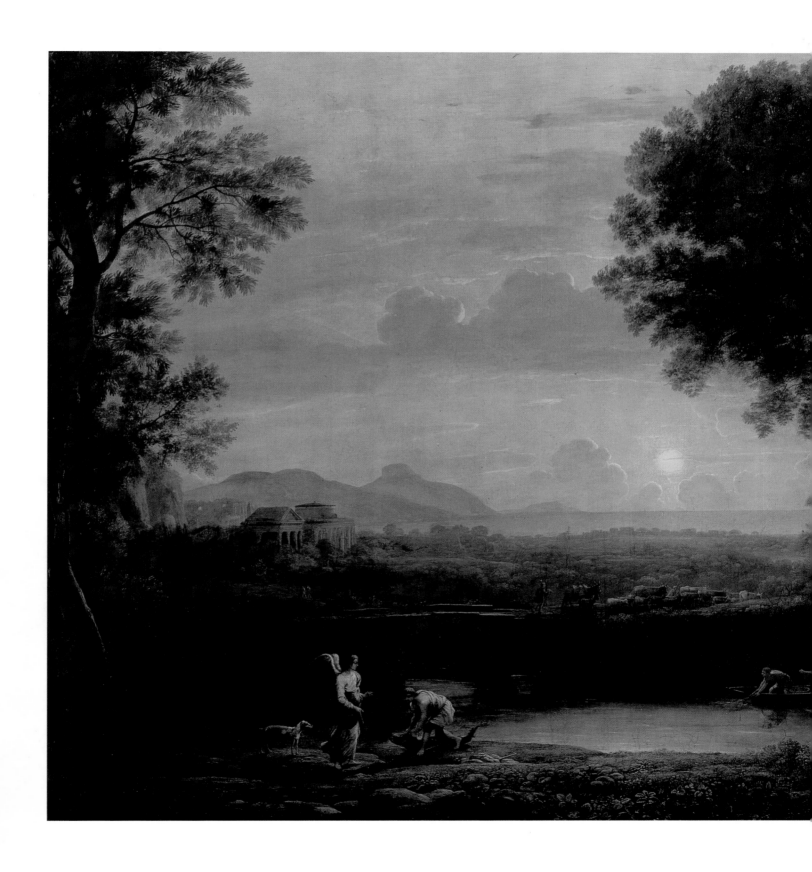

11. EVENING (LANDSCAPE WITH TOBIAS AND THE ANGEL). (1663)

Oil on canvas, 116 x 159.5 cm.
Hermitage, St. Petersburg
Inv. No 1236
Companion piece to *Noon* (*Landscape with the Rest on the Flight into Egypt*), No 10
Source: Book of Tobit 6:2-5
LV 160 (companion to LV 154)

Röthlisberger (1961) cites a letter written by Cornelis de Wael, Halmale's Roman agent, to his patron Antonio Ruffo in Messina. De Wael mentions a painting commissioned from Claude Lorrain by a patron in Flanders. Most likely, the painting in question is the Hermitage's *Tobias and the Angel*, for although the artist was then working on two canvases for a Flemish client, it is the Hermitage piece that most fully corresponds to the size stated in the letter (*Bolletino d'Arte*, X, 1916, p. 169). The figures of the fishermen, Tobias and the angel can be seen in *Tobias and the Angel* (1639, Prado, Madrid) and *The Flight into Egypt* (1660, Thyssen-Bornemisza Collection, Madrid).
Preparatory drawings: Staatliche Graphische Sammlung, Munich; British Museum, London (Hind 1926, No 286). The composition occurs in an earlier, 1662, drawing (LV 156).

Provenance: See No 10.

Exhibitions: 1935 Moscow (p. 43); 1956 Leningrad (p. 35); 1981 Vienna (pp. 68-71).

Catalogues and inventories: Cat. 1797, No 4227; *Inv.* 1859, No 3430; *Cat.* 1863-1916, No 1428; *Cat.* 1958, p. 305; *Cat.* 1976, p. 200.

Landscape with Tobias and the Angel. Drawing, 1663.
British Museum, London.

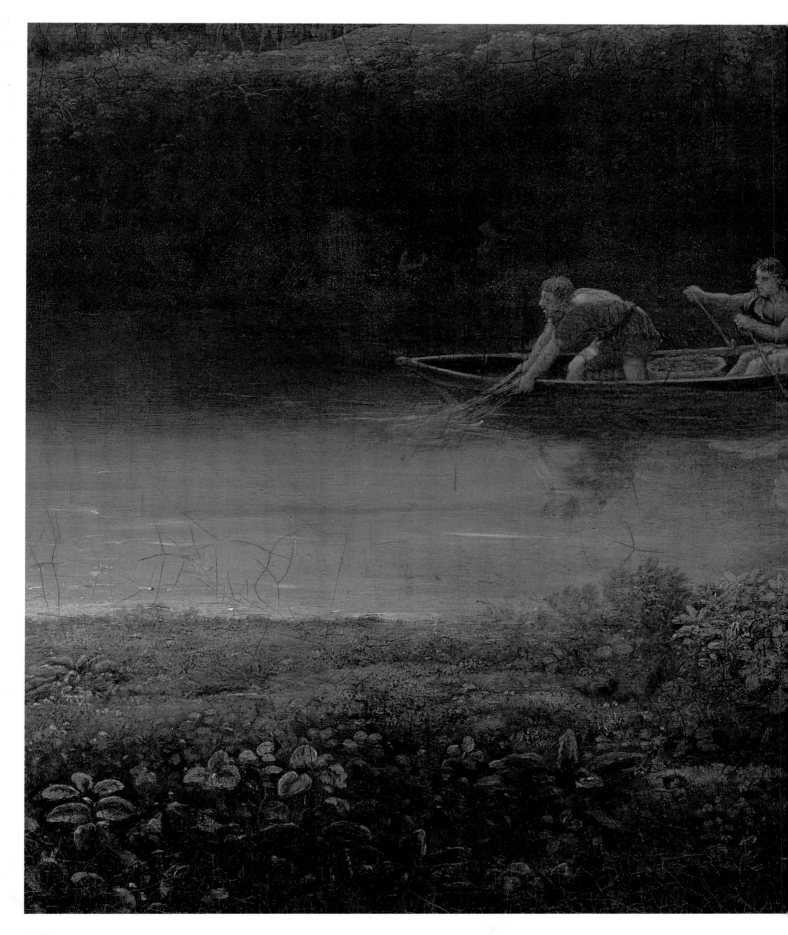

Tobias and the Angel.
Drawing, 1660-63.
British Museum, London.

Tobias and the Angel.
Drawing, 1660-63.
British Museum, London.

Tobias and the Angel.
Drawing, 1663.
Staatliche Graphische
Sammlung, Munich.

References: Verzeichniss 1783, p. 10, No 32. Smith 1837, No 160, pp. 280, 281. *Livret* 1838, p. 391. Waagen 1864, p. 295, No 1430. Pattison 1884, pp. 220, 245. Bouyer 1905, pp. 69, 70. Friedländer 1921, pp. 93-96, fig. on p. 93. Réau 1928, No 218. Courthion 1932, fig. 60, pp. 32, 49. Weisbach 1932, pp. 319, 320. Christoffel 1942, p. 154. Hetzer 1947, p. 16. Sterling 1957, pp. 26, 28. Röthlisberger 1958, p. 222. Röthlisberger 1960, pp. 210, 218. Röthlisberger 1961, vol. 1, pp. 379-381, vol. 2, fig. 263. Röthlisberger 1968, vol. 1, p. 319, vol. 2, Nos 913-917. Chatelain 1973, pp. 179-181. Röthlisberger 1977, No 231.

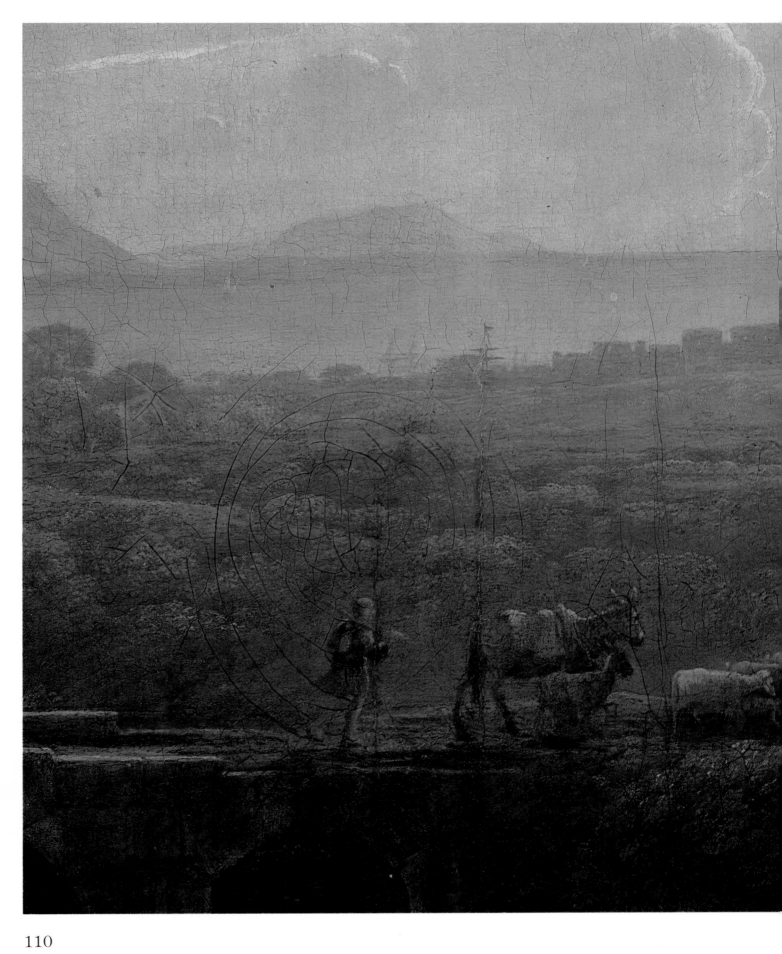

110

The Flight into Egypt. 1660.
Thyssen-Bornemisza Collection,
Madrid.

*Landscape with Tobias
and the Angel.* 1639.
Prado, Madrid.

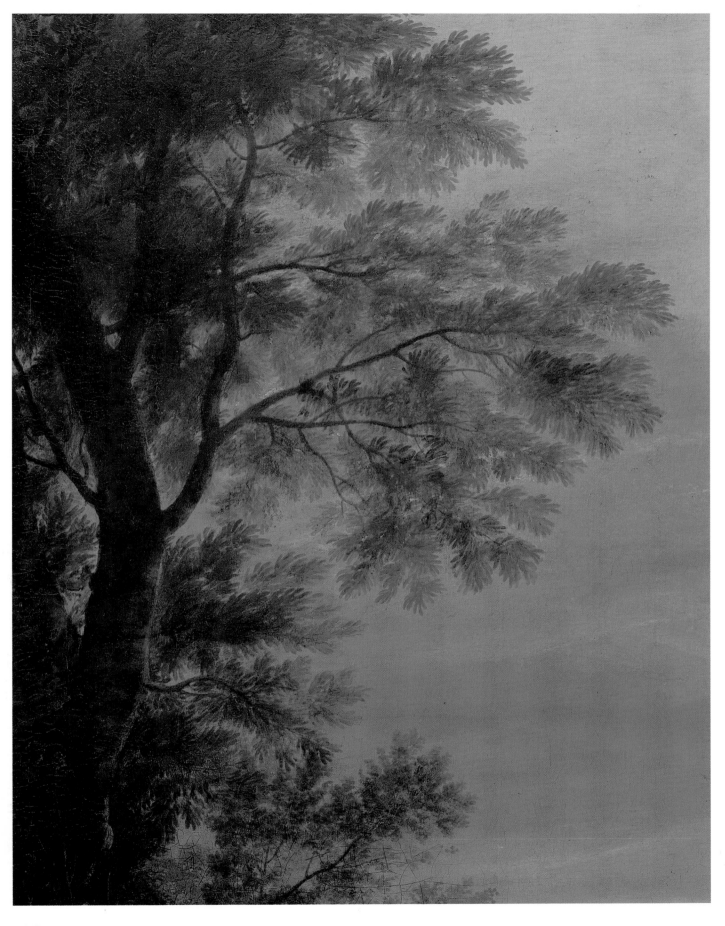

112

12. MORNING (LANDSCAPE WITH JACOB, RACHEL AND LEAH AT THE WELL). (1666)

Oil on canvas. 113 x 157 cm.
Signed and dated, lower left corner:
CLAVDIO INV ROMAE 1666
Hermitage, St. Petersburg
Inv. No 1234
Companion piece to *Night (Landscape with Jacob Wrestling with the Angel)*, No 13
Source: Genesis 29:2-10 (the text makes no mention of Leah's presence at the well)
LV 169 (companion to LV 181)

Claude Lorrain drew on this biblical story for several of his compositions, always setting the central figures against an isolated tree: *Landscape with Jacob, Laban and His Daughters* (1654; Collection of the Earl of Egremont, Petworth

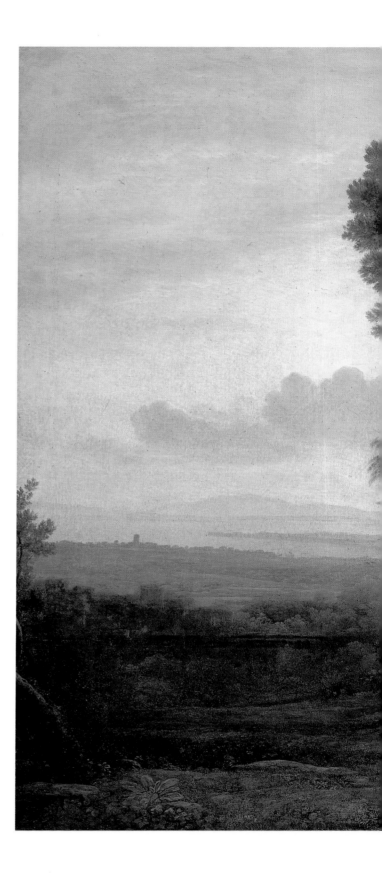

Jacob, Rachel and Leah at the Well. Drawing. 1667.
British Museum, London.

Jacob at the Well. Drawing. c. 1665.
British Museum, London.

116

Jacob at the Well. Drawing. *c.* 1665.
British Museum, London.

Jacob at the Well. Drawing. 1665.
National Gallery of South Africa, Cape Town.

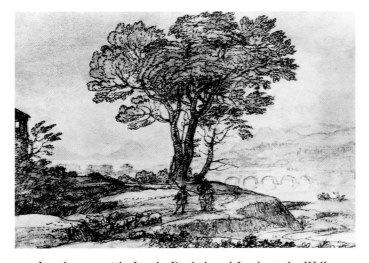

Landscape with Jacob, Rachel and Leah at the Well.
Drawing. 1665. National Gallery of Victoria, Melbourne.

House, England), *Landscape with Jacob, Laban and His Daughters* (1659; Norton Simon Foundation, Los Angeles), *Landscape with Jacob, Laban and His Daughters* (1676; Dulwich College Gallery, London).
Preparatory drawings: British Museum, London (Hind 1926, Nos 270, 272); National Gallery of South Africa, Cape Town; National Gallery of Victoria, Melbourne.

Provenance: See No 10.

Exhibitions: 1955 Moscow (p. 43); 1956 Leningrad (p. 35); 1969 Budapest (No 15); 1972 Warsaw - Prague - Budapest - Dresden (No 58); 1981 Vienna (p. 72).

Catalogues and inventories: Cat. 1797, No 4225; Inv. 1859, No 3420; *Cat.* 1863-1916, No 1428; *Cat.* 1958, p. 304; *Cat.* 1976, p. 200.

References: Verzeichniss 1783, p. 3, No 8; Smith 1837, No 169, pp. 286, 287; *Livret* 1838, XL, No 6, p. 391; Waagen 1864, p. 294, 295, No 1428; Pattison 1884, pp. 96, 245, 290; Bouyer 1905, pp. 69, 70; Friedländer 1921, pp. 93, 95; Réau 1928, No 216; Courthion 1932, pp. 32, 49, fig. 57; Weisbach 1932, pp. 319-320; Christoffel 1942, p. 152; Hetzer 1947, p. 17; Sterling 1957, p. 26; Röthlisberger 1958, p. 222; Röthlisberger 1960, pp. 210, 218; Röthlisberger 1961, vol. 1, pp. 399-401, vol. 2, fig 272, 273; Röthlisberger 1968, vol. 1, pp. 356-358, vol. 2, Nos 959-965; Chatelain 1973, pp. 179-181; Röthlisberger 1977, No 240.

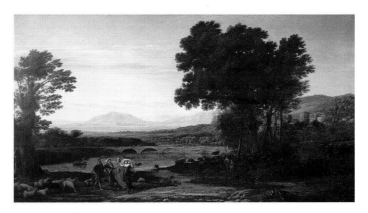

Landscape with Jacob, Laban and His Daughters. 1654.
Collection of the Earl of Egremont,
Petworth House, England.

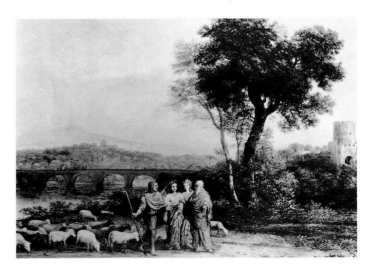

Landscape with Jacob, Laban and His Daughters. 1659.
Norton Simon Foundation, Los Angeles.

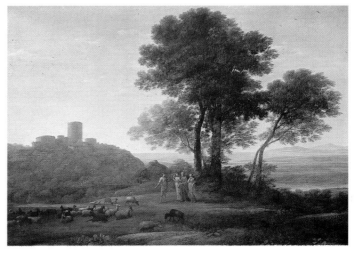

Landscape with Jacob, Laban and His Daughters. 1676.
Dulwich College Gallery, London.

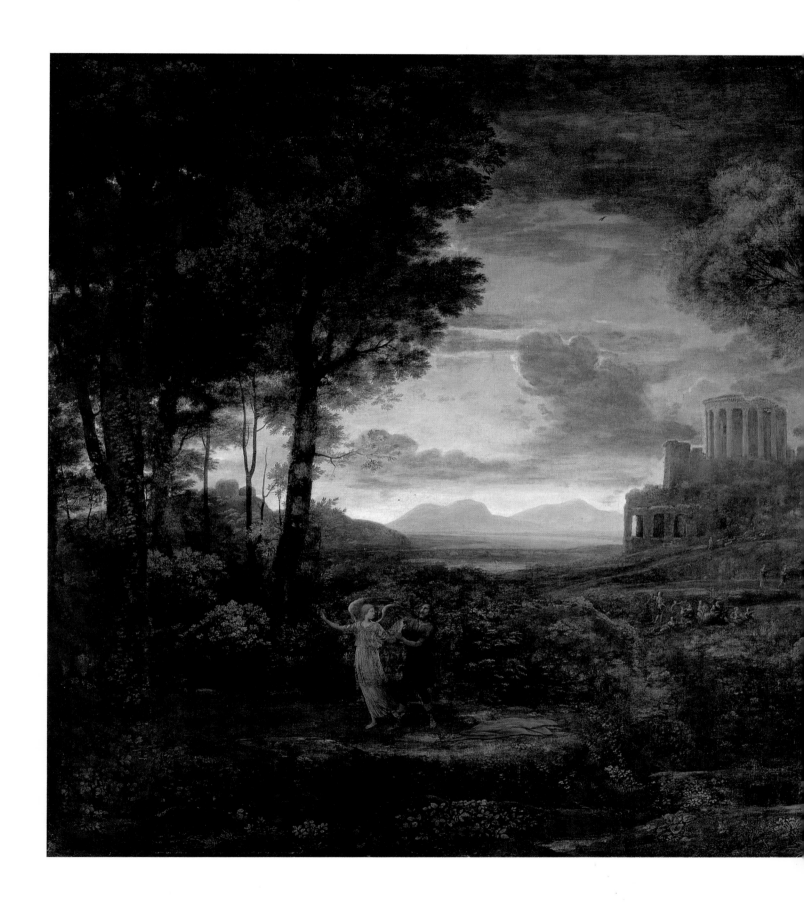

124

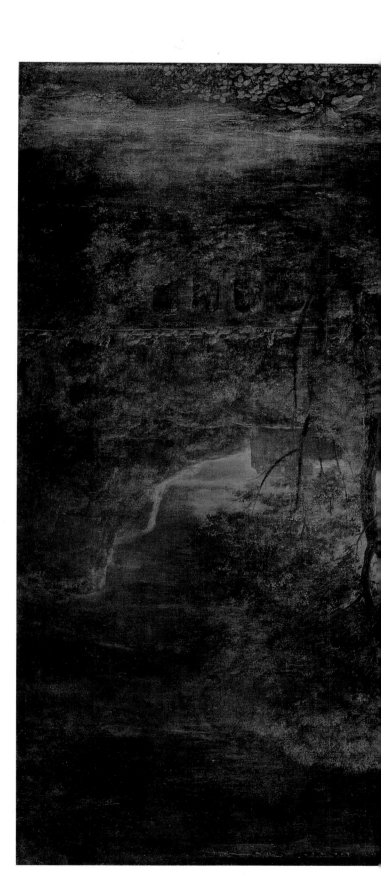

13. NIGHT (LANDSCAPE WITH JACOB WRESTLING WITH THE ANGEL). (1672)

Oil on canvas. 113 x 157 cm.
Hermitage, St. Petersburg
Inv. No 1237
Companion piece to *Morning (Landscape with Jacob,
Rachel and Leah at the Well)*, No 12
Source: Genesis 32:24-26
LV 181 (companion to LV 169)

Preparatory drawings: British Museum, London
(Hind 1926, No 292); Collection of the Duke of
Devonshire, Chatsworth, Fitzwilliam Museum,
Cambridge.

Provenance: See No 10.

Exhibitions: 1956 Leningrad (p. 35).

Jacob and the Angel, Drawing, 1670-71.
British Museum, London.

Jacob and the Angel, Drawing, 1670-71.
British Museum, London.

Catalogues and inventories: Cat. 1797, No 4228; Inv. 1859, No 3423; Cat. 1863-1916, No 1431; Cat. 1958, p. 304; Cat. 1976, p. 200.

References: Verzeichniss 1783, p.13, No 40; Smith 1837, No 181, pp. 294, 295; Livret 1838, XL, No 9, p. 391; Waagen 1864, pp. 294, 295; Pattison 1884, p.220; Bouyer 1905, pp. 69, 70; Friedländer 1921, pp. 93-95; Réau 1928, No 218; Courthion 1932, pp. 32, 49, fig 61, 62; Weisbach 1932, p. 320; Christoffel 1942, p. 155; Hetzer 1947, p. 17; Sterling 1957, p. 27; Röthlisberger 1958, p. 222; Röthlisberger 1960, p. 210; Röthlisberger 1961, vol. 1, pp. 426-428, vol. 2, fig. 295; Röthlisberger 1968, vol. 1, pp. 387-389, vol. 2, fig 1048-1056; Chatelain 1973, pp. 179-181; Röthlisberger 1977, No 257, p. 121.

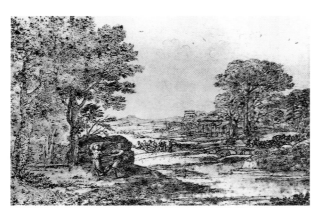

Jacob and the Angel.
Drawing. 1671.
Collection of the Duke
of Devonshire,
Chatsworth, England.

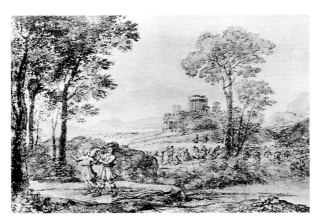

Jacob and the Angel.
Drawing. 1671.
Fitzwilliam Museum,
Cambridge.

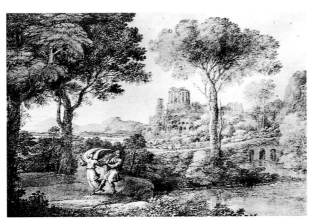

Jacob and the Angel.
Drawing. 1672.
Louvre, Paris.

126

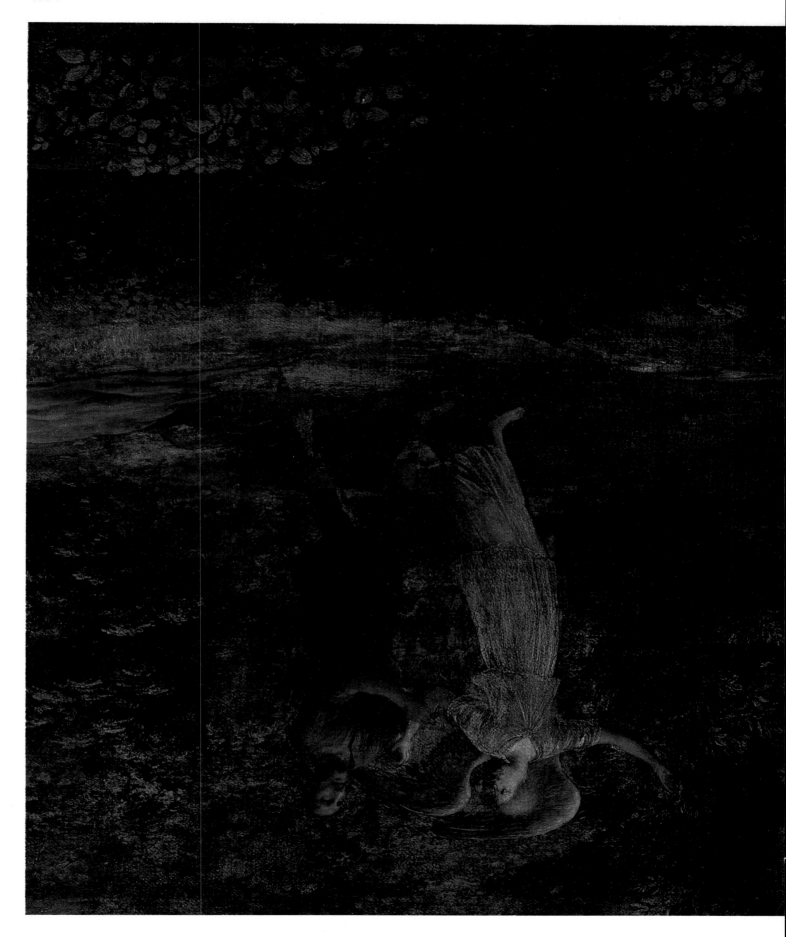

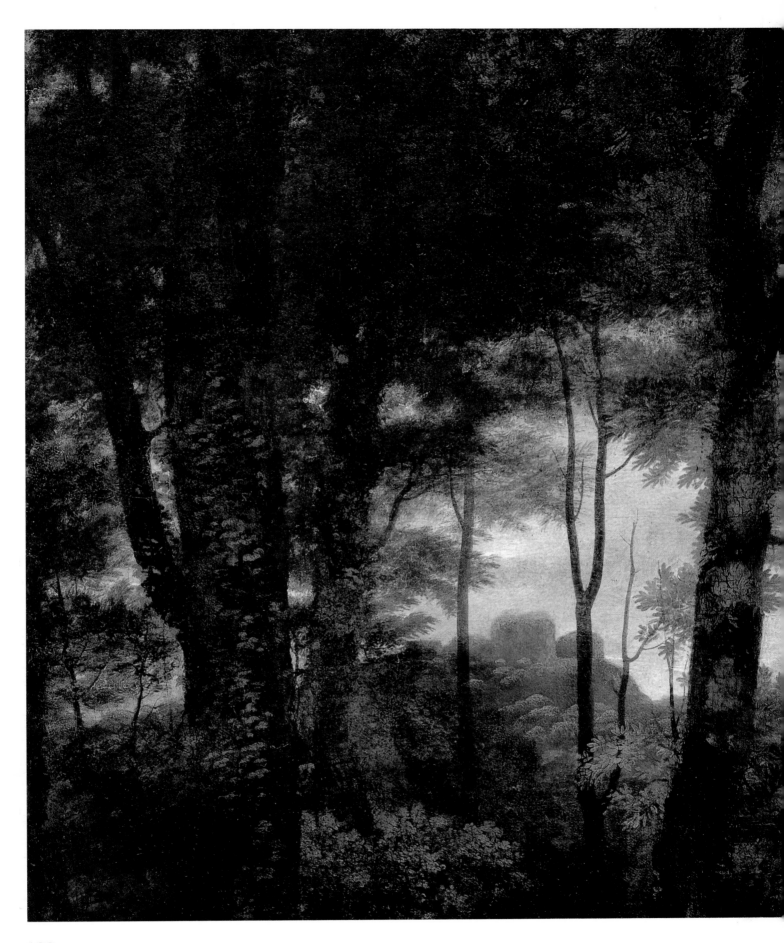

128

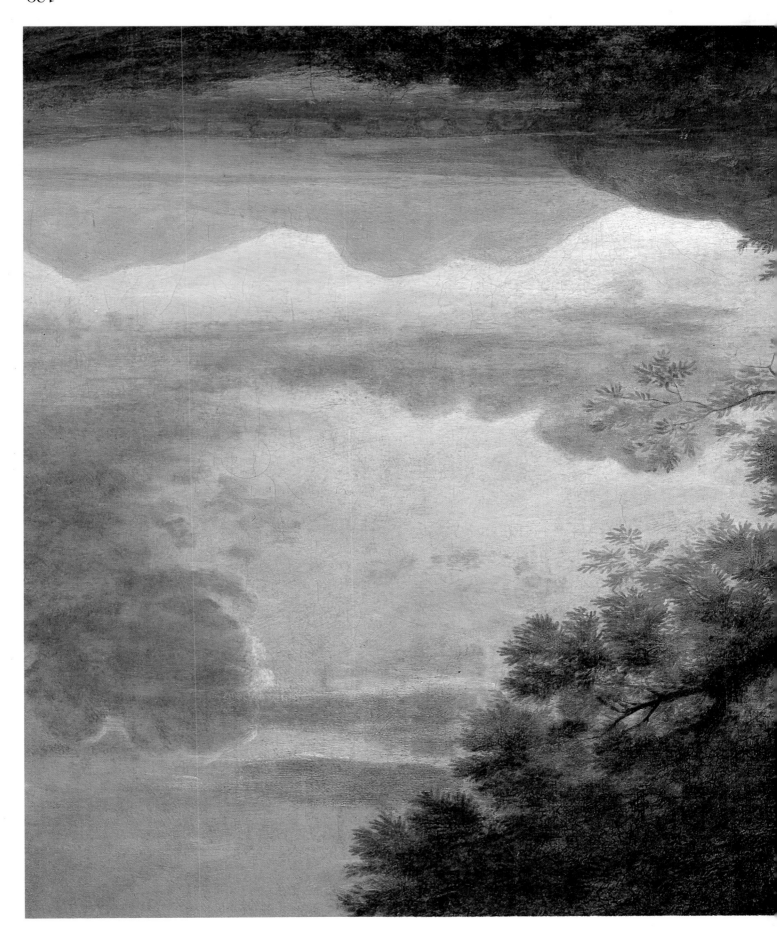

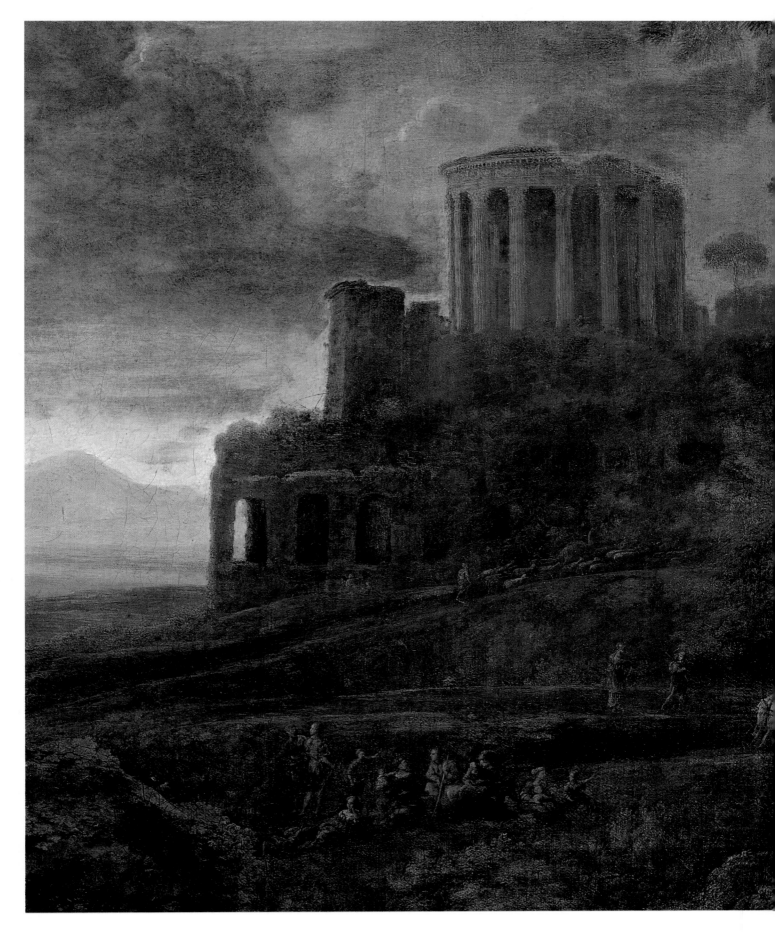

130

14. LANDSCAPE WITH DANCING FIGURES. (1669)

Oil on canvas. 102 x 134 cm.
Hermitage, St. Petersburg
Inv. No 6552

The date 1669 is based on the engraving executed by Chatelain and Vivarès in 1742 when the date on the canvas was still legible.

There is no corresponding drawing in the *Liber Veritatis*. Röthlisberger (1961) thinks that it may have been on one of the now lost LV sheets that covered the period 1668 to 1672. The composition is analogous to the earlier *Landscape with Country Dance* (1637; Collection of the Earl of Yarborough, Brocklesby Park, Lincolnshire, England), though some of the details differ. The original composition of 1637 reappears in general outline in *The Village Fête* (1639; Louvre, Paris) and a 1638 etching (A. Blum, *Les Eaux-fortes de Claude Gellée*. Paris, 1923, No 35). The number of figures in the Hermitage piece, their arrangement and poses are in accord with the etching. The absence of a corresponding *Liber Veritatis* drawing may be explained by the fact that both the composition and the figures had already been recorded by the artist, and he may have decided to dispense with yet another drawing. In contrast to the 1637 painting and the etching, both of which have figures in the *bambocciata* style, the Hermitage canvas presents idealized figures in keeping with Claude's later style. Some of the figures can be traced to the peasants in

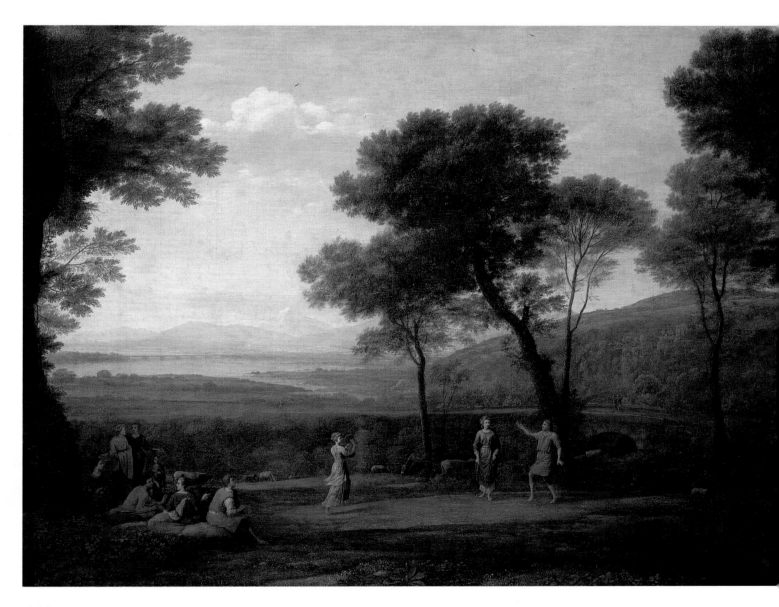

The Village Fête. 1639.
Louvre, Paris.

Landscape with Dancing Satyrs and Nymphs. 1646.
National Museum of Western Art, Tokyo.

Landscape with Country Dance. 1637. Collection of the Earl
of Yarborough, Brocklesby Park, Lincolnshire, England.

Landscape with Country Dance. 1640.
Collection of the Duke of Bedford, England.

Landscape with Dancers (1637, Uffizi, Florence),
Landscape with Villagers Dancing (1637,
Collection of the Duke of Westminster, London)
and *Landscape with Dancing Figures* (1646,
private collection, London).

Provenance: 1742-1773, Collection of the Duke of Kingston;
1776, the Duke's widow took the collection to St. Petersburg
and the paintings were kept in Count Cherryshov's mansion;
1800, Collection of Count A. Stroganov; 1930, received by
the Hermitage with the Stroganov Collection.

Exhibitions: 1956 Leningrad (p. 35); 1972 Dresden (p. 72,
No. 25); 1973 Warsaw (No 2).

Catalogues and inventories: Cat. 1958, p. 307; Cat. 1976, p.
200.

*References: Catalogue raisonné des tableaux qui composent
la collection du comte A. Stroganoff,* St. Petersburg, 1800, No
9, Smith 1837, No 338, p. 355, L. Dussieux: *Les Artistes*

français à l'étranger. Paris, 1856. p. 581; Ernst 1929, p. 252; V. Gerz, "Claude Lorrain, *Landscape with Dancing Figures*: the Painting and the Print", *Proceedings of the Hermitage Museum* (Leningrad), 12, 1957, p. 37 (in Russian); Röthlisberger 1961, vol. 1, pp. 476, 477, vol. 2, fig. 281; Röthlisberger 1977, No 249, p. 119.

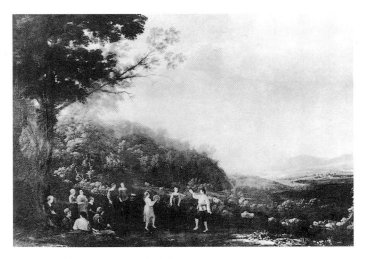

Landscape with Villagers Dancing. 1637.
Collection of the Duke of Westminster, London.

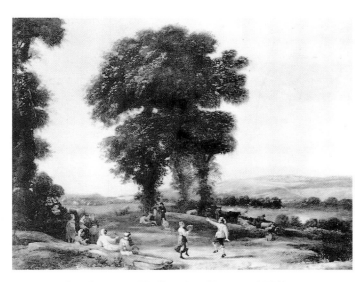

Landscape with Dancing Figures. 1637.
Rafael Valls Gallery, London.

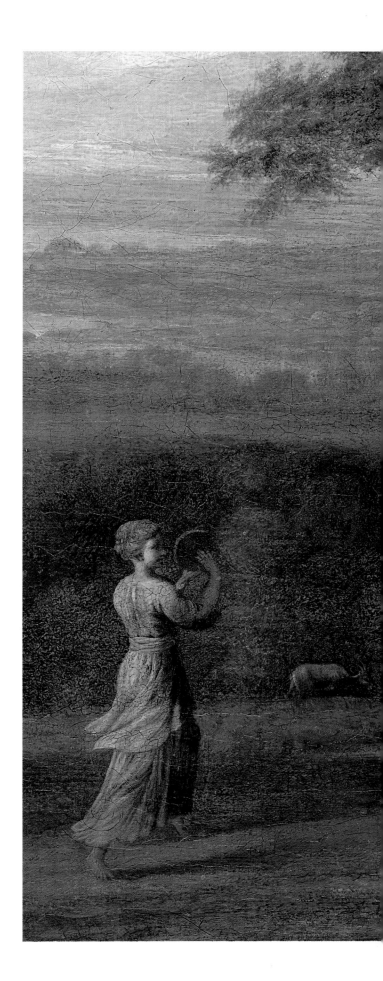

138

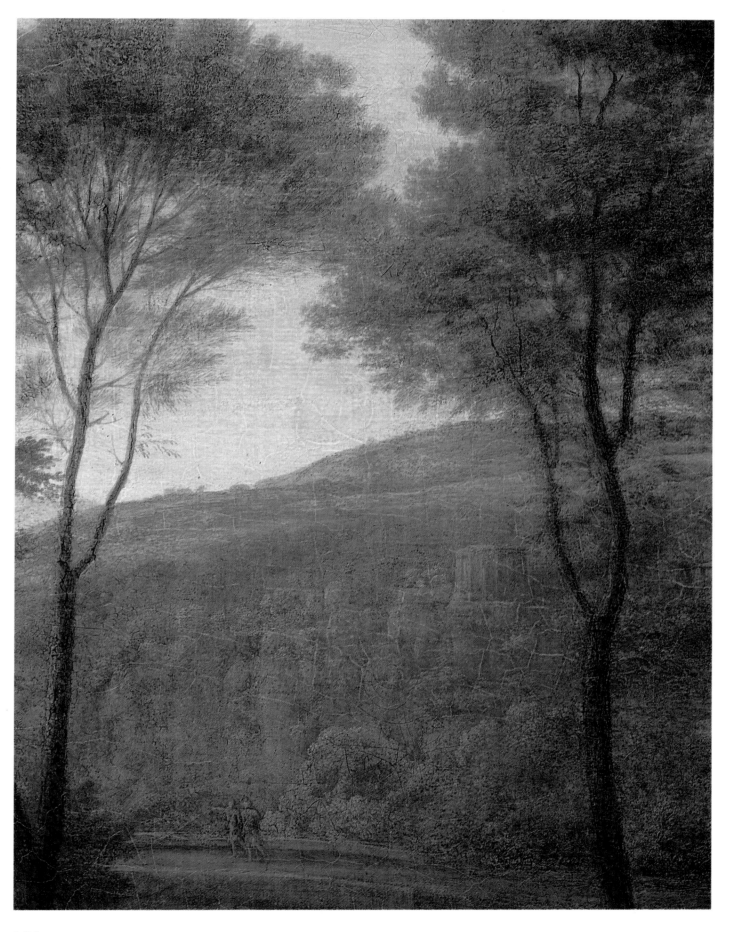

140

The Dance. 1635-1637. Etching. 19.2 x 25.5 cm.
Hermitage, St. Petersburg.

Dance on a River Bank. 1636-1638. Etching. 12.6 x 19.2 cm.
Hermitage, St. Petersburg.

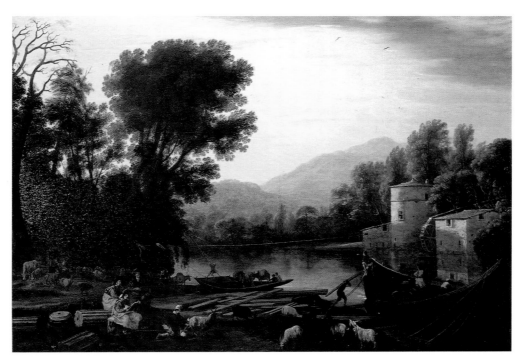

Watermill. 1631.
Museum of Fine Arts, Seth K. Sweetser Fund, Boston.

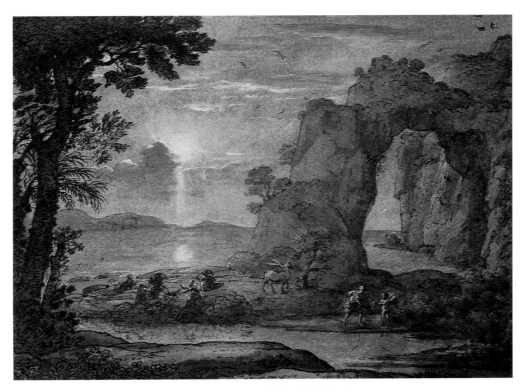

Perseus or the Origin of Coral. 1674. Drawing.
British Museum, London.

Natalia Serebriannaya

CLAUDE LORRAIN:
THE ARTIST'S EVOLUTION

In the seventeenth century two lines of approach to the perception of nature and two corresponding visual trends are clearly discernible in Italian and French art. The first projected the concept of a majestically serene and beautiful landscape incorporating human figures as an integral component of the Universe; usually to be seen in the background were cities, Classical ruins, grazing cattle, wide valleys, quiet rivers and the distant mountains. The other presented nature as a mighty and violent entity, next to it human beings were as inconsequential as grains of sand. This type of landscape featured wild thickets and fallen trees, untenanted buildings, turbulent streams and virgin forests which sheltered hermits, robbers or pirates, and it was less likely to be tied to certain subjects borrowed from literature. The first type of landscape is in line with the principles of Classicist painting, and the second with the Baroque.

The art of Claude Lorrain (Claude Gellée) clearly belongs to the former group. The well-ordered realm of his paintings remains undisturbed, and the men and women with whom it is peopled are wise, dignified and noble-minded beings. Natural cataclysms such as tempests or hurricanes, floods or thunderstorms with fierce lightning are unknown in this peaceful land.

At this point one may recall the ideas of Erwin Panofsky[1] as to the gradual evolvement of the Arcadian image, for they fully apply to the entire heritage of Claude Lorrain and to the development of the ideal landscape in general.

In Greek mythology Arcadia was a pastoral region ruled by Pan, the home of untamed, savage creatures. In the Latin verse of Ovid it duly emerged as a wild, primitive world before the rise of civilization. But Virgil's *Eclogues* changed Arcadia into an idyllic realm of love, music and eternal spring, and it was Virgil's poetic images of a happy, graceful earthly paradise that dominated the concept of Arcadia throughout the Renaissance and in the seventeenth century. Because it was also irretrievably lost, a nostalgic mood tinged with various shades of melancholy pervaded the works of writers, artists and philosophers when they took up the subject of the Golden Age of mankind.

This mood is projected quite strongly by the landscapes of Nicolas Poussin and even more so by the work of Claude Lorrain whose ideal landscapes re-create the illusory ancient world described by Ovid and Virgil. Horace's principle *ut pictura poesis*, which postulated the community and interaction of the arts, was very important in shaping the seventeenth-century attitude to nature and landscape. Painting was interpreted as wordless poetry, and artists felt constrained to use subjects borrowed from literary sources, such as the Bible, Ovid's *Metamorphoses* and Virgil's *Aeneid*, or contemporary works of which Tasso's poems were the most popular.

The work of Claude Lorrain might appear at first sight to have a lack of variety, yet each of his landscapes is permeated with a special appeal, conveying very distinctive thoughts and feelings. He does not strive for the epic and universal in the manner of Poussin; his narrative is more emotional and he merely touches on philosophical issues, leaving it to the spectator to ponder over them. The life of Claude Lorrain appears uneventful. His early career remains poorly researched to this day. According to some sources he arrived in Rome in 1613, but we have fully reliable data only from the mid-1620s. One thing is certain: from 1627 to the end of his days the artist lived and worked in Rome. His biographers describe him as a kindly, quiet man, whose life was free of any dramatic events. There is nothing to suggest that he ever left Rome. He never had a bustling workshop full of pupils. He was a very slow artist, painting about five or six works annually. Almost all of his creations survived safely: approximately 300 paintings, 51 etchings and about 1200 drawings.

Claude had earned wide renown by 1630, and he proceeded to work for a succession of Roman popes from Urban VIII to Innocent XI. His paintings graced the walls of Buen Retiro, the Spanish king's palace near Madrid. He painted for Cardinal Carlo de' Medici, Cardinal Camillo Massimi, Agostino Chigi (nephew of Pope Alexander VII), and Prince Lorenzo Onofrio Colonna, for Italian prelates and the art patrons of Rome. He was the most consistently successful foreign painter based in Rome throughout the sixty years of his artistic career.

A unique and truly invaluable aid for the students of Claude Lorrain's œuvre is his *Liber Veritatis*, which contains detailed drawings of most of his finished canvases (now in the British Museum, London).

Filippo Baldinucci tells us that the artist started the *Liber Veritatis* when he worked for King Philip IV of Spain (1636 - 39).[2] In his article on the *Liber Veritatis* Michael Kitson confirms that it must have originated in 1635 or 1636.[3] The artist made drawings from his finished works when they were still in his studio waiting to be delivered to the customers. This became his regular practice, and so the drawings follow in a chronological order — something that is of great help in studying his heritage and reveals the successive stages in his artistic progress.

A source like the *Liber Veritatis* is rare in art history, and many researchers have tried to establish of what use such a drawing-book could be to its author? Baldinucci is convinced that the impetus for the *Liber Veritatis* was the master's wish to protect his work from the imitators who had become active at that time.[4] This opinion should not be dismissed. By the mid-1630s Claude was very popular, and had acquired some wealthy clients, his solid success provoking a spate of imitations, copies and patent forgeries, and one can appreciate the artist's desire to prevent his works from being confused with those of his imitators. Also, he may have wished to keep a close account of the finished paintings sent to the customers, perhaps to avoid chance repetition in his own future compositions on similar subjects. The *Liber Veritatis* may have had still another purpose, serving as a sort of pattern book for prospective patrons who were not sure about the subject or landscape motif of the painting they wanted to commission. We know some later copies of certain *Liber Veritatis* compositions which the artist must have painted at his clients' special request. Maurice Röthlisberger notes that nearly all of Claude's works are companion pieces, the only exceptions being the author's own

copies (with some modifications) of his earlier works.[5] Röthlisberger suggests that these may have been selected and commissioned by the artist's patrons with the help of his "pattern book".

All of Claude's works were painted to fulfil specific commissions. We do not know a single piece produced solely at the artist's own prompting. The size and subject of each painting fully depended on the customer's wish. The subject was often of key importance because it could contain an allusion to a particular life story or suit a patron's personal inclinations, and it is safe to assume that the artist's individual style was revealed in the interpretation of the material which he had to handle rather than in the subject itself.

Claude's paintings appear to lack any well-defined subjects till the mid-1630s. The earlier works were, for the most part, genre scenes or pastoral pieces in the tradition of early seventeenth-century French and Italian landscape art. But later the artist's use of stories from literary and historical works increased noticeably. His interpretation of the themes selected by his patrons was in some cases very distinctive, abounding in subtle allusions and often taking an unorthodox approach. It is generally believed that, since in the seventeenth-century art any landscape traditionally incorporated a certain story, many artists treated the latter with indifference and concentrated on conveying the landscape motifs. This may to some

degree apply to Baroque landscapes and pastoral scenes, but not to the Classicist landscapes of Nicolas Poussin and Claude Lorrain. For Poussin the subject matter was of primary importance, for he used it to express his philosophy. Röthlisberger's examination of the subjects used by Claude Lorrain shows that the master's interpretation always rested on a profound understanding of some underlying meaning.[6] He became increasingly fascinated by an in-depth treatment of his subjects, for which Nature herself provided wonderful settings.

The Siege of La Rochelle. 1631.
Louvre, Paris.

Claude's mature work is marked by a subtle and distinctive interpretation of the commonest subjects. Even when the literary source is stated in the painting's title, the pictorial details and the arrangement and number of figures often do not follow the story in question. Although the main theme was dictated by the customer, the treatment; was apparently chosen by the artist. Often the paintings are not tied to a definite literary source but they do have a clear associative meaning, e.g. *Allegory of the Dawning of the Roman Empire* and *Allegory of the Evening of the Roman Empire* (Collection of the Earl of Radnor, Longford Castle, Wiltshire, England).

At the beginning of his artistic career Claude preferred scenes from the lives of Christian saints, e.g. his large harbour pieces produced in the 1640s often depict holy people embarking on pilgrimages.

But as time passed his subject range widened. He turned his attention to less popular biblical episodes as well as to Ovid's *Metamorphoses*. A view set off by Classical edifices became a stage setting where incidents from the lives of Greek and Roman gods and heroes were enacted. The treatment of Ovidian texts is far from conventional; there are no sophisticated allegories, no actual transformations or gods soaring through the skies (we should note that the artist's biblical pieces are equally devoid of angels hovering in the blue). He also avoided violent passions, being concerned primarily with the sentiments of his protagonists which he strove to reflect in or enhance by the landscape. Biblical subjects received a more austere and epic treatment in his mature work. In the later part of his artistic career Claude increasingly turned to Roman history and Virgil's *Aeneid*. To some extent this is attributable to those of his patrons who claimed to be descendants of Aeneas, the legendary ancestor of the Roman people, and who had a special interest in Roman history. But the artist himself wished to express his approach to Classical history and Antiquity in general, and the *Aeneid* was eminently suitable for that purpose.

Claude's creative gift was shaped in a manner more or less traditional for a seventeenth-century landscape artist. As already mentioned, the first decade of his artistic career remains obscure. According to Filippo Baldinucci,[7] he came to Rome in 1613 with one of his relatives and stayed there for some time before going to Naples to work for the painter Gottfried (Goffredo) Wals. He came back to Rome to become an apprentice to Agostino Tassi till April 1625, returning to his native Lorraine where he assisted Claude Deruet in painting fresco decorations for the Carmelite church in Nancy. In 1627 he

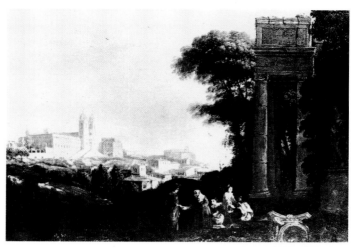

View of the Trinità dei Monti in Rome. c. 1632. Drawing
Hermitage, St. Petersburg

reappeared in Rome and took up residence on the via Margutta.

Tassi and Wals clearly influenced the early work of Claude Lorrain. Their paintings gave him some understanding of the poetic style of Adam Elsheimer and the Northern landscape tradition of Paul Bril. He was also strongly influenced by the compositions of Bartholomeus Breenbergh, Filippo Napoletano and the style of the *bambocciata*.

Works like *Landscape with Merchants* (1629-30; National Gallery of Art, Washington) and *The Mill* (1631; Museum of Fine Arts, Boston) evince a strong dependence on Agostino Tassi. These pastoral scenes abound in details such as animals, bales of merchandise, and gangplanks with people moving up and down. All this is separated from the background by the dark masses of trees or water-mills; in the distance are hills with buildings and towns, and the composition terminates in blue mountains. These pieces follow the Tassi and Bril tradition of river landscapes, the artist revealing a fascination with the marked contrasts of light and shade and employing a dark colour scheme.

Landscape with Arch Rock (c. 1629;

Coast View with the Heliads Mourning Phaethon. 1635.
Wallraf-Richartz Museum, Cologne.

Museum of Fine Arts, Houston, Texas) and *Pastoral Landscape* (c. 1629; Manning Collection, New York) feature motifs employed by many seventeenth-century landscape artists, such as arched rocks, Classical ruins, buildings emerging in the distance, grazing cattle and clumps of trees. But Claude's early landscapes have some characteristic features of their own: the foreground has a strongly emphasized ground level, and it is flanked by tall trees on one side and tall hills or edifices on the other; human figures are in shadow. The middle distance has plenty of strong light coming from behind the tall trees whose leaves absorb the rays of the sun. The cold, stiff lighting brings to mind Paul Bril's work. One of the earliest Claude landscapes with *The Flight into Egypt* (1631; Collection of the Duke of Rutland, Belvoir Castle, Grantham, England) and the *Rest on the Flight into Egypt* (1631; Collection of the Duke of Westminster, London), his *Pastoral Landscape* (1634; Norton Simon foundation, Los Angeles) and *Landscape with Herdsmen* (1630-35, National Gallery of Art, Washington) all have asymmetrical and overcrowded compositions, and a three-dimensional effect is achieved through a succession of diagonally arranged planes. But the early 1630s saw the appearance of works that indicated the direction of the artist's later development. Of primary importance here was his interest in natural lighting and the treatment of sunlight. In *Landscape with Herdsmen* (1630-35; private collection, France), *Landscape with Cephalus and Procris reunited by Diana* (1630-35; destroyed, previously Staatliche Museen, Berlin) and *A View in Rome with the Trinità dei Monti* (c. 1632; National Gallery, London), the rigid composition of the successive planes is alleviated by the lighting. Two pieces in the Louvre, *Coast View* and *Pastoral Landscape* (both 1630 - 33), show the artist retaining the coulisse effect but intent on clearing the foreground. These are the first compositions which, despite the cool colour scheme and rather stiff painterly manner, give the landscape a poetic quality, its stretch of open sea reflecting the sunlight. The solitary figures on the coast add a somewhat melancholy note.

Claude Lorrain's experiments in his early period yielded important works such as *The Judgement of Paris* (1633; collection of the Duke of Buccleuch, Bowhill, Scotland), *The Rape of Europa* (1634; Kimbell Art Museum, Fort Worth, Texas) and the *Coast View with the Heliads Mourning Phaethon* (1635; Wallraf-Richartz Museum, Cologne). It was at this stage that the artist began to have wide recourse to Ovid's *Metamorphoses*. He also continued to evolve the traditional Old and New Testament subjects — mostly episodes involving journeying : the motif came to dominate the artist's work in the 1640s (*The Flight into Egypt, Rest on the Flight into Egypt* and *Christ on the Road to Emmaus*).

147

The Judgement of Paris retains all the compositional features of his earlier paintings (coulisses, diagonally set planes and blurred vistas), but they are used with a greater sense of freedom and the smoothly merging planes make for an integrated pictorial space. The emphasis is shifted to the sunlight figures in the foreground.

The coulisse construction is still in evidence in *The Rape of Europa* but there is no clear-cut division into planes and the treatment of space is made more complex with the help of numerous details. For the first time the artist painted stately trees against a light sky in such a way that the sun filters through the foliage. The line of the horizon is lower than before but the distance is still cut off from the painting's main space. The role of light is substantially different, interplaying with the colour to make it more sonorous. It is used to accentuate the main figures, to stress the principal elements of the composition and to organize the painting space. Claude cultivated these artistic devices, defined for the first time in *The Rape of Europa*, in his later works and they gradually became more sophisticated.

Coast View with the Heliads Mourning Phaethon (1635) fully dispenses with the dark and massive coulisse settings. They are replaced with an airy and elegant decorative frame provided by the superimposed ship masts, tree branches and graceful portico columns. Instead of fencing off the "stage" where the action takes place, these elements tie it to the surrounding landscape. The space is suffused with sunlight which saturates every plant, object, or figure. This painterly device is in full accord with the subject of the canvas. Helios' burning fury provoked by his son Phaethon's obsession with driving the sun chariot is spent. The sun-god — still the absolute master of all living things — now caresses the earth without scorching it.

The scope of the painting's vistas is quite striking. What before appeared to be a deep-rooted fear of open space is superseded by an obvious enjoyment of it. The space remains remarkably unified, the integrating element being the light which blurs the outlines of the succeeding planes. Though the sun is the artist's real protagonist, it is deliberately concealed; the spectator can only divine its presence behind the tree-tops.

From the mid-1630s Claude began to introduce into his compositions the architectural motifs of concrete monuments from the Classical period or Renaissance edifices. Thus, the rotunda in *The Rape of Europa* is a version of the well-known Temple of Vesta (or Sibyl) at Tivoli, and the palace in the *Coast View with the Heliads* brings to mind the Villa Medici.

At about the same time Claude finally resolved the problem of uniting the different planes, learning to link the far-off vistas with the overall composition. A tentative solution was found in the *Coast View with the Heliads* although the influence of the habitual use of successive planes is still in evidence — for instance, the hill with figures, the bay, the harbour before the flight of steps leading to the palace, the jutting promontory and the other beyond it — but since these elements do not overlap, the picture space remains unbroken.

Villagers Dancing (1634 - 36; City Art Museum, St. Louis, Missouri) still retains the arrangement into planes but here they have no sharp dividing lines. The receding perspective of the river with its wooded banks is an organic part of the picture as a whole, not cut off as abruptly as before; and the line of the horizon can be clearly seen. This subject, a village festival with dancing peasants, first tackled by the artist in the 1630s, reappeared with modifications throughout his long painting career.

148

Harbour with the Villa Medici. 1637.
Uffizi, Florence.

At this time Claude Lorrain's artistic language was influenced by Jacques Callot, who was also a native of Lorraine. His cycle of etchings — *Grandes Misères de la Guerre* — was published in 1633 in Paris by Israel Henriet. Scholars see a connection between Jacques Callot's *Siege of Breda* and Claude's companion pieces *The Siege of La Rochelle* and *View of the Pass of Susa Forced by the Troops of Louis XIII* (both 1631; Louvre, Paris).[8] We also know that Claude later made copies of the famous Callot series.

The progress made by the artist is witnessed by the splendid coast views and harbours of the later 1630s and the early 1640s, which earned him well-deserved renown. Some scholars believe that in these marines Claude for the first time employed many painterly solutions which were not found in his rustic landscapes.[9] Perhaps it would be more plausible to suggest that this was a simultaneous process: the devices evolved for landscapes of one kind were at once applied to the other. Suffice it to compare two companion pieces painted in the same year, 1633: the above-mentioned *Judgement of Paris* and *Coast View* (both in the Collection of the Duke of Buccleuch, Bowhill, Scotland).

The traditional coulisses are more obvious in *Coast View* with its bulky porticos, and the succession of planes is still there — the far background is separated from the painting's central ground — and the lighting is not uniform. In fact, the sharply contrasted lighting pattern is reminiscent of the early style of Tassi. There seems to be nothing to support the theory of the very different evolution of the two landscape types, especially since at this point many of Claude's paired works began to include one coast view and one rustic landscape.

The Harbour, painted in the early 1630s (private collection, Los Angeles), may serve as an example of the artist's reversion to the archaizing forms of the late 1620s. There are again the massive coulisses, the dark foreground and the figures in half shadow. The lighting suggests *River Landscape with the Temple of the Sibyl (Temple of Vesta) at Tivoli* (1630 - 35, National Gallery of Victoria, Melbourne): we see the same dark strip of foreground shaded by a grand portico, the same sunlit rock in the middle; the far background is again blurred and the space terminates abruptly at the horizon. Interestingly enough, the *Liber Veritatis* drawing (No 2) which reproduces this composition presents a less elaborate lighting arrangement; some of the painting's compositional imbalances are also minimized (e.g. the relative sizes of the portico and the human figures are more realistic).

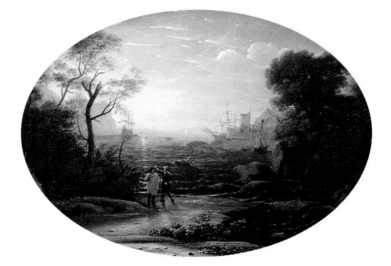

Coast View. 1630-33.
Louvre, Paris.

Claude Lorrain moved a step further with his harbour scenes in 1634 to 1636. *Morning in the Harbour* (1634; Hermitage, St. Petersburg) presents a more mature version of this type of composition; the one Claude chose to employ in all the harbour scenes that followed, abandoning once and for all the traditional scheme evolved by Tassi. The architectural setting is used to create a decorative effect instead of fencing off part of the space as it did before: reflected by the magnificent gilded décor, the sunlight sparkles on the mirror-like surface of the sea. The composition shows an open harbour with the sea receding into the vast distance, the space expanding slowly to meet the sun: Claude was at last able to depict vistas without dividing the painting's space into planes. In all his later works the earth, the sea and the sky were treated as one whole, but the sky gradually began to prevail, taking up sometimes as much as two-thirds of the painting. It became a fully-fledged element on a par with the water, the sun, the woods and other vegetation.

In *Seaport with the Capitol* (1636; Louvre, Paris), *Harbour with the Villa Medici* (1637; Uffizi, Florence) and *Coast View* (1639; Louvre, Paris) the composition is quite simple in spite of the abundance of staffage and architectural details. Claude displays his fine mastery of perspective.

The architectural motifs are both realistic and recognizable, being selected, for the most part, from amongst the Renaissance monuments preserved in Rome. The artist drew them from nature or from available etchings, and he often brought together details from different buildings to create architectural fantasies. Scholars have suggested a link between Claude's dawn and sunset scenes depicted against architectural perspectives and similar sixteenth-century stage sets.[10]

Claude's early harbour views were without any narrative purpose, being, as a rule, genre scenes with boats riding the sea, with boatmen, porters, merchants and travellers preparing to set sail, traders offering their wares and idle onlookers. *Harbour with the Villa Medici* may be regarded as a classical *veduta* combining architectural fantasy and reality. The classical canon prefers verisimilitude to reality but it admits of fantasy based on a realistic representation. Claude's method of drawing numerous sketches from nature is in full keeping with this. According to Sandrart,[11] the artist sometimes actually painted outdoors, and then worked up these studies in the studio to form his canvases. He also made sketches of architectural motifs such as Renaissance and sixteenth-century buildings and surviving monuments of Classical Antiquity, which he subsequently incorporated into his architectural fantasies.

The crucial stage in the evolution of the harbour scenes came when the artist was commissioned by the Spanish King Philip IV to provide paintings for his Buen Retiro Palace near Madrid. The series included a harbour view. Previously Claude's harbours had been subject-free, but from that time on they invariably featured events from Classical history or episodes from the lives of the saints. The harbour painted for the Spanish king

was *The Port of Ostia with the Embarkation of St. Paula*, and its companion piece was *Landscape with Tobias and the Angel* (both 1639; Prado, Madrid). In *The Port of Ostia* the artist combined

The Port of Ostia with the Embarkation of St. Paula. 1639. Prado, Madrid.

real and fantastic architectural elements. One recognizes in this imagined harbour the familiar contours of the Villa Medici. Luigi Salerno may be right in stating that such a method creates the romantic atmosphere of an ideal landscape, revives

151

in human memory the events of times gone by.[12] The narrow channels by the piers, the clusters of buildings on both sides of the harbour and the drawn-out vertical format of the canvas enhance the effect of a corridor leading directly to the sun, which dissolves into the sea before one's eyes. The rays of the setting sun fall on one side of the harbour, the other side is illuminated by their reflection; this strip of light creates the sensation of the sun drawing the spectator towards it, out to the boundless sea. Hereafter all of Claude's landscapes were to have this captivating appeal.

Seaport: The Embarkation of St. Ursula (1641; National Gallery, London) and *The Landing of Cleopatra at Tarsus* (1642; Louvre, Paris) are very impressive and colourful compositions but the artist took care to avoid dramatic effects in conveying the different states of nature. He lit both landscapes with a gentle sunlight of varying degrees of strength and warmth, but the sun itself is hidden from view by buildings or foliage, its rays dissolving in the wide expanse of the sky. Never again would the artist employ marked contrasts of light and dark.

For Claude Lorrain light and sun seem to imply something of special importance. It is to meet the sun that the ships are leaving the harbours; it is the sun that lures them onwards to undiscovered lands and ports. Let us recall that travelling was far from safe at that time; journeys were long and fraught with unforeseen happenings, but they also held out the promise of a happy arrival. A long journey, especially by water, always involved thoughts about fate and fortune, and even the possibility of a miracle. Claude played up these traditional seventeenth-century implications to invest his coast views and his embarkation scenes with the mood of anticipation and hope peculiar to a journey. Travelling is a subject very much in evidence in all of the artist's works produced in the 1630s and 1640s, and it clearly affected his choice of biblical episodes: *Rest on the Flight into Egypt, The Flight into Egypt* and *Christ on the Road to Emmaus.* Nearly all the religious pieces by the artist painted during this period are marked with emotional tension, a sense of anxiety, a presentiment of fate and its inevitability. The subject received a somewhat different treatment in his later works.

Meanwhile, the artist became increasingly preoccupied with Graeco-Roman culture as a whole. He resorted more and more often to stories from Classical mythology, using Ovid's *Metamorphoses* as his source. One of the first essays in this direction was *Landscape with Apollo and Marsyas* (1639-40; Pushkin Museum of Fine Arts, Moscow). It shows that Claude Lorrain was able to intensify and develop the principles formulated in his works of the mid-1630s. The composition of *Apollo and Marsyas* recalls

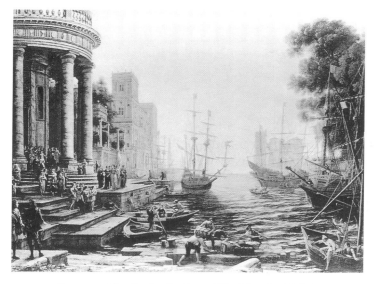

Seaport: The Embarkation of St. Ursula. 1641.
National Gallery, London.

152

those of *The Rape of Europa* in the Kimbell Art Museum (Fort Worth, Texas) and the *Harbours* in the Louvre, but it appears to be over-crowded, in particular as regards the staffage and the rich vegetation rendered with an abundance of detail. The artist was able to bring together the most successful devices of his early years

Landscape with Dancing Satyr and Figures. 1641.
Museum of Art, Toledo, Ohio.

and his latest achievements in colouring and lighting to create an atmosphere saturated with light. He also introduced something that later became a favourite device: the tragic event — the savage punishment to be meted out to Marsyas who had challenged Apollo in music-making — is set against a serenely beautiful view; majestic Nature is an impassive onlooker. A contrast between the beautiful and the tragic, the base and the sublime, was found throughout seventeenth-century painting, but in classicizing landscapes the actual event was often presented through anticipation or a presentiment of its occurrence, or as a recollection of it. In his subsequent compositions Claude likewise strove to convey intensely tragic or dramatic events through recollection or retrospection instead of representing them directly. Their emotional essence would be conveyed through the state of outwardly peaceful nature, that state varying according to the artist's use of light.

Of no small interest is Claude's gradual introduction of episodes from mythology into his subject range. At an early stage he was reluctant to employ even those incidents from the *Metamorphoses* which were in vogue in the seventeenth century, and in his later years he could tackle the less popular episodes to which he gave an individualistic interpretation.

In the first half of the seventeenth century many artists favoured scenes of bacchanals. Tradition has it that artists who came to Rome from other countries were greatly impressed by their first encounter with Titian's famous *Bacchanals* at the Villa Aldobrandini, and often tried to recreate the great master's joyous perception of the world in similar scenes. Poussin, for example, developed the subject over almost a decade. Joachim von Sandrart describes how, on having seen Titian's masterpiece in the company of Poussin, Claude Lorrain, François Duquesnoy and Pietro da Cortona, he and his companions readily agreed that "Titian created no other work as attractive, refined or resplendent as this".[13] Claude paid tribute to this infatuation in his *Landscape with Dancing Satyr and Figures* (1641; Museum of Art, Toledo, Ohio) and *Landscape with Dancing Satyrs and Nymphs* (1646; National Museum of Western Art, Tokyo). The first forms a kind of link between the compositions of the late 1630s and those of the artist's mature period, setting out the main principles of his *grande manière* of the 1650s. It is the first rustic landscape (not coast view) to present broad horizons and to dispense with the division

153

into planes. The wide, free space with its high vaulted sky and soft uniform lighting is endowed with amazing depth.

The bacchanal theme was subsequently superseded by the village festival. The artist kept on turning to this motif, which was more congenial to his own approach, throughout his later work.

Claude then developed a particular landscape motif to which he would have recourse in a series of pastoral views. His contemporaries and biographers invariably stressed his interest in the Roman Campagna rather than in Rome itself. Sandrart recalls that the artist would spend hours walking through the groves to select and sketch views, individual motifs, trees and buildings.[14] He had probably made a more thorough study of the natural setting around Rome than any other artist then working in the city. He also made use of his records of architectural monuments, often introducing into his rustic landscapes even such a famous building as the Roman Colosseum. Unlike Poussin, Claude Lorrain took liberties with archæological accuracy and authenticity. He was not interested in antiquities as such, and to him Classical ruins were part and parcel of the Italian landscape, as were its Renaissance monuments and contemporary structures. They provided noble highlights for his landscapes and reminded the spectator of the fleeting nature of human life. Fragments of

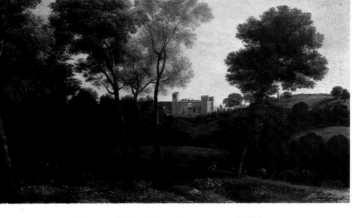

View of the Villa Crescenza. 1648.
Metropolitan Museum of Art, New York.

Classical ruins were used by most seventeenth-century painters in their *Vanitas* pieces, but for Claude they were also a symbol of mankind's glorious past, of the ideal world of Classical Antiquity.

He gradually evolved a type of landscape set in a wide valley with scattered trees creating an open view, and distant hills with buildings, temple ruins and remnants of aqueducts. A bridge in the distance and a river with wading cattle in the foreground became almost obligatory. Herdsmen rest under the trees. The horizontal planes are set off by the verticals of tall trees with luxuriant crowns; the sky takes up at least three-fifths of the painting's height. The same elements are always present, yet the composition is never repeated. In *Landscape with Herdsmen* (1644 private collection, San Francisco), *Pastoral Landscape* (1645; Barber Institute of Fine Arts, Birmingham), *View of Tivoli* (1644; Richard L. Feigen and Co. Gallery, New York) and in many other pieces Claude successfully tackled the task of conveying the gradations of lighting according to the time of the day. Describing his promenades with the artist in the environs of Rome, Sandrart noted that Claude was particularly concerned with the changing play of light on the same objects.[15] The softly dispersed light of Claude's landscapes comprises many gradations of daylight, from the misty morning to the warm evening saturated with the heat of

the long day. The artist is able to convey the subtle nuances of atmospheric changes and the transparency of the air. *View of the Villa Crescenza* (1648; Metropolitan Museum of Art, New York) is a very fine example of masterly handling of light at sunset: the last rays of the sun linger on the gilded tree-tops but the hollows beneath the trees are already plunged into shadow which blurs the contours of shrubs, of human and animal figures. This canvas supports Sandrart's sensational statements that in the course of his long walks Claude occasionally made sketches in oils, thus anticipating the *plein air* method[6].

Another such work is the *Italian Landscape* (1648; Hermitage, St. Petersburg;[5]) featuring the artist's favourite motif: home-bound cattle fording a river. There is the inevitable bridge in the distance and a country-house on the hill to the left; to the right is a wide river valley with hills and buildings in the background. In the foreground are two shepherdesses, one of them playing a reed pipe, and a shepherd in a setting of tall trees, thick bushes and graceful herbs. The three figures are enfolded in the soft light of the evening sun, and a peaceful end-of-the-day atmosphere pervades the scene.

Quite often an Antique monument deliberately set in a narrative-free landscape lends a specific meaning to the whole work. Two such landscapes tinged with nostalgia for Rome's former grandeur —

Landscape with the Arch of Constantine. 1651.
Collection of the Duke of Westminster, London.

Landscape with the Arch of Titus (1661) and *Landscape with the Arch of Constantine* (1651; both in the Collection of the Duke of Westminster, London) — seem to contrast the austere world of Classical Antiquity to the gentle pastoral world.

As time passed Claude Lorrain increasingly introduced into his pastoral landscapes subjects borrowed from Ovid's *Metamorphoses*. At this stage he again turned to painting coast scenes. Looking at *Mercury and Aglauros* (1643; Pallavicini Collection, Rome) we miss the familiar early pattern of limited space with a modest outlet into the distance on the very horizon; in the new compositional arrangement the emphasis is on the boundless vista. A piece of ground with fragments of Antique columns, ruins of a portico, luxurious trees, the Colosseum in the distance and figures in the foreground takes up only a third of the painting's space; the rest is dedicated to the sea and the sky. The result is an amazing Claude-like impression of an integral space undivided by any gradations of planes or varied lighting effects.

In the mid-1640s we see the artist turning to widely diverse mythological subjects. The first steps in this direction are *Landscape with Argus Guarding Io* (1644; Collection of the Earl of Leicester, Holkham Hall, Norfolk, England), *Landscape with Cephalus and Procris* (1645; National Gallery, London),

Landscape with Apollo and Marsyas (1645; Collection of the Earl of Leicester Holkham Hall, Norfolk, England) and *Coast View with Apollo and the Cumaean Sibyl* (1646; Hermitage, St.Petersburg[4]). Apollo and the Cumaean Sibyl inspired the artist once more twenty years later (1665; private collection). Several interpretations of this story are known. In the Middle Ages the Cumaean Sibyl was honoured as the prophetess who foresaw the Nativity of Christ and the future gran-

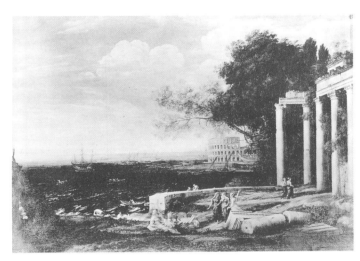

Mercury and Aglauros. 1643.
Pallavicini Collection, Rome.

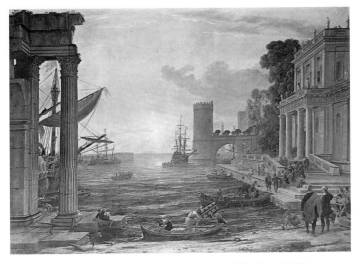

The Embarkation of the Queen of Sheba. 1648.
National Gallery, London.

deur of the Catholic Church; Apollo was seen in this context as the prefiguration of Jesus Christ. Diane Russel, while she allows this interpretation with its allusion to the Christian theme of eternal life, doubts the identification of Apollo and the Sibyl with Christ and his Church.[17] The far stronger message of this painting is the fleeting nature of life. Apollo points to the handful of dust which seeps through the Sibyl's fingers as a reminder that human life runs out like grains of sand. The broken columns in the foreground which once decorated beautiful edifices and the ruins in the picture's middle ground are symbols of the futility of earthly existence. Beyond the stretch of water lie the ruins of the monuments of an early civilization which arose, flourished, fell into decline and was reduced to dust, the same dust that the prophetess shows Apollo. Here there is no hint of the renascence of life to support the Christian interpretation. The traditional symbol of eternal life assumed by seventeenth-century art, a withered tree sprouting young green shoots, is also absent. Claude's painting, on the contrary, stresses the everlasting power and beauty of nature in contrast to the transient works of human hand and the evanescence of human life.

The *Apollo and the Cumaean Sibyl* of 1665 is a similar but somewhat gentler treatment of the subject. The colourful sunset with deep shadows in the foreground creates a romantic setting. The interpretation of the sunset theme may have been dominated by Cardinal Massimi who commissioned the earlier piece (1646; Hermitage, St. Petersburg) together with four other pictures: the man — a lover of antiquities and the owner of a remarkable collection of ancient books and manuscripts — showed great interest in archaeology. Seen in the

foreground is a representation of the Colosseum reconstructed by the artist's fantasy, while in the distance, against the background of the sea, are ruins of the same Colosseum — a reminder that even the grandest creations of people will eventually be destroyed. Goats next to these majestic ruins hint at Apollo's love for the passionless prophetess. This motif is repeated in the 1665 painting, but like all the other accents it is less emphatic there: cattle tended by a herdsman graze next to ruins in the background.

The companion piece of the Hermitage painting is the above-mentioned *Landscape with Argus Guarding Io* (1644). The two works reveal all the characteristic features of Claude's pendants: the same literary source, the same format of the canvases, the same horizon level and the same internal proportions, whilst the light comes from opposite sides. In *Apollo and the Cumaean Sibyl* the light runs from right to left from the promontory projecting into the sea; in *Argus Guarding Io* the light is slanted left to right, running from behind the foliage of a tall tree to the rounded temple on the right whose contours are reminiscent of the Temple of the Sibyl (Temple of Vesta) at Tivoli. Claude liked to match a coast view with a wooded landscape, achieving a fine compositional balance and consonant details. The slightly asymmetrical structure which may be unnoticed at first sight is fully seen only when the two pieces are directly compared; the observer then feels how complementary the paintings really are in spite of the distinctive character of each pendant. The artist was able to achieve a double purpose: two contrasting landscape motifs were brought together, and the elements of the physical world — the earth, the sea and the sky — were all presented.

This is what brings together the *Landscape with Paris and Oenone* (1648) and *Seaport: Ulysses Returns Chryseis to Her Father* (1644; both in the Louvre, Paris). The contrast between these companion pieces is still more striking: there is the harbour with magnificent palaces running down to the mirror-like, sun-drenched sea; and here we have the forest scene with waterlogged river banks overgrown with trees and bushes, illuminated by the mild rays of the evening sun. But the two contrasting works complement each other as they reveal the infinitely diverse beauty of the universe.

Seaport: Ulysses Returns Chryseis to Her Father and *The Embarkation of the Queen of Sheba* (1648; National Gallery, London), the last in the series of grand harbour scenes of the late 1640s, retain the principal compositional devices of the harbours of the late 1630s and early 1640s, but the picture space is noticeably wider and clearer, and has acquired a new grandeur. This space is meticulously organized, and the *bambocciata* genre scenes are superseded by less cluttered motifs. All this testifies to Claude's striving for a purer Classicist style. The colour scheme is as rich as before, and the enhanced lighting effects lend both paintings a festive touch. But the artist renders the sunlight in a natural way, creating his effects with the help of gradations of light and shade and the bright costumes of the figures. There is a different treatment of light as it falls on the boats and the buildings, the portico columns and the harbour's flagstones; the light may strike an object directly or it may be reflected by the water's surface as the artist experiments with a wide variety of nuances. A stream of light pours out from the picture's depth to diffuse gently in the foreground and envelop the figures arranged against it.

It may be due to the influence of Poussin's landscapes that Claude showed this preference for an uncluttered, clear space treated in a generalized manner. After 1648 he did not return to his large-scale coast views, but he never gave up harbours and the motif of travelling. The coast scenes of the early 1650s — *The Embarkation of St. Paula* (1650; Musée Départemental des Vosges, Epinal, France), *The Arrival of Aeneas at Latium* (1650; Collection of the Earl of Radnor, Longford Castle, Wiltshire, England), *The Embarkation of St. Paul* (1654; City Museum and Art Gallery, Birmingham) present a modest portico or a deserted stretch of shore, occasionally with Classical ruins. The emphatically horizontal foreground reminds us of a theatre stage on which a grand performance is enacted, charged with profound meaning. The noble and austere natural setting and the stage-like poses of the central characters convey the importance of the episodes from the lives of saints or ancient heroes depicted.

The 1650s saw the beginning of Claude's *grande manière*; it was the period when he was particularly concerned with the landscape's architectonic structure. In addition to the influence of Poussin, he was stimulated by his interest in the work of Raphael, Carracci and Domenichino. In the two companion pieces, *The Rape of Europa* and *Battle on a Bridge* (both 1655; Pushkin Museum of Fine Arts, Moscow; 7, 8), attention is concentrated on resolving the question of composition. The atmosphere and the subtle gradations of lighting are rendered by means of well-developed and skilfully-used devices, but the artist does not tie the scene to a definite time of the day.

The composition of *The Rape of Europa* is totally subordinate to the content. The artist chose to present the moment when Zeus, disguised as a beautiful white bull, is ready to make for the sea with his precious burden. The key motif is the abduction of Europa and her coming voyage across the boundless sea on the back of the bull. The composition is conceived in such a way as to convey the rapid movement of the bull towards the alluring, compelling sea. The rocky coastline runs along a diagonal from left to right, crossing another diagonal, running in the opposite direction. As the diagonals cross, the flowing movement is interrupted, adding a discordant note of alarm to the seemingly tranquil landscape motif. The second diagonal (right to left) is emphasized by the wide band of water which is at first contained by the shore line but, in the background, runs into the open sea as if mapping out the bull's course. A head wind whips up white foam on the water's surface and this, together with Europa's upswept draperies, enhance the mood of uncertainty and alarm with which the princess is about to embark on her mysterious journey.

The same feeling of anxiety pervades the second painting of this pair, *Battle on a Bridge*, the precise subject of which has never been reliably established. One thing, however, is certain: the artist wanted to show how the reigning harmony of nature is upset by the destructive activities of man. The composition has many features in common with its companion piece but the diagonals are slightly re-arranged, enabling the artist to accentuate different things. The coastline, continued by the line of the bridge, is cut across in the centre by the line formed of people and animals, running to seek the protection of nature, trying to reach the woods to escape the rage of the battle. The lagoon beyond the bridge is wider and calmer than the small cove in *The Rape of Europa*. It is cut off in the distance by the

contours of a massive rock which blocks part of the horizon, slowing down and then halting the movement into the depths of the picture. This creates a contrast between the turmoil in the foreground — the work of human will — and the majestic background of the calm sea — the embodiment of eternally beautiful nature that offers shelter and peace. Obviously the artist regarded the actual battle as an occasional event which could only momentarily upset the equilibrium of nature. Despite the masterly treatment of the atmosphere and the subtle gradations of lighting, the artist was apparently again not interested in tying this picture to a particular time of the day: the lighting is as neutral as it is in the other paintings dating from the same period.

As to the identification of the battle itself, M. Röthlisberger supports the suggestion voiced by P. Rosenberg that this could be the battle between Constantine and Maxentius,[18] an episode much favoured in sixteenth- and seventeenth-century art. This subject was likely to appeal to the artist's client, Cardinal Fabio Chigi, who became Pope Alexander VII in April 1655, the year in which the painting was executed.

In the 1650s Claude Lorrain painted marvellous landscapes with mythological subjects which exemplify his approach to nature as a means of conveying the inner states of the human soul. The most characteristic of the 1650s compositions are *Coast Scene with Bacchus and Ariadne on Naxos* (1656; Arnot Art Gallery, Elmira, N.Y.), *Landscape with Acis and Galatea* (1657; Gemäldegalerie, Dresden), *Landscape with Psyche and the Palace of Eros* (1664; National Gallery, London). Indeed, looking at these pictures, the spectators are concerned above all with the characters' feelings, and not with the story. Claude built up his land-

The Arrival of Aeneas at Latium. 1650. Collection of the Earl of Radnor, Iongford Castle, Wiltshire, England.

Landscape with Acis and Galatea. 1657. Gemäldegalerie, Dresden.

scape from carefully selected elements that were in accord with his characters' moods: thus, in *Acis and Galatea* we see a deserted stretch of shore overgrown with bushes and sheltered by impassive rocks, the sunlight filtering from behind them. The peaceful landscape is a perfect setting for this poetic idyll of mankind's Golden Age. The tragic *dénouement* is omitted from the picture; there is no hint of its imminent approach. Claude pre-

ferred to stress the concept of harmony between nature and human beings.

The same concentration on the characters' emotional state is seen in *Coast Scene with Bacchus and Ariadne on Naxos*, the plot of which is variously identified by scholars.[19] The Arnot Art Gallery lists it as *Ulysses and Nausicaa*. Whatever the interpretation, one thing is beyond doubt: the artist wished to convey and emphasize by every means at his disposal the sense of the uncertainty and inconstancy of the surrounding world which is experienced by the heroine, be she Ariadne abandoned by Theseus and alarmed by the appearance of Bacchus or Nausicaa troubled by vague presentiments. The cool tone of the foaming sea and of the sky with its transparent veil of flimsy clouds, the sharp shadows on the coast and the water, the wild rocky foreground surrounded by an impenetrable thicket of bushes, the Antique ruins — all help to emphasize the princess's mood. The companion to *Bacchus and Ariadne* is *Landscape with Apollo Guarding the Herds of Admetus* (1654; Collection of the Earl of Leicester, Holkham Hall, Norfolk, England), a total contrast with its peaceful, idyllic mood.

Landscape with Psyche and the Palace of Eros is a work of remarkable harmony. Totally absorbed in her own thoughts and feelings, Psyche is unaware of her surroundings which are suffused with the

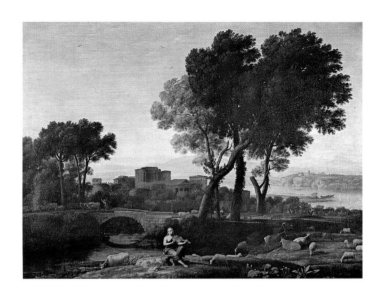

Landscape with Apollo Guarding the Herds of Admetus. 1654.
Collection of the Earl of Leicester,
Holkham Hall, Norfolk, England.

expectation of an important and mysterious event. There is magic in the air: the trees are motionless, the rocks and the castle are silent and impassive, it is only the white horses on the gentle waves that betray the presence of a light breeze. All is quiet, reflecting the state of Psyche's mind. The painting's companion piece, *Landscape with Psyche Saved from Drowning Herself* (1655; Wallraf-Richartz Museum, Cologne), depicts the same time of day, but instead of pensiveness it conveys the mood of desperation corresponding to a suicide attempt, though this is presented in an equally tranquil, dreamlike setting. Both paintings emphasize human loneliness and nature's indifference to people's thoughts and feelings.

The artist's experiments with the portrayal of the relationship between human beings and nature, reflected in the *grande manière* of the late 1650s and early 1660s, can be seen also in the subjects which he selected. He turned his attention to major episodes from the Bible, some of which were rarely tackled by artists, always scrupulously close to the text. Claude's preference for the most impressive biblical stories is often ascribed to the philosophical principles of stoicism, at that time familiar and congenial to many artists, despite the lack of any corroboration from his biography.[20] What is certain, however, is that in these years the artist was influenced by the heroic

Landscape with Psyche and the Palace of Eros, 1664.
National Gallery, London.

landscapes of Poussin, as witnessed by the sublime views, the monumental structure and architectonic style of his own work.

There are five paintings by Claude Lorrain in the Hermitage collection that date from this period: *Christ on the Road to Emmaus* (1660), *Noon* (*Landscape with the Rest on the Flight into Egypt*) (1661) *Evening* (*Landscape with Tobias and the Angel*) (1663), *Morning* (*Landscape with Jacob, Rachel and Leah at the Well*) (1666) and *Night* (*Landscape with Jacob Wrestling with the Angel*) (1672). If they are compared with the above-mentioned mythological pieces, their natural setting appears far more restrained, subordinated to some intellectual basis and less coordinated with the story presented. This rationalist note, which runs through all of Claude's work, does not prevent him from

achieving subtle poetic effects.

The most traditional of the Hermitage Claude paintings is *Christ on the Road to Emmaus*[9]. The foreground is enclosed on both sides by tall trees and ancient ruins, but the space narrows as it lures the eye into the distance, hinting at a long journey, the latter echoed in the figures of weary travellers and the sails of the ships gliding over the bay's glassy surface. The subdued colour scheme, the undefined state of nature and the diffused lighting help to focus attention on the story and thereby stress the significance of the episode. During this period in his creative career the artist was very careful in selecting landscape motifs, which were, for the most part, conventional: here we see a general impression of nature, in contrast to the landscape motifs of the earlier paintings depicting the specifics of the Roman Campagna.

In two other Hermitage paintings — *The Rest on the Flight into Egypt* (10) and *Tobias and the Angel* (11) — the landscapes, as in *Christ on the Road to Emmaus*, are clearly dominated by a geometrical principle, while the lighting conveys the natural atmosphere of the day. In this way one and the same landscape motif is used to present and to blend the symbolic and the concrete, something that is characteristic of Claude's artistic vision. The preference for a majestic view that would do justice to a famous biblical episode betrays the influence of Domenichino, whose work particularly attracted Claude in the 1640s and 1650s. Each of the pendants features a panoramic view with many minor details. Both compositions have the emphatically horizontal arrangement of planes, animated by the verticals of tall trees. Special attention is paid to creating the illusion of depth through gradations of light as well as the relationship between the large-scale foreground and the successive planes that draw the eye into the distance. The impression is further enhanced because the artist separates the foreground with its figures from the next plane by a stretch of water, this compositional isolation serving to emphasize the group of main characters and thereby to enhance the meaning of the episode. Despite their differences — in *The Rest on the Flight into Egypt* the light-

ing is indefinite but in *Tobias and the Angel* it clearly evokes a sunset — each picture is marked by a striking inner unity of atmosphere. Morning and evening were quite important to Claude: according to Röthlisberger,[21] he preferred the morning hours for heroic and tragic subjects, reserving the evening for joyous, happy scenes — thus the fish in *Evening (Tobias and the Angel)* symbolizes the hope of healing Tobias, father of blindness.

Noon (The Rest on the Flight into Egypt) incorporates one of the artist's best-loved themes, that of travelling. The journey of the Holy Family was perceived by Claude, and by all seventeenth-century artists, as one of the most important episodes described in the Gospels. According to the principle of decorum in art, pictorial details had to be so selected that their decorative qualities were in keeping with the content; for example, this particular scene required a noble landscape setting. Indeed, the view in *The Rest on the Flight into Egypt* is stately and austere, pervaded by silence and peopled by shepherds guarding their grazing cattle; severe Nature seems to unbend and to offer shelter to those who look to her for safety. In the two pendants that followed several years later, *Jacob, Rachel and Leah at the Well* and *Jacob Wrestling with the Angel* (13) the severity of the last pair was somewhat softened. The carefully worked

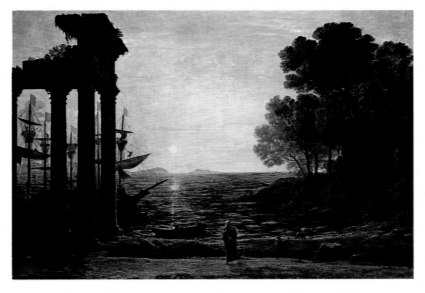

Ezekiel Mourning Over the Destruction of Tyre. 1667.
Collection of the Duke of Sutherland, Merton, England.

162

out spatial arrangement is preserved, and the austere epic style of *The Rest on the Flight into Egypt* and *Tobias and the Angel* is much in evidence, but there is also a pronounced lyrical note. In *Jacob, Rachel and Leah* the latter stems from the story itself: Jacob meets Rachel for the first time and their love is born. The poses of the stately figures in Classical draped garments are graceful and deliberate, while the broad, panoramic view is free of all commonplace details. The surrounding landscape is calmly sublime; nature seems to respond to the subtlest changes in the characters' emotions. The foreground is bathed in a diffuse reflected light which filters through the thick foliage of the tree and the few wispy clouds; the wide plain in the background is lit by the bright rays of the sun penetrating from behind the clouds; but in the composition's central part the light is fluctuating and uncertain. It is with the same hesitancy and uncertainty that Jacob makes his first steps towards Rachel. The running male figure and some cattle near the temple in the background hint at Jacob's eventual flight. The artist chose this biblical episode to evolve one of his favourite devices, that of light coming from the picture's depth. All the compositional details, the trees, the buildings and the figures are set against the light, and the effect is remarkable: the spectator can see the birth of a new day. In the Book of Genesis the story takes place when the sun is high in the sky, but the artist wrote on the reverse of his *Liber Veritatis* drawing (No 181): *l'alba del giorno* — dawn. He remained true to his penchant for the rare and elusive states of nature and decided to paint the transition from night to daybreak. The colour scheme is lovely and unusual: the deep greens and blues of the trees, bushes and herbs in the foreground are so transparent as

almost to create the effect of watercolours, while in the depth of the valley we see a transition to colder shades of blue, continuing into the distant pale blue mountains and cool blue sky saturated with a stronger light. The brightest point in the composition is the luminous edge of the central cloud. This painting provides a superb example of another of the artist's distinctive devices: the objects seem to be covered with a silvery film that creates the illusion of gentle movement, of branches and grasses swaying and the river flowing. In the middle ground are the figures of Jacob's family and his divided cattle moving off in different directions, one group going uphill to the temple, the other across the bridge. These secondary details represent a minute and accurate development of the story, the beginning of which is shown in the foreground.

At the end of the 1660s Claude Lorrain created one of his most austere biblical paintings, *Ezekiel Mourning Over the Destruction of Tyre* (1667; Collection of the Duke of Sutherland, Merton, England), which may be likened to an epic paeon to a civilization irretrievably lost. The prophet's lonely figure on the deserted coast, amidst the ruins of what was once a beautiful city, stands out against the boundless cold sea lit by the rays of the dying sun, embodying the loneliness and isolation of man in the face of the vastness of nature. *Abraham Expelling Hagar and Ishmael*, which is almost ascetic in its composition and cold monochromatic colouring, and *Hagar and the Angel* (both 1668; Alte Pinakothek, Munich) project the same mood. The artist uses the biblical episode to depict human loneliness when confronted with Nature — who, for all her splendour, can easily crush human beings — and man's moral fortitude in the face of ordeal.

163

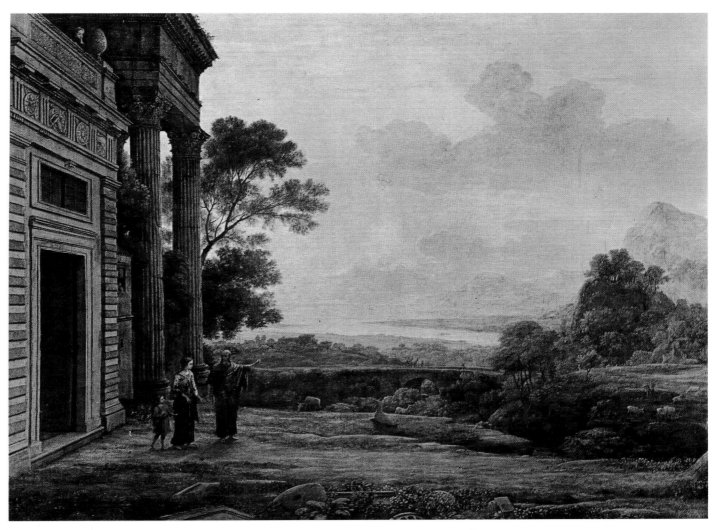

Abraham Expelling Hagar and Ishmael. 1668.
Alte Pinakothek, Munich.

In the early 1670s Claude turned oftenest to episodes from Virgil's *Aeneid*, which inspired more than a dozen works at this time. Original in composition and in the treatment of the subject; they present an idealized, heroicized world of Classical Antiquity.

Coast View of Delos with Aeneas (1672; National Gallery, London), *Aeneas Hunting in Libya* (1672; Musées Royaux des Beaux Arts, Brussels), *The Nymph Egeria Mourning Numa* (1669; Capodimonte Gallery, Naples) and *View of Carthage with Dido and Aeneas* (1676; Kunsthalle, Hamburg) are among the major paintings of the period. The latter is indeed probably the most famous of the artist's late works. He finished its companion piece, *Landscape with Ascanius Shooting the Stag of Silvia* (1682; Ashmolean Museum, Oxford), only shortly before he died. In his final pieces Claude paid increasing attention to the subject matter. In *View of Carthage with Dido and Aeneas* the two central figures and staffage are given particular importance, while the landscape may be likened to a stage set designed to frame a meaningful historic

episode. From behind a small rectangular temple comes the flotilla with which Aeneas must abandon the city of Carthage and Dido, the city's queen and founder who loves him, because he himself is destined to found Rome. There is a note of anxiety and alarm in this stately landscape which is enhanced by the alternating dark and light patches of the ground, the dark mass of trees on the left and the contrasting mild sunlight caressing the portico on the right. The intense blue of the sea sets off the bright red costumes of the main figures, whilst the flock of black birds in the sky and the approaching black cloud are portents of the tragic event — Dido's death — to come. The artist remains true to his principle: the tragic *dénouement* is left out of the picture, but is hinted at in the landscape.

Towards the end of his life Claude also returned to the subjects which he had treated in his earlier works, producing several pastoral views after his own well-established pattern. They still incorporate subjects from the Old and New Testament, but these do not dominate the treatment of the landscape motif.

The graphic work of Claude Lorrain is worthy of close attention because it reveals yet another facet of his talent: his original experimentation with drawing and etching techniques.

We know that the artist set great store by his own graphic notations, sketches and drawings. After a careful study Röthlis-

berger became convinced that Claude kept all of his drawings to the end of his days and often made use of them when working on his paintings.[22] The drawings were many and varied: rapid notations from life, sketches of compositions, animal and human figures, preparatory drawings for major works and, finally, drawings made from his finished paintings and incorporated into the *Liber Veritatis*. He used all kinds of drawing techniques and media — pen and ink, brown wash, pencil and white gouache — and also used different coloured paper — white, pale blue, pink or brownish. The most attractive of his drawings are those done from nature in a free manner, often with the help of unorthodox techniques.

Claude's earlier drawings, like his paintings, reveal his desire to achieve a compositional balance between deeply shadowed and brightly lit areas, which he did by alternating the blank white paper with darker areas worked up in pen. Bold experiments of this kind occur only in the work of seventeenth-century masters.

Claude's paintings present nature in a state of ideal calm, but his drawings feature its wild power: turbulent rivers and streams, stormy seas, trees punished by heavy winds.

Like all landscape artists Claude was fond of depicting trees. Precise pen sketches are combined with free tonal areas, creating natural life-like images. The tree-tops seem to be saturated with sunlight, air and

Hagar and the Angel. 1668.
Alte Pinakothek, Munich.

wind, their branches intertwine in fanciful disarray. Here the artist employed an imaginative rather than a rationalizing approach.

The *Liber Veritatis* drawings which were made after the finished paintings are very different. They are carefully outlined and lack sharp contrasts, tonal patches and free shading. The verve of the pencil sketches gives way to painstaking draughtsmanship. The poetic rendering of a motif from nature is dependent on the painting's composition and subject matter. Nature therefore is not presented in its virgin beauty; the artist offers a poetic, sublimated image, an ideal landscape. Claude employed wash with tone throughout his artistic career, but most of all in his early years when his prime concern was the treatment of light. Later he used this technique more sparingly, in order to achieve a desired spatial effect and subtle modelling, and he always gave precedence to composition and elaborate details. Drawings from his later period, which have remarkable compositional balance, are perhaps over-elaborate; often they abound in details and diverse tonal relations. Despite the modest means of expression and outward simplicity, the drawings look almost like finished paintings. Quite often they are subject-free, and incorporate merely conventional pastoral personages such as shepherds, shepherdesses or dancing peasants: to the artist these figures were symbols of the harmonious bond between human beings and nature, a harmony visualized as a dance (an interpretation that originated in Classical Antiquity and popular in the seventeenth century when the dance was assumed to reflect the movement of celestial bodies which represented cosmic harmony).

Perseus, or the Origin of Coral, a preparatory drawing for a later painting (executed in 1674 for Cardinal Massimi; British Museum, London), is one of Claude's most beautiful and unusual drawings. The time of day is not quite clear, but the artist's choice of pale blue paper suggests a night scene. This is corroborated by the white glint on the water surface which was commonly used to depict moonlight. On the other hand, Claude did not paint night scenes, though many of his landscapes are set at dawn. Most probably this drawing presents the transition from night to dawn, like the Hermitage painting *Night (Jacob Wrestling with the Angel)*. The media used in *Perseus* present a rather striking combination: the pale blue paper, pencil with white wash and emphatic white highlights seem to reflect the mystery and magic of Ovid's *Metamorphoses* and create a painterly effect.

In the field of etching the artist's main concern was the same as in painting and drawing: lighting at different times of the day and the effect of sunrays on the landscape. The prints are marked by a masterly handling of the different states of nature, such as a sunny day (*The Dance, Dance on a River Bank*), a cloudy day (*Herd at a Watering Place, The Rape of Europa*), the elusive atmosphere of morning and evening (*The Ford, Morning in the Harbour, The Departure for the Fields*), light shadows enveloping thick bushes (*The Vision*) and deep shadows beneath groups of trees (*Landscape with Dancing Figures, The Cowherd*). Claude's drawings and prints, compared to his paintings, employ a remarkably wide range of technical devices.

The close hatching in *The Vision* is a regular feature of the artist's earlier etchings, which have many technical faults (nor are the later prints entirely free of faults). Claude seems to be preoccupied with the overall effect of the fin-

The Nymph Egeria Mourning Numa. 1669.
Capodimonte Gallery, Naples.

...ished etching: expressive power comes before impeccable execution. In *The Flight into Egypt* the cross-hatch-ing is so close that the figures occasion-ally merge with the background, but the large blank areas ensure the creation of the desired effect of strong light on a summer day when deep shadows alternate with sunlit areas.

In his graphic works Claude evinces the same interest in transitional phases of atmosphere and lighting during the night as in his painted works. In *The Ford* he uses broken hatching to convey the diffu-sed moonlight. There are small, sharply outlined patches of light on the figures, animals and tree-tops. The tree masses, standing out clearly in the dusk, have a structure of their own and, as in the paint-ings, seem to be suffused with light and air. Diane Russel traces this etching back to the etchings of Adam Elsheimer,[23] the author of famous night scenes who had a strong influence on many painters based in Rome. Claude, too, must have been familiar with Elsheimer's etchings.

A recurrent motif in the artist's etchings is that of a herd fording a river or grazing peacefully. Sometimes the animals serve as staffage, sometimes they are the main subject. One such etching, *Herd at a Watering Place*, is notable for the lazy rhythm of the animals' movements which matches the tranquil noontide atmosphere. Textures are expertly rendered with the help of fine shading: by varying the direction and thickness of the lines the artist depicts the rugged dry ground, the rough tree trunks, the animals' smooth shiny coats and the ripples on the transparent water caused by their feet.

The Cowherd is rightly considered one of Claude's finest etchings. Here everything is in perfect harmony: the well-designed and balanced composition, clear-cut contours and subtle gradations of light make it a convincing representation of a sultry summer day as it draws to a close. The large number of copies printed during the artist's lifetime shows that this etching found favour among his contemporaries, and it was also greatly admired by art lovers in the nineteenth and twentieth centuries.

We know that nature in a state of turmoil is alien to the work of Claude Lorrain. Some of his landscapes are sombre, charged with gloomy foreboding, but the majestic repose of nature is never disturbed. *The Goatherd (Herd Returning in Stormy Weather)*, one of the first

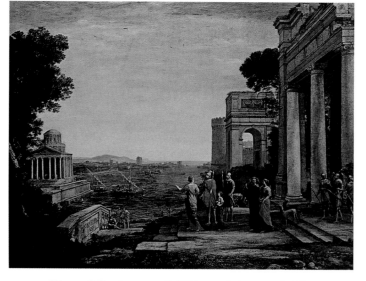

View of Carthage with Dido and Aeneas. 1676.
Kunsthalle, Hamburg.

etchings executed by the artist after an interval of ten years, is his one and only tribute to the storm motif. It was produced in 1650 or 1651, in the same period that Poussin painted *The Tempest* and *Calm Weather*. These two masterpieces may have affected Claude's choice of such an uncharacteristic subject, but it is more likely that he simply decided to take up a — for him — fresh and unusual motif. And he decided to use the medium in which he experimented most actively and which he also selected to produce his one and only portrayal of a storm at sea. Perhaps the artist tried to tackle in etching the motifs which he felt no need to depict in his paintings. As we noted above, his etchings and particularly his drawings, are executed with remarkable freedom.

The pastoral motif receives quite a different treatment in the etching *Shepherd and Shepherdess Conversing in a Landscape*. This elaborately executed work is the epitome of quiet village life. In its impeccable finish, graphic emphasis and accentuated division into planes it reminds us of the *Liber Veritatis* drawings. The etching with romping goats, one of Claude's favourite motifs, is both amusing and interesting. Similar goat figures occur in many of his canvases. This etching, one of the artist's first, resembles a sketch from life, with its fresh and unusual treatment.

Village festivals also figure in Claude's graphic works especially in the 1630s:

The Dance (c.1635-37), *Dance on a River Bank* (1636-38) and *Landscape with Dancing Figures* (c.1637). During this period Claude experimented actively with etching techniques. For the *Dances* he used an acid-moistened brush in order to achieve a near-painterly effect of aerial perspective: the hill in the middle ground is slightly distanced from the dancing figures and seems to be veiled in a light haze — and the same device is used for the deep shadows cast by the trees in the foreground — but the dancers' figures are well outlined. Rembrandt was the only other artist who subsequently used this device, bringing it to perfection. Claude employed it only in some of his earlier etchings, since his primary goal was to improve the quality of his painting. The village dance, one of his best-loved subjects, takes place in this etching amidst a lovely sunny landscape under the branches of stately trees. The artist glorifies the joy of life which is matched by the beauty of natural setting.

Close to these village scenes are *The Wooden Bridge* (*Eliezer and Rebecca Taking Leave of Her Father*, c. 1640) and *Landscape with Mercury and Argus* (1662). The artist's last etching of a village scene (1663) corresponds to the *grand manière* of his paintings: impressive and clear motifs come to the fore, scenes of peaceful life are framed by beautiful tranquil landscapes.

Landscape with Ascanius Shooting the Stag of Silvia. 1682.
Ashmolean Museum, Oxford.

Claude's graphic depictions of harbour motifs concentrate on conveying the effect of direct sunlight and the aerial perspective, and here the artist demonstrates his technical perfection. The lines are precise and the forms distinct, shaded areas are cleverly balanced by the blank of the white paper, and this produces the effect of sunlight filtering through the heavy damp air over the morning sea. *Harbour with Large Tower on the Left*, with the strong and somewhat stiff shading used by the artist in the later 1630s, gives us an idea of the now lost painting of the same name. The 1639 print, *Coast Scene with an Artist Drawing*, seems to bear out Sandrart's testimony that this is how Claude himself used to work in the open air in the environs of Rome.

In the 300 paintings which he accomplished in the course of his long career Claude Lorrain expressed his thoughts and feelings through the medium of sophisticated allusions that are sometimes not easy to decipher. The view of his heritage as a simple expression of the artist's worship of nature cannot be accepted. He depicted nature and people in contradictory and meaningful interactions, and his works to this day evoke a deep response in the spectator's soul. A patient study of the artist's works will be rewarded by full comprehension of both Claude's approach to art and the spirit of the seventeenth century as a whole.

Natalia SEREBRIANNAYA

NOTES

1 - E. Panofsky, *Et in Arcadia Ego : Poussin and the Elegiac Tradition*, in: *Meaning in the Visual Arts*, New York, 1957; p. 297-301.

2 - F. Baldinucci, *Notizie de' professori del disegno*, Florence, 1846, vol. 5, p. 92.

3 - M. Kitson, M. Röthlisberger, "Claude Lorrain and the Liber Veritatis-I", in: *Burlington Magazine*, 1959, N° 670, p. 18.

4 - Baldinucci, *op. cit*, p. 91.

5 - M. Röthlisberger, "Les Pendants dans l'œuvre de Claude Lorrain" in: *Gazette des Beaux-Arts*, 1958, N° 51, p. 216.

6 - M. Röthlisberger, "The Subjects of Claude Lorrain's Paintings", in: *Gazette des Beaux-Arts*, 1960, N° 55, April, p. 209-224.

7 - Baldinucci, *op. cit*, p.92.

8 - D. Russel, *Claude Gellée dit Le Lorrain*, Paris 1983, pp. 53, 130, 131, 317.

9 - L. Kroncke, "Claude Lorrain and the Development of Marine Painting in Italy", in: D. Russel, *op. cit.,* p. 68.

10 - I. G. Kennedy, "Claude and Architecture" in Journal of the Warburg and Courtauld Institutes, 1972, N°35, p. 273.

11 - J. von Sandrart, *Teutsche Academie*, Nuremberg, 1675-1679, vol. 1, part 2, p. 160.

12 - L. Salerno, *Pittori di paesaggio del Seicento a Roma*, Rome, 1978, vol. 1, p. 378.

13 - Sandrart, *op. cit.*, vol. 1.

14 - Ibid.

15 - Ibid.

16 - Ibid.

17 - D. Russel, *op. cit.*, p. 104.

18 - M. Röthlisberger, *Claude Lorrain. The Paintings*, vol. 1-2: New Haven, 1961, vol. 1, p. 329.

19 - M. Röthlisberger, *op. cit.* pp. 333-335 ; J. Smith, *A Catalogue Raisonné of the Works of the Most Eminent Dutch, Flemish and French Painters*, vol. 8, London, 1837, pp. 226-267.

20 - L. Salerno, *op. cit.*, pp. 19-21.

21 - M. Röthlisberger, *Le Paysage comme idéal classique*, in: M. Röthlisberger, *Claude Lorrain*, Paris, 1977, p. 8.

22 - M. Röthlisberger, *Claude Lorrain: The Drawings*, Berkeley-Los Angeles, 1968, vol. 1, p. 79.

23 - D. Russel, *op. cit.*, p. 104.

EXHIBITIONS

PRINCIPAL CATALOGUES
AND INVENTORIES

EXHIBITIONS

1908 St. Petersburg
Exhibition of Painting mounted by the magazine
Starye Gody (The Old Years). St. Petersburg,
1908 (*Starye Gody*, 1908, No 7-8).

1954 Leningrad
Travelling Exhibition of Works of Western
European Art. Leningrad, 1954.

1955 Moscow
Exhibition of French Art: 15th-20th
Centuries. Moscow, 1955.

1956 Leningrad
Exhibition of French Art: 12th-20th
Centuries. Leningrad, 1956.

1965 Bordeaux
Chefs-d'œuvre de la peinture française
dans les musées de Leningrad
et de Moscou. Bordeaux, 1965

1965-1966 Paris
Chefs-d'œuvre de la peinture française
dans les musées de Leningrad
et de Moscou. Paris, 1965-1966.

1968-1969 Belgrade
Old Masters from the Hermitage: Works
by Western European Painters (16th-18th
Centuries) from the Hermitage Collection.
Narodni muzej, Belgrade, 1968-1969.

1969 Budapest
Francia mesterek a Leningardi Ermitazsbol.
Szepmüvészeti Müseum. Budapest, 1969.

1970 Göteborg
Eremitaget i Leningrad. 100 malningar
och teckningaz fran Renässans till 1700-
tal. Konstmuseum, Göteborg, 1970.

1972 Dresden
Meisterwerke aus der Ermitage, Leningrad,
und aus dem Puschkin-Museum, Moskau.
Albertinum, Dresden, 1972.

1972 Warsaw - Prague - Budapest - Dresden
Europäische Landschaftsmalerei,
1550-1650. Dresden, 1972.

1973 Warsaw
Malarstwo francuskie XVII-XX w. ze
zbiorow Ermitazu. Muzeum Narodowe w
Warszawie, Warsaw, 1973.

1975-1976 Washington - Houston
Master Paintings from the Hermitage and
the State Russian Museum, Leningrad.
National Gallery of Art, Washington, D.C.;
M. Knoedler Inc., New York, N.Y.;
The Detroit Institute of Arts, Detroit,
Mich.; Los Angeles County Museum of
Art, Los Angeles, Cal.; The Museum of
Fine Arts, Houston, Tex. (also in
Winnipeg and Montreal, Canada).

1977 Tokyo - Kyoto
Master Paintings from the Hermitage
Museum, Leningrad. The National
Museum of Western Art, Tokyo;
The Kyoto Municipal Museum of Art,
Kyoto; 1977.

1978 Prague - Bratislava
Padesat mistrovskych del ze sbirek
sovetskych muzei a galerie. Prague 1978.

1981 Vienna
Gemälde aus der Ermitage und dem
Puschkin-Museum. Kunsthistorisches
Museum, Wien. Vienna, 1981.

1982 Moscow
The Classical Tradition in European
Painting: 15th-20th Centuries. Moscow, 1982.

1985 Sapporo - Fukuoka
Western European Master Works
from the Hermitage.
June 13-August 22, 1985.

1987-1988 Belgrade - Ljubljana - Zagreb
Svetski majstori iz riznica Ermitaza od XV-
XVIII veka. Narodni muzej,
Belgrade; Narodna Galerija,
Ljubljana. Zagreb, 1987-1988.

1987-1988 New Delhi
The National Committee Festival of India.
The National Museum, New Delhi. The
USSR Organizing Committee of the
Festivals in the USSR and India.
The Ministry of Culture of the USSR.
The Hermitage, Leningrad. Masterpieces
of Western European Art from the
Hermitage, Leningrad. New Delhi, 1987-1988.

1988 Sydney - Melbourne
Masterpieces from the Hermitage,
Leningrad. Western European Art of the
15th-20th Centuries. Art Gallery of New
South Wales, Sydney; National Gallery of
Victoria, Melbourne; 1988.

PRINCIPAL CATALOGUES AND INVENTORIES
Key to Abbreviations

THE HERMITAGE, ST. PETERSBURG

Cat. 1773-1785
Catalogue raisonné des tableaux qui se trouvent dans les galeries et cabinets du Palais impérial, St. Petersburg, 1773-1785 (Hermitage Archives, fund 1, inv. VIa, No 85).

Cat. 1797
Catalogue of Paintings in the Imperial Gallery of the Hermitage (compiled with the participation of F. Labensky), St. Petersburg, 1797 (Hermitage Archives, inv. VI; in Russian).

Inv. 1859
Inventory of Paintings and Ceiling Decorations in the Charge of the Second Department of the Imperial Hermitage, 1859 (deposited in the department of Western European art; in Russian).

Cat. 1863-1916
Imperial Hermitage. Catalogue of the Picture Gallery (compiled by A. Somov), St. Petersburg, 1863-1916 (in Russian).

Cat. 1958
State Hermitage. Department of Western European Art. Catalogue of Paintings, vol. 1, Leningrad, Moscow, 1958 (in Russian).

Cat. 1976
State Hermitage. Western European Painting, vol. 1: *Italy, Spain, France, Switzerland,* Leningrad, 1976 (in Russian).

THE PUSHKIN MUSEUM OF FINE ARTS, MOSCOW

Cat. Pushkin Museum 1948
Pushkin Museum of Fine Arts. Catalogue of the Picture Gallery, Moscow, 1948 (in Russian).

Cat. Pushkin Museum 1957
Pushkin Museum of Fine Arts. Catalogue of the Picture Gallery, Moscow, 1957 (in Russian).

Cat. Pushkin Museum 1961
Pushkin Museum of Fine Arts. Catalogue of the Picture Gallery, Moscow, 1961 (in Russian).

Cat. Pushkin Museum 1986
Pushkin Museum of Fine Arts. Catalogue of the Picture Gallery, Moscow, 1986 (in Russian).

OTHER REFERENCES

Baldinucci 1846
F. Baldinucci, *Notizie de' professori del disegno...* vol. 5, Florence, 1846.

Bouyer 1905
K. Bouyer, *Claude Lorrain.* Paris, 1905.

Chatelain 1973
F. Chatelain, *Dominique Vivat Denov et le Louvre de Napoléon.* Paris, 1973.

Christoffel 1942
U. Christoffel, *Poussin und Claude Lorrain.* Munich, 1942.

Courthion 1932
P. Courthion, *Claude Gellée.* Paris, 1932.

Ernst 1929
S. Ernst, "Les tableaux de Claude Lorrain dans les collections Joussoupoff et Stroganoff". In: *Gazette des Beaux-Arts,* 2, 1929

Friedländer 1921
W. Friedländer, *Claude Lorrain.* Munich, 1921.

Hetzer 1947
Theodor Hetzer, *Claude Lorrain.*
Frankfurt, 1947.

Hind 1926
A. M. Hind, *Catalogue of the Drawings of
Claude Lorrain…*, London, 1926.

Kuznetsova 1982
I. Kuznetsova, *French Painting: 16th to the First
Half of the 19th Century. Catalogue of the
Pushkin Museum of Fine Arts,* Moscow, 1982
(in Russian).

Kuznetsova, Georgievskaya 1979
I. Kuznetsova, E. Georgievskaya, *French Painting
from the Pushkin Museum. 17th to 20th Century,*
Leningrad, 1979.

Livret 1838
F. Labensky, *Livret de la Galerie impériale de
l'Ermitage.* St. Petersburg, 1838.

Pattison 1884
Mrs. Mark Pattison, *Claude Lorrain, sa vie et ses
œuvres d'après des documents inédits.*
Paris, 1884.

Réau 1928
Louis Réau, "Catalogue de l'art français dans les
musées russes, Paris, 1928". In: *Bulletin de la
Société d'histoire de l'art français,* 1929.

Röthlisberger 1958
M. Röthlisberger, "Les pendants dans l'œuvre
de Claude Lorrain". In: *Gazette des Beaux-Arts.*
51, 1958, April.

Röthlisberger 1960
M. Röthlisberger, "The Subjects of Claude
Lorrain's Paintings". In: *Gazette
des Beaux-Arts,* 55, 1960, April.

Röthlisberger 1961
M. Röthlisberger, *Claude Lorrain:
The Paintings.* vols 1, 2. London, 1961.

Röthlisberger 1968
M. Röthlisberger, *Claude Lorrain:
The Drawings.* vols 1, 2. Berkeley,
Los Angeles, 1968.

Röthlisberger 1977
M. Röthlisberger, "Le paysage comme idéal
classique". In: *Tout l'œuvre peint de Claude
Lorrain* (introduction and catalogue raisonné
by M. Röthlisberger with the assistance of
Doretta Cecchi). Paris, 1977.

Sandrart 1675
J. von Sandrart, *Die Teutsche Academie.* vols 1,
2. Nuremberg, 1675-1679.

Smith 1837
J. Smith, *A Catalogue Raisonné of the Works of
the Most Eminent Dutch, Flemish and French
Painters.* vol. 8, London, 1837.

Sterling 1957
Ch. Sterling, *Musée de l'Ermitage: La peinture
française de Poussin à nos jours.* Paris, 1957.

Verzeichniss 1783
*Verzeichniss der Hochfürstlichen Hessischen
Gemälde-Sammlung in Cassel.* Cassel, 1783.

Waagen 1864
G.Y. Waagen, *Die Gemäldesammlung in der
Kaiserlichen Ermitage zu St. Petersburg nebst
Bemerkungen über andere dortige
Kunstsammlungen.* Munich, 1864.

Weisbach 1932
W. Weisbach, *Französische Malerei des 17.
Jahrhunderts.* Berlin, 1932.

CHICAGO PUBLIC LIBRARY
SULZER REGIONAL
4455 N. LINCOLN AVE. 60625